TIME

HISTORY'S GREATEST EVENTS

100 Turning Points That Changed the World:
An Illustrated Journey

TIME

MANAGING EDITOR Richard Stengel
ART DIRECTOR D.W. Pine

History's Greatest Events

100 Turning Points That Changed the World: An Illustrated Journey

EDITOR Kelly Knauer
DESIGNER Sharon Okamoto
PICTURE EDITOR Patricia Cadley
RESEARCH Tresa McBee
COPY EDITOR Bruce Christopher Carr

TIME HOME ENTERTAINMENT
PUBLISHER Richard Fraiman
GENERAL MANAGER Steven Sandonato
EXECUTIVE DIRECTOR, MARKETING SERVICES Carol Pittard
DIRECTOR, RETAIL & SPECIAL SALES Tom Mifsud
DIRECTOR, NEW PRODUCT DEVELOPMENT Peter Harper
DIRECTOR, BOOKAZINE DEVELOPMENT & MARKETING Laura Adam
PUBLISHING DIRECTOR, BRAND MARKETING Joy Butts
ASSISTANT GENERAL COUNSEL Helen Wan
BOOK PRODUCTION MANAGER Suzanne Janso
DESIGN & PREPRESS MANAGER Anne-Michelle Gallero
BRAND MANAGER Michela Wilde

SPECIAL THANKS TO:
Christine Austin, Jeremy Biloon, Glenn Buonocore, Jim Childs, Susan Chodakiewicz, Rose Cirrincione, Brian Fellows, Jacqueline Fitzgerald, Carrie Frazier, Lauren Hall, Malena Jones, Brynn Joyce, Mona Li, Robert Marasco, Amy Migliaccio, Kimberly Posa, Brooke Reger, Dave Rozzelle, Ilene Schreider, Adriana Tierno, Alex Voznesenskiy, Sydney Webber, TIME Imaging

The four chapter-opening essays in this volume incorporate some material from a TIME cover story anticipating the 2000 Millennium written by John Elson in 1992.

ISBN 10: 1-60320-162-9; ISBN 13: 978-1-60320-162-9
Library of Congress Control Number: 2010927619
Printed in China

We welcome your comments and suggestions about TIME Books. Please write to us at:
TIME Books, Attention: Book Editors, PO Box 11016, Des Moines, IA 50336-1016

If you would like to order any of our hardcover Collector's Edition books, please call us at 1-800-327-6388.
Monday–Friday, 7:00 a.m.–8:00 p.m., or Saturday, 7:00 a.m.–6:00 p.m., Central Time.

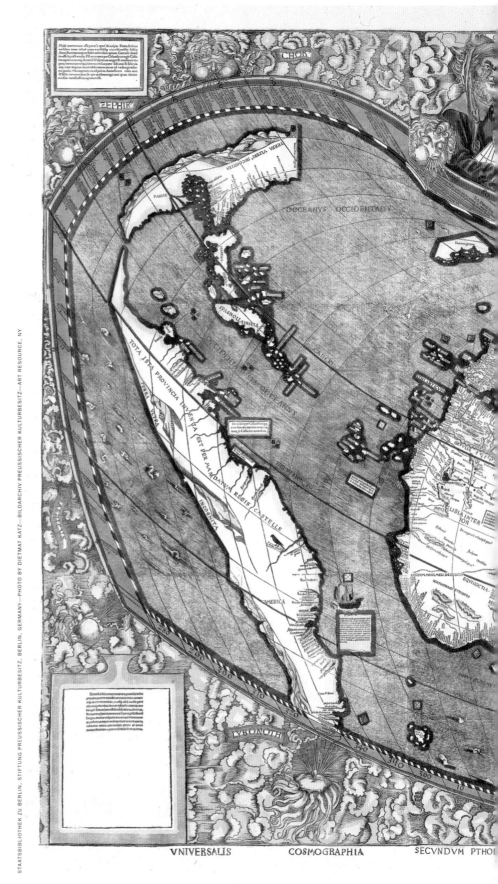

STAATSBIBLIOTHEK ZU BERLIN, STIFTUNG PREUSSISCHER KULTURBESITZ, BERLIN, GERMANY—PHOTO BY DIETMAT KATZ—BILDARCHIV PREUSSISCHER KULTURBESITZ—ART RESOURCE, NY

A NEW WORLD BECKONS *German cartographer Martin Waldseemüller published this woodcut-print world map in 1507, only 15 years after Columbus sailed to the Americas. It is the first map to use the term* America *for the New World, whose two continents it renders as a narrow isthmus*

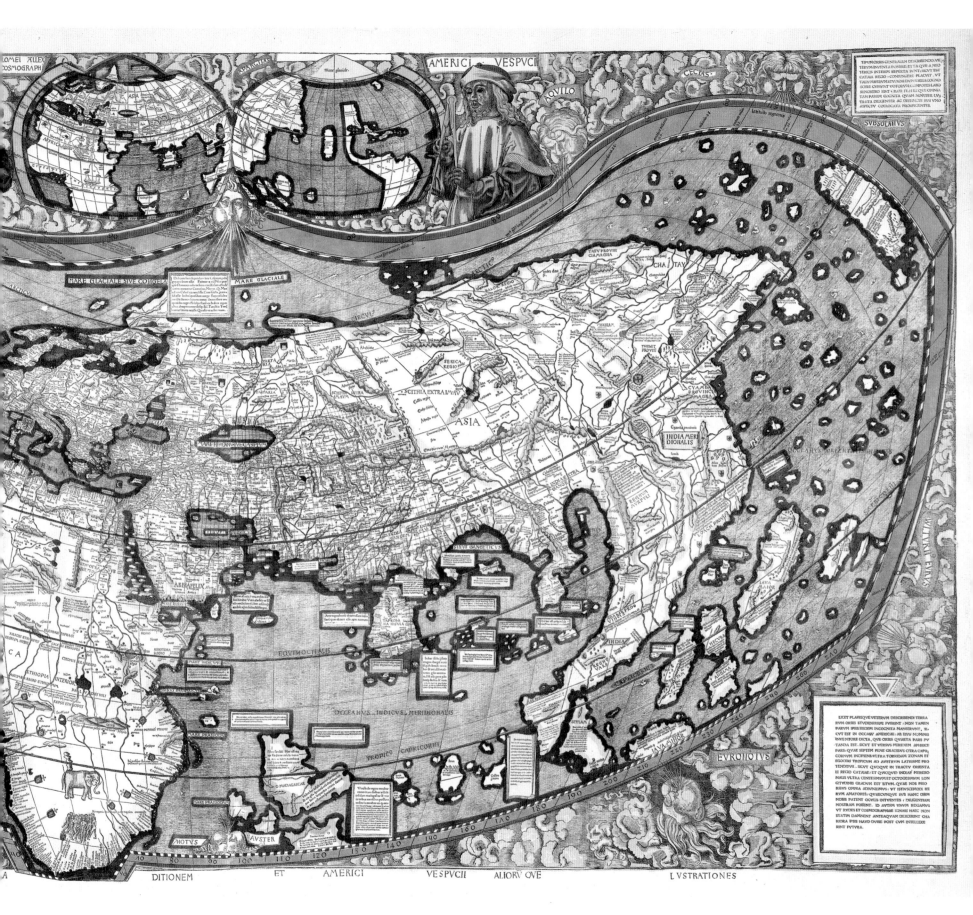

iii

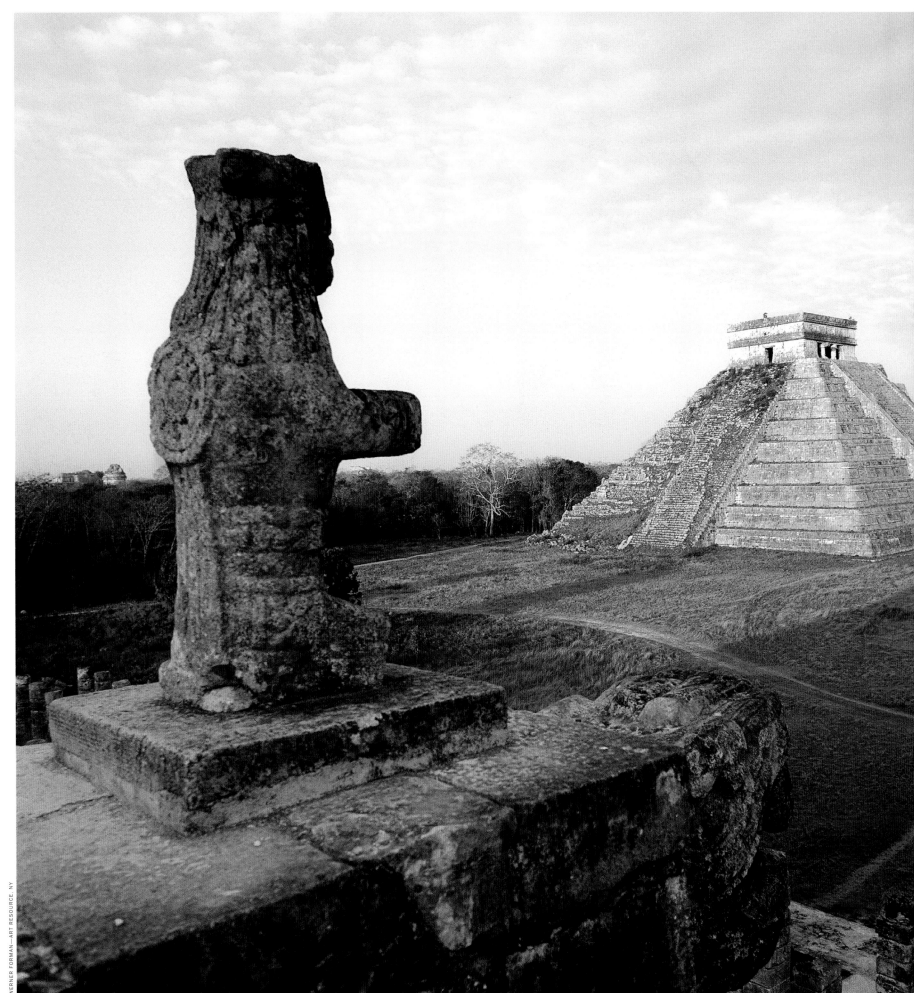

Contents

LOST WORLD *The Maya civilization was separated from the rest of the world by two vast oceans. Its achievements, like the mighty city of Chichen Itza in Mexico's Yucatán Peninsula, had no opportunity to influence other cultures*

When Great Events
Spark Great Arguments

"History will be kind to me," declared Winston Churchill, "because I intend to write it." And write it he did, winning a Nobel Prize for Literature for his multi-volume history of World War II. A difficult truth lies within the British statesman's easy jest, for our vision of the world always reflects the perspective from which we view it. And that's certainly true of this volume, which refracts world history through the lens of a U.S. newsmagazine and undoubtedly reveals a special interest in U.S. and European events. The book also reflects the vantage point of a particular time in history, the early years of the 21st century. As of 2010, the great rivalry between the U.S. and Soviet Union, the cold war that divided the world into two superpower blocs for four decades after the end of World War II, has receded in history's rear-view mirror. The broad currents driving world events today are more random: they include a new age of international terrorism, China's rapid rise as a world economic power, the advent of the World Wide Web and a global renascence in the religion of Islam.

Wait a minute—the World Wide Web? Admittedly, the debut of the Web doesn't match D-day or the fall of the Berlin Wall as one of history's photogenic pivot-points. Even Steven Spielberg would be hard-pressed to inject much excitement into the moment in 1991 when British physicist Tim Berners-Lee hit the "return" button on his computer and sent an e-mail containing the address of the world's first website to his colleagues.

■ A TURNING WHEEL
This figure of a potter working clay was created during Egypt's 5th Dynasty, circa 2445 to 2421 B.C., as cultures, societies and religions began to take shape

■ AN EXPANDING VIEW
After the Middle Ages our world seemed both smaller and larger, as astronomers located our planet in space, and mariners found it held new continents to explore

But this most recent in a series of ongoing communication revolutions is changing our world in ways we are only beginning to sense, altering not only our lifestyles but also our politics, laws and arts. It was this steady advance of technology, along with its often unexpected consequences, that led us to present our list of great events in chronological order. Particularly since the Renaissance, the interplay between science and society has become a primary force driving historical change, and that march of know-how gives the book a strong narrative arc. Yet man's technological progress has not always been matched by moral and social progress, and that dichotomy gives the book's list of mankind's turning points an underlying, frustrating tension.

And as for that list: no doubt readers will find much to quarrel with in our selections. The delicious subtext of a book of this sort is the opportunity it presents for readers to match wits with the editors and judge us dismally lacking in historical insight. Where, you may ask, are the Battles of Marathon, Lepanto and Stalingrad? The invention of penicillin or anaesthetics? Where are Confucius, Shakespeare and Galileo? The Spanish Armada? All were considered; all were rejected. This is our list, and we encourage you to compile your own.

The most surprising aspect of our journey through the centuries was the revelation of the extent to which individual lives can shape our common trajectory. TIME's signature editorial decision is its annual selection of a Person of the Year, the individual who has most influenced the year just past, for good or ill. In similar fashion, even when we opened our lens to its widest setting, selecting history's most significant events often brought us face to face with history's most significant people. Jesus and Muhammad, Alexander the Great and Napoleon, Newton and Einstein prove that it is entirely possible for single individuals to grab hold of history's rudder and change its course—whether or not they choose to join Winston Churchill in crowing about it.

—*The Editors*

■ A CHANGING SOCIETY
The Industrial Revolution wrought a fundamental alteration in society. As cities replaced farms and machines replaced human labor, the pace of life accelerated

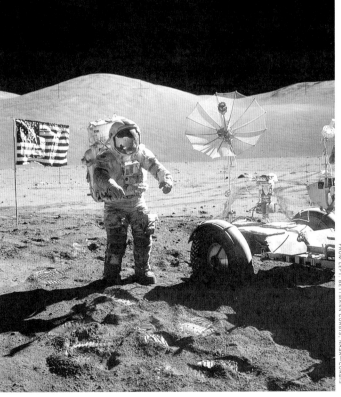

■ AN UNKNOWN FUTURE
The turn of the second millennium after Christ brought technological marvels, but advances in politics and society lagged behind science's triumphs

The Ancient World

MANKIND'S EARLY BREAKTHROUGHS ■ DAWN OF THE ALPHABET ■ MINOAN CIVILIZATION FALLS
CODE OF HAMMURABI ■ ABRAHAM'S COVENANT ■ AKHENATEN'S RELIGION ■ BUDDHA'S MESSAGE
THE GOLDEN AGE OF PERICLES ■ ALEXANDER THE GREAT'S CONQUESTS ■ JULIUS CAESAR'S ROME
JESUS ESTABLISHES CHRISTIANITY ■ CONSTANTINOPLE IS FOUNDED ■ BARBARIANS SACK ROME
MUHAMMAD FOUNDS ISLAM ■ VIKINGS RAID LINDISFARNE ■ CHARLEMAGNE UNITES EUROPE
ISLAM'S GOLDEN AGE OF LEARNING ■ MAYA CIVILIZATION COLLAPSES ■ BATTLE OF HASTINGS
UNIVERSITY OF BOLOGNA IS FOUNDED ■ EUROPEAN CRUSADERS CONQUER JERUSALEM
MAGNA CARTA IS SIGNED ■ GENGHIS KHAN'S CONQUESTS ■ BLACK DEATH RAVAGES GLOBE

Few of us today would consult a sundial to determine the time. A solar sextant is a magnificent tool for finding one's position, but a G.P.S. application on a cellphone is a bit handier. And the days of commissioning a scribe to write a message to a friend on papyrus have definitely passed. Time and technology have moved on. Egypt's pharaohs are mummies; Greece's marble-clad temples, once painted in garish hues, have been scoured into white purity. The ancient world survives in the form of ruins, shells that once held life and meaning but have lost their inner flame. Yet there is a singular exception: when we turn to spiritual matters, most of us worship the same gods and follow the same rites as our distant predecessors. All the world's major religions were established long centuries ago, but they have never lost their central place in human life. Islam, founded at the turn of the 7th century A.D., is enjoying a period of remarkable renascence that began in the mid-20th century. Spiritual seekers around the globe continue to adapt the teachings of Siddhartha Gautama, the Buddha, to their particular cultures. Modern Christian evangelists are baptizing converts by the thousands in Africa, and Christian principles are a powerful force in U.S. politics. Jews have famously hewn to their ancient creed through centuries of diaspora and suffering and still rejoice in the creation of the state of Israel in their ancient homeland. Only the great polytheistic pagan religions that nourished the spirit of Sumerians and Babylonians, Egyptians and Greeks have been left behind. Empires rise and fall; armies conquer and are vanquished in turn. But the great religions endure, linking the present to the past, the vital connective tissue of human history.

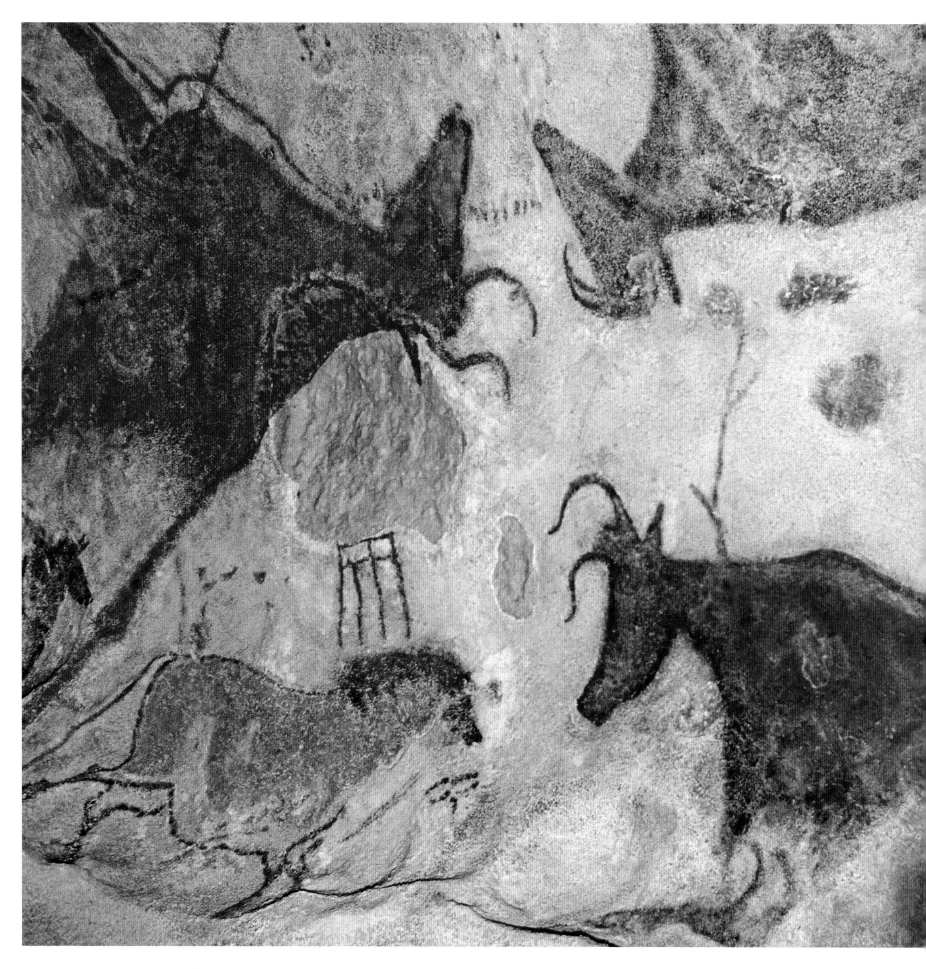

Mankind's Prehistoric Breakthroughs

1 Unlike an absorbing Dickens novel, this book cannot offer a detailed backstory for the early adventures of its main character, *Homo sapiens*. After all, it strives to document history's greatest events, and many of humanity's most significant milestones occurred during the era we describe as prehistoric. Yet it would be deeply unsatisfying not to recognize the many achievements that took place before history and society first began to emerge from the mists of the past. Who was the first human to shape a bone or a rock into a tool? Who was the first to create a wheel and axle? Who first tilled the soil and planted seeds? Who first tamed a dog and put it to work herding sheep? Who was first to harness fire's power? Offer sacrifice to a god? Take a vow of marriage? What brilliant early metalsmith first heated copper and tin to create bronze? (This event comes closer to history, for the earliest samples of bronze are now dated 3000 to 2000 B.C. and were found in today's Iraq and Iran.)

The study of early man is a young science, and there is much yet to learn. It was only in the mid-19th century, with the discovery of Neanderthal Man's remains, the coining of the term *dinosaur* and the publication of Charles Darwin's theories, that a sense of what scientists call the "deep past" took shape. Today most scientists believe that modern *Homo sapiens* was not the inevitable design for an intelligent human; there were different sorts of hominids, many false starts and dead ends. At certain times in some parts of the world, two different hominid species may have competed for survival. Some prospered; others failed. We cannot name the Napoleons, Einsteins and Edisons of prehistory. Yet any enumeration of the highlights of the human story must take note of their triumphs.

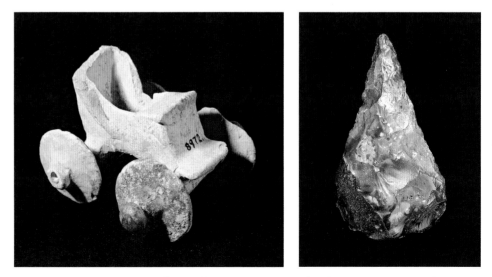

EARLY MASTERPIECES *The brilliant prehistoric cave paintings found in southern Europe offer our closest encounter with early man. At left is a detail from the famed artworks in Lascaux in France, now believed to date to about 15,000 B.C. Above left is a model of a chariot from Mesopotamia, dating from 2000 to 1595 B.C. Above right is a chiseled flint handaxe from England, dating from 350,000 B.C.*

The Development of the Alphabet

2 Scholars cannot tell us when humans first began to speak distinct languages, but they are more certain about the first appearance of written communication in the form of the alphabet. There are a dizzying array of alphabets, of course: English is written in what is called the Latin alphabet; Russian and other Slavic peoples employ the Cyrillic alphabet; the French, partial to nuance, add a host of accented letters to the standard Latin symbols. In an alphabet, individual letters indicate specific sounds, but there are other systems of rendering speech in written form. Logograms, literally "word-writings," are composed of characters that indicate entire words, while syllabaries represent individual syllables as distinct characters. And then there are unique alphabets created for specific uses, such as Braille and Morse code.

The Chinese began using pictograms, pictures standing for words, around 5000 B.C. In the Mediterranean, the earliest examples of writing come from two sources. Ancient Sumer, the influential Mesopotamian civilization, developed cuneiform, a pictographic system. Its earliest known samples date to the 34th century B.C. This script gradually grew more stylized as the number of pictographs was reduced, until they finally emerged as letters. Egypt was the second home of early writing; its hieroglyphs were a combination of characters and pictograms. Such writing was originally reserved for religious purposes: the prefix *hier-* indicates that hieroglyphs are, literally "sacred carving." The oldest known hieroglyphs date from 3400 to 3200 B.C. With the development of writing, the information revolution had begun.

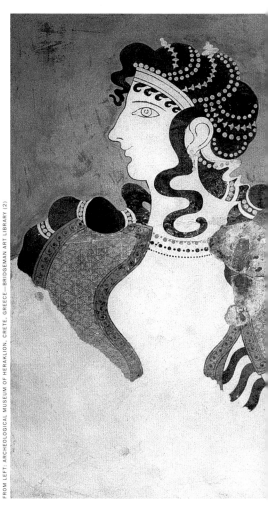

FROM LEFT: ARCHEOLOGICAL MUSEUM OF HERAKLION, CRETE, GREECE—BRIDGEMAN ART LIBRARY (2)

MINOAN MARVELS *Above, three stylish women, informally known as* The Blue Ladies, *flaunt their curls in a fresco from the Palace of Knossos on Crete. Minoan arts were quite advanced for their time, revealing a matriarchal society in which female goddesses predominated and female priests were the primary religious figures. At top right is an elegant stone bull's head with horns of gilded wood.*

At near right is the structure dubbed the "purification pool" by Arthur Evans, who excavated the Palace of Knossos and argued that it was the model for the legendary Labyrinth of Greek mythology

NATIONAL MUSEUM OF ARCHEOLOGY, LA VALLETTA, MALTA—ERICH LESSING—ART RESOURCE

OLD NEWS *This marble marker from Gozo, a Maltese island, employs Phoenician script, the precursor to many modern alphabets, including those used in Arabic, Hebrew, Latin and Greek languages*

SCALA—WHITE IMAGES—ART RESOURCE, NY

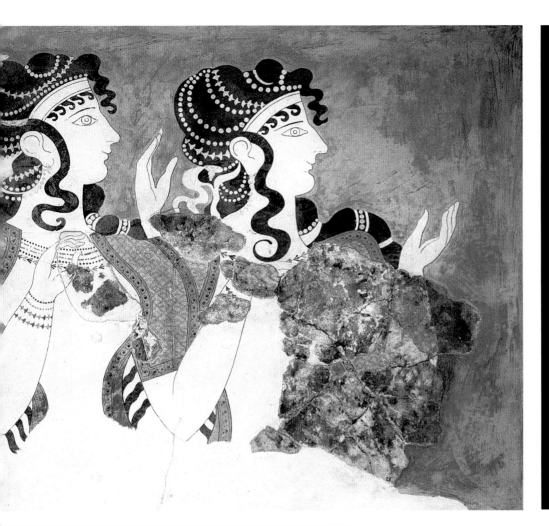

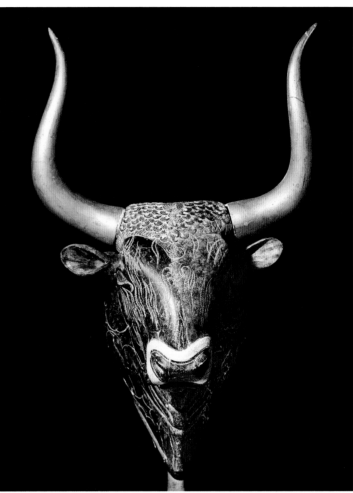

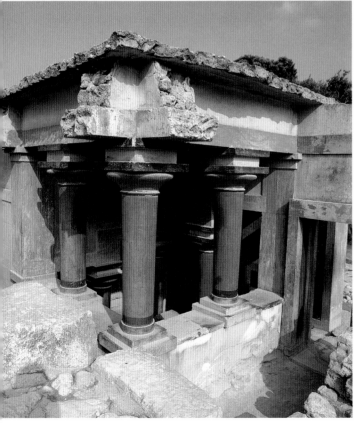

Minoan Civilization Peaks, Only to Perish

3 Imagine an ancient society, in which goddesses outrank gods and women are the equal of men. Imagine a ritual dance of humans and bulls, acrobatics as art and perhaps as religious rite. Imagine a mighty civilization, located at the center of the Mediterranean Sea, grown rich upon maritime trade with its neighbors and home to extensive palaces, bustling cities and ornate decorative arts. Now imagine that this great culture was washed away in a single, cataclysmic natural disaster. If the legend of the lost continent of Atlantis crosses your mind—join the scholars and historians who have long believed that the Minoan culture centered on the island of Crete, which flourished in the years between 3000 and 1500 B.C., was the prototype for this venerable myth, first related by Plato in two of his *Dialogues*.

The pioneer of Minoan studies was a Briton, Arthur Evans, who excavated the extensive ruins at Knossos, outside today's Heraklion, early in the 20th century. Evans named the civilization after the legendary Minos, King of Crete. The Atlantis connection is intriguing, but the importance of Minoan culture is far from mythical. Scholars see it as likely the most advanced and important civilization of its day, pointing to the Minoan artifacts that have been unearthed in port towns across the Mediterranean; as recently as 2009, Minoan-style frescoes and artifacts were found in Israel. Minoans built paved roads and developed a written language, Linear A. But why did their culture decline? The prevailing view is that it was irreparably damaged in the massive eruption of a volcano on the island of Thera, today's Santorini, which was accompanied by a major tsunami. Scientists are divided over the timing of this event: radiocarbon dating puts it at 1650 to 1600 B.C., but ancient Egyptian chronologies suggest a more recent date, 1550 to 1500 B.C. The lesson of the Minoans is easier to determine: even mankind's greatest works are no match for nature's power.

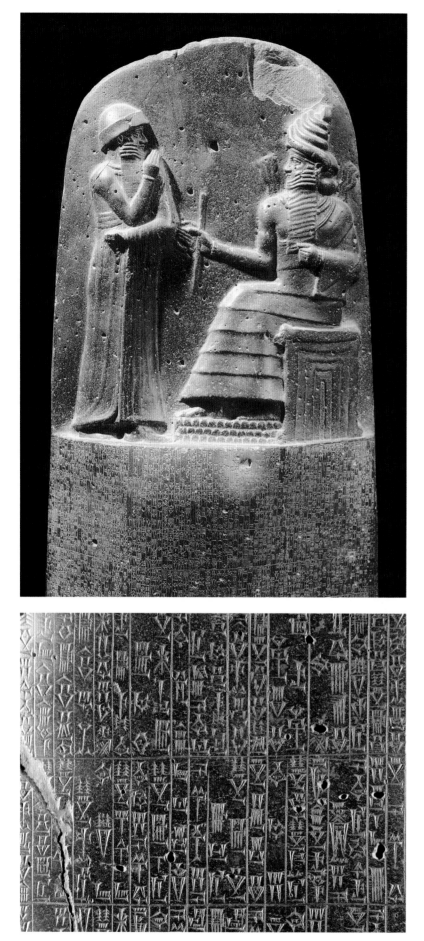

EQUAL JUSTICE UNDER LAW *At top, the upper section of the stele shows Hammurabi seated upon a throne. His ziggurat-style headpiece would be echoed in the design of the Great Mosque of Samarra, built some 25 centuries later in Samarra, Iraq (see page 28). At bottom is a close-up of the cuneiform characaters inscribed on the stele*

Hammurabi's Code Reflects The Dream of a Just Society

4

Reviled and admired, envied and feared, ancient Babylon—the remains of which lie some 50 miles (80 km) south of Baghdad—has for centuries been shrouded in myth. Despite its description by Greek historians as a center of political power, lingering fables tend to overshadow any sense of what the city was actually like. "Everyone knows the name and the legends of Babylon," Francis Joannès, a professor of ancient history and Mesopotamia at the Sorbonne, told TIME in 2008. "But what people don't necessarily know is its reality." Yet nothing could be more real than the magnificent Code of Hammurabi stele, a 7-ft.-high (2 m) column of basalt upon which Babylon's King inscribed 282 codified laws and punishments in cuneiform, the Babylonian script that predates hieroglyphs. This ancient tablet is one of the earliest known written records of the laws that give order and shape to human society, and it is by far the most complex.

Ruling in the early 18th century B.C., Hammurabi, the sixth King of Babylon, used an aggressive military policy to conquer rival city-states and to establish Babylon as Mesopotamia's political heart, a status it would maintain until 539 B.C. But Hammurabi was concerned about more than expansion, as reflected by the laws carved upon the stele. Although its prescriptions sound extreme today ("If a man commits a robbery and is caught, that man will be killed"), it helped Hammurabi craft his image as a just ruler: the stele was displayed publicly, so no citizen, regardless of status, could plead ignorance of its laws.

The stele bearing Hammurabi's Code was discovered by French archaeologists in 1901 in Iran's Khuzestan province, site of the ancient Persian city of Susa, where it had been carried as plunder in the 12 century B.C. by Shutruk-Nakhunte, the King of Elam, a rival Mesopotamian kingdom. It is a reminder that kings and kingdoms may perish, but society's need for laws is eternal.

FROM TOP: PHOTO BY HERVE LEWANDOWKI—LOUVRE, PARIS, FRANCE—REUNION DES MUSEES NATIONAUX—ART RESOURCE, NY; PHOTO BY RAPHAEL CHIPAULT—LOUVRE, PARIS, FRANCE—REUNION DES MUSEES NATIONAUX—ART RESOURCE, NY

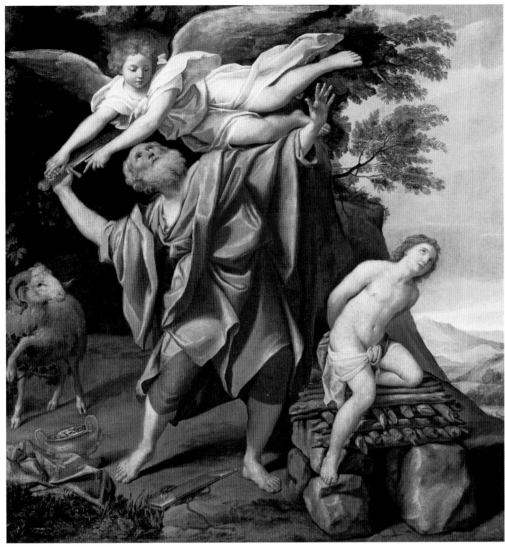

LAMBS OF GOD *In this painting of* The Sacrifice of Abraham *by Renaissance artist Domenichino, the patriarch is being restrained from slaying Isaac by an angel. The sheep is a symbol of Christ, a similar sacrifice*

JUDAISM'S PATRIARCH *This Hebrew Torah dates to A.D. 1343 and is from Erfurt, Germany*

Abraham Is the Patriarch of Three Religions

5

The story of Abraham may be no more than a story: other than the tales of the Old Testament and the traditions of Islam, there is no scientific evidence of the existence of this figure, who is regarded as a patriarch by three great religions, Judaism, Christianity and Islam. All call him "Father," but it is in the Torah's Book of Genesis, from Judaism's Old Testament, that we first encounter him. He is depicted as coming from a family that sold idols, but he turned away from polytheism when the Lord appeared to him and they made a Covenant. Abraham would be the father of a great nation, the Lord promised him; in return, Abraham must circumcise himself as a sign of his devotion to his single Lord. Later, God raised Abraham up, making him wealthy and powerful, only to test his faith in memorable fashion, asking him to sacrifice his son Isaac. Abraham prepares to do so, but his hand is stopped at the last moment by an angel. In Islam, it is Abraham's (Ibrahim's) other son, Ishmael, who is the intended sacrifice and who becomes the ancestor of all Muslims.

If Abraham did live, historians believe it would have been between 2100 B.C. and 1500 B.C., hundreds of years before the date most historians assign to Judaism's origins. Fact or fable, he represents a revolution in thought. He is the Ur-monotheist, the first man in the Bible to abandon all he knows to choose one Lord. In making a compact with a single God, rather than offering occasional appeasement to a host of deities, he changed religion, society and history.

The Abrahamic Religions

Judaism Jews trace their religion to the stirring first words of the 12th chapter in Genesis, the first book of the Torah. God's admonition to Abraham is often referred to as the Call: "Go forth from your native land/ And from your father's house/ And I will make of you a great nation." In accepting the Covenant, Abraham and his descendants, the Jews, became the Chosen People. The sign of the Covenant, circumcision, became an enduring hallmark of Jewish identity.

Christianity The Apostle Paul, a converted Jew, made the connection between Abraham and Christianity as he struggled to allow Gentiles, non-Jews, to become Christians. Abraham is named in the Roman Catholic Mass and in Protestant hymns. His intended sacrifice of Isaac is often regarded as an early biblical foreshadowing of the sacrifice of Christ.

Islam Muslims regard Ibrahim as one of the four most important prophets. The Koran portrays him as the first man to make full surrender to Allah, and each of the five repetitions of daily prayer ends with a reference to him. The holy book recounts Ibrahim's building of the Kaaba, Mecca's central shrine, where his footprint may be seen. Muhammad said that Islam restored Ibrahim's message.

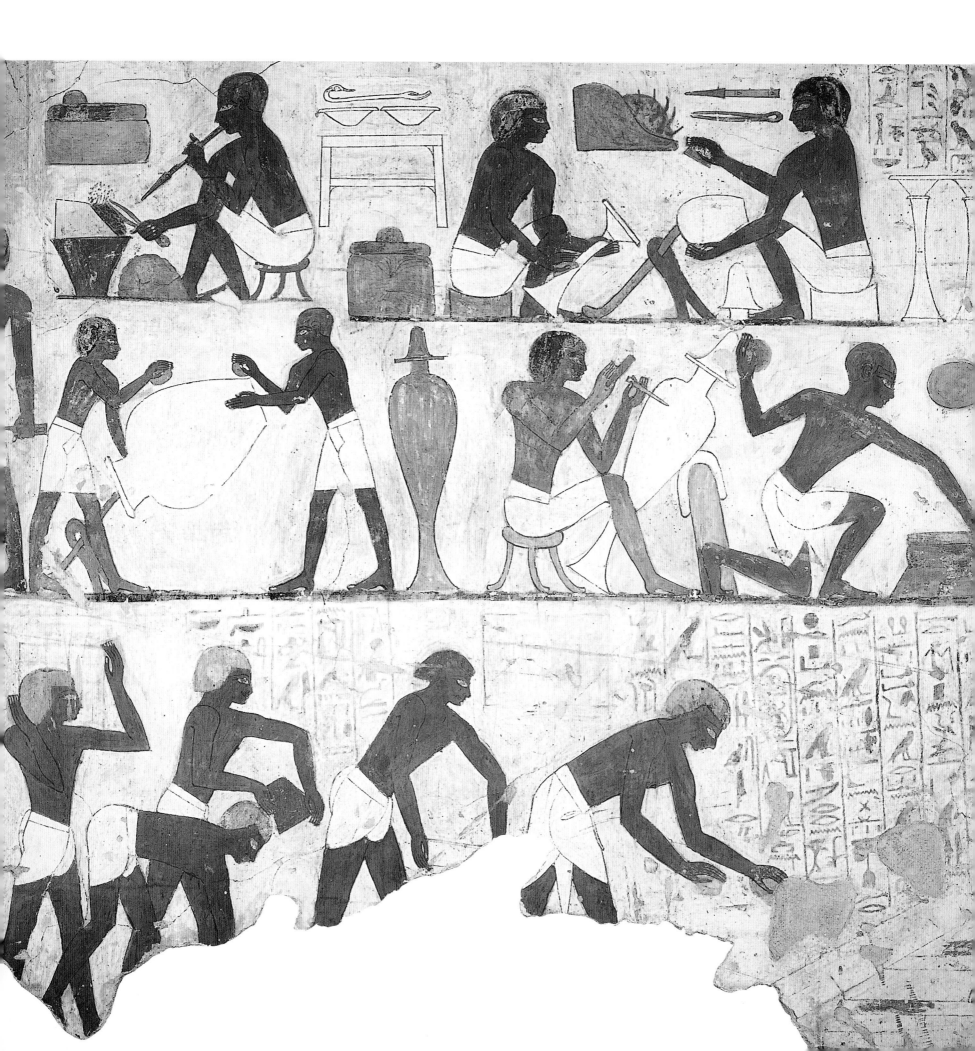

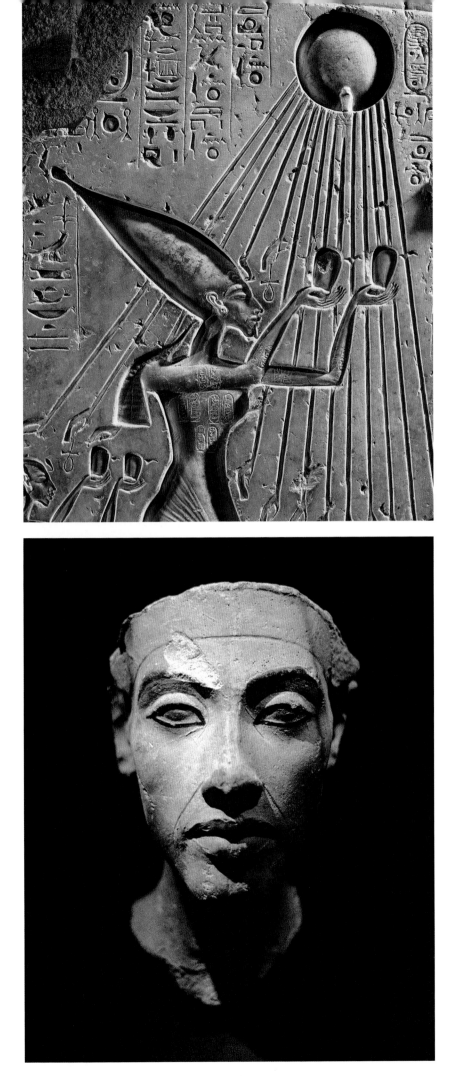

A Rebel Pharaoh Defies Egypt's Divine Cosmology

6 His wife was Nefertiti. His son was Tutankhamun, a.k.a. King Tut. His God was Aten, the life-giving disk of the sun—and such was his devotion to this God that Pharaoh Amenhotep IV abandoned his dynastic name and christened himself Akhenaten, spirit of the Aten. The Pharaoh defied tradition in choosing to worship a single God, for Egypt had been a polytheistic society since the civilization began to take shape, circa 3150 B.C.

We can trace Akhenaten's progress, if not his motives. We know the Pharaoh changed his name around 1346 B.C., not long into his reign, but we don't know if this stemmed from a dramatic conversion experience or was the expression of a long-held belief. But once committed, Akhenaten strove to promote his radical views to his people. He closed the old state temples and directed most religious funds to Aten's priests. He founded a great city, Akhetaten (today's Amarna), on the east bank of the Nile, between Cairo and Luxor, intending it to serve as Egypt's political capital and center of Aten worship. Everything was to be new in this great new metropolis, including its arts, which differed radically from previous Egyptian styles. Akhenaten's artists portrayed the royal family in less stylized and more natural ways, and they also depicted informal scenes of royal family life that perhaps shocked conservative citizens accustomed to regal grandeur.

Indeed, Akhenaten's new religion proved too alien to survive his death, which occurred some 17 years into his reign. His son Tutankhaten renounced Aten and changed his name to Tutankhamun soon after becoming Pharaoh. King Tut went on to abandon the new city of Akhetaten, and in time Egyptians came to refer to the worship of Aten as the Amarna Heresy. History, after all, is written by the victors.

SOLAR SPLENDOR *At left, hieroglyphs from the period before Akhenaten took power show the stylized, flat sort of portraiture favored in traditional Egyptian arts. Under Akhenaten's reign a more naturalistic style took hold, as seen in the bust of the Pharaoh at left. Above the bust is a depiction of Akhenaten making an offering to the sun god Aten. Some of the art of the Pharaoh's controversial reign was later destroyed by traditionalists*

An Enlightened Asian Seeker
Founds an Enduring Philosophy

7 In the beginning, it is said, the Buddha found enlightenment underneath the bodhi tree, near what is now Nepal. Siddhartha Gautama was a pampered prince born around 563 B.C. who frustrated his father's efforts to shield him from the sights of suffering and death, became a wandering holy man and eventually formulated the Four Noble Truths that unite all Buddhists today. Life, declared the Buddha, or "Enlightened One," is full of suffering. Most of that suffering, including the fear of death, can be traced to "desire," the mind's habit of seeing everything through the prism of the self and its well-being. Yet this craving can be transcended, leading to peace and eventually to an exalted state of full enlightenment called Nirvana. The means to reach Nirvana lies in the Eightfold Path of proper views, resolve, speech, action, livelihood, effort, mindfulness and concentration.

The Truths dovetailed with India's ancient Hindu scheme of reincarnation: every human is reborn again and again, in an endless and wearying cycle called samsara, each life affected by the good and bad deeds performed in previous existences, according to a system called karma. The attainment of Nirvana allows us finally to step away from what one writer called "the squirrel cage of birth and rebirth" and enter into oneness with the cosmos. From the beginning, a practice of meditation was the chief mechanism to gain the awareness necessary for enlightenment.

The Buddha posited no creator God; no Jehovah, Jesus or Allah. His Truths are so distinct from the primary concerns of other faiths that some Western observers regard Buddhism as a philosophy or even a psychology. Yet because it puts so little emphasis on specific doctrines, and because Buddha himself is regarded as a sage rather than a god, Buddhism has proved highly malleable; its various branches have been adapted to suit cultures far from Asia. Ironically, Buddhism is now little practiced in the land of its birth, India, where Hindu and Muslim faiths prevail. But around the globe, some 325 million followers continue to meditate, seeking to share with Buddha the enlightenment he found beneath the bodhi tree.

NOURISHING *A stone head of Buddha has become entwined with the roots of a fig tree in the ancient shrine of Wat Mahathat, in Ayutthaya, Thailand. Buddhists see the founder of their religion not as a god but as a human who found enlightenment*

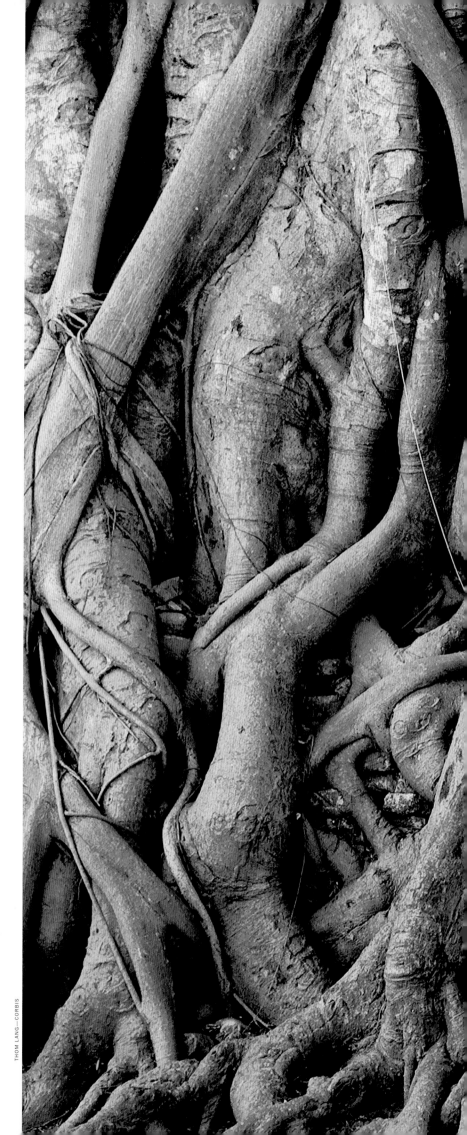

THOM LANG—CORBIS

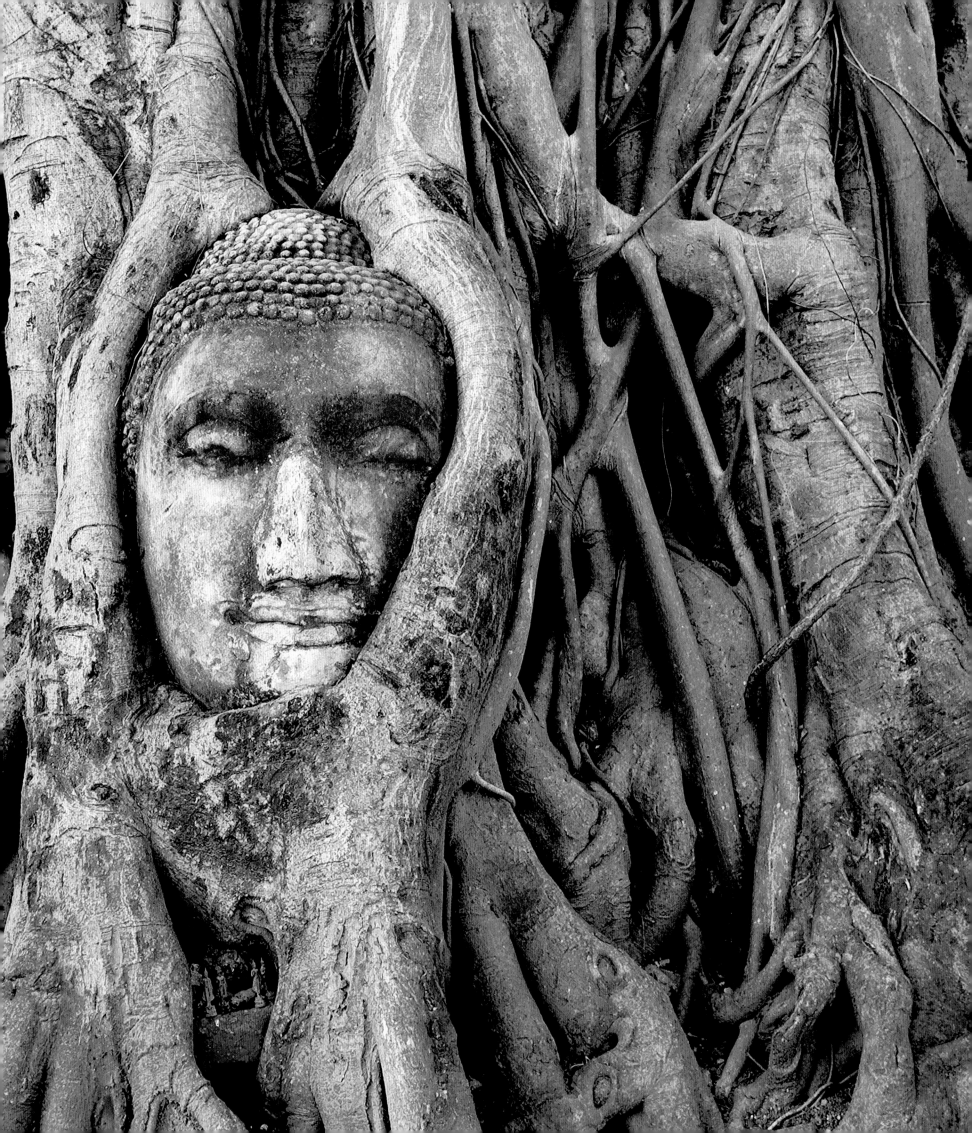

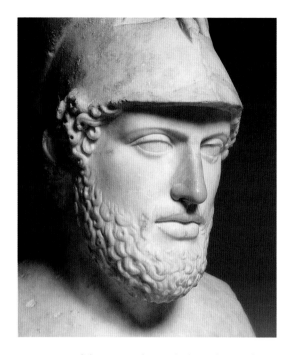

Greece Enjoys a Golden Age

8 The ancient Greeks had long arms, so long that we can still trace their fingerprints everywhere in modern life. Democracy and philosophy, theater and sculpture, Apollo and Dionysus—add Facebook and keggers, and you'd have a complete freshman-year curriculum for many U.S. college students. Yet there's a reason for the renown: Greek civilization represents a high point of culture in the ancient world, when Archimedes and Euclid laid the foundations for modern science, Aristophanes and Sophocles wrote comedies and tragedies that still grace the stage, and Plato and Aristotle shaped the fundamental perspectives on life still explored by modern philosophers.

Classical Greece reached its high point in Athens under the statesman Pericles, who ruled the city-state for some 31 years, between 461 and 429 B.C. Pericles expanded Athens' power, converting the Delian League, once a federation of equals, into an Athenian Empire. He commissioned many of the great structures of the Acropolis, including the Parthenon. As a general, he led Athens against Sparta, Thebes and others in the Peloponnesian War. And as an orator and statesman, he advocated freedom of expression and other principles now considered fundamental to democracy. Yet his vision of democracy did not include equal rights for women—or for the slaves whose labors made the arts and culture of Athens possible. Indeed, our idealized vision of the Greeks conveniently omits much. "Whatever speaks of demonism, fear, magic and irrational superstition is simply swept under the carpet," noted TIME art critic Robert Hughes in 1993. As he pointed out, the marble statues and temples we admire for their austere purity were once painted in garish hues. And while the Greeks exalted reason, "Their culture was webbed with placatory or 'apotropaic' rituals, charms and images meant to keep the demons at bay."

STATESMAN *The well-known bust of Pericles, above, is a marble Roman copy of an original bronze statue created by the leader's contemporary, the sculptor Kresilas. Pericles commissioned the Parthenon and other buildings atop the Acropolis in Athens, at right*

Highlights of Classical Greek Civilization

750-480 B.C. In the Archaic period, a term first used by art historians, Greek culture starts to take shape, as population, living standards and the arts all begin to flourish.

490 B.C. Persia's King Darius I invades Greece but is repelled at the Battle of Marathon. His son Xerxes invades again, in 480 B.C., but after taking Athens, he is finally defeated by an allied Greek army.

478 B.C. The Delian League, a confederation of Greek city-states led by Athens, is founded to keep the Persians at bay.

431 B.C. The Peloponnesian War pits the 173 members of the Delian League against a coalition led by Sparta. The long, intermittent conflict ends in 404 B.C., after Sparta destroys the Athenian fleet in Sicily.

371 B.C. Thebes defeats Sparta in the Battle of Leuctra and briefly becomes the dominant city-state of Greece.

357 B.C. King Philip II of Macedonia first intervenes in Greek affairs; he eventually becomes master of Greece. His son, the warrior-king Alexander the Great, extends Macedonian rule from Egypt to China.

323 B.C. The Hellenistic Age follows Alexander the Great's death, as Greek culture spreads in the Middle East and Europe.

VASE *An amphora dating to circa 480-70 B.C. shows Greek soldiers battling Persians*

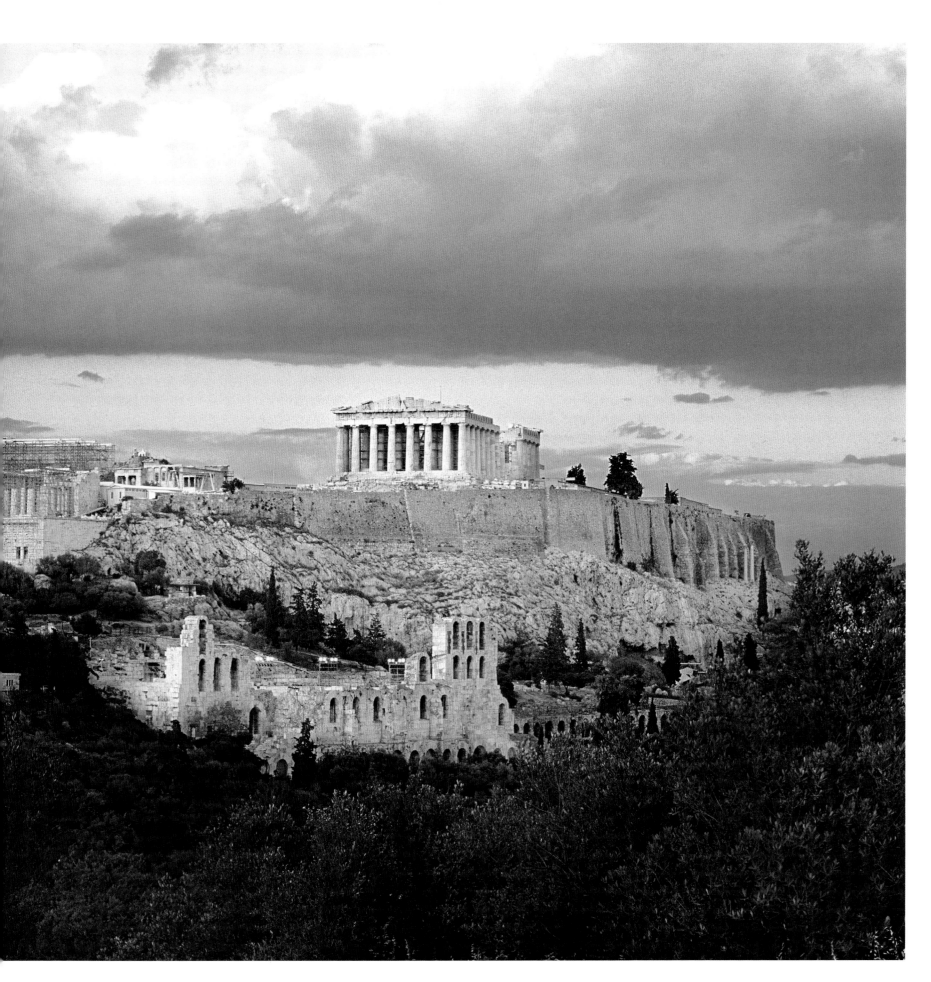

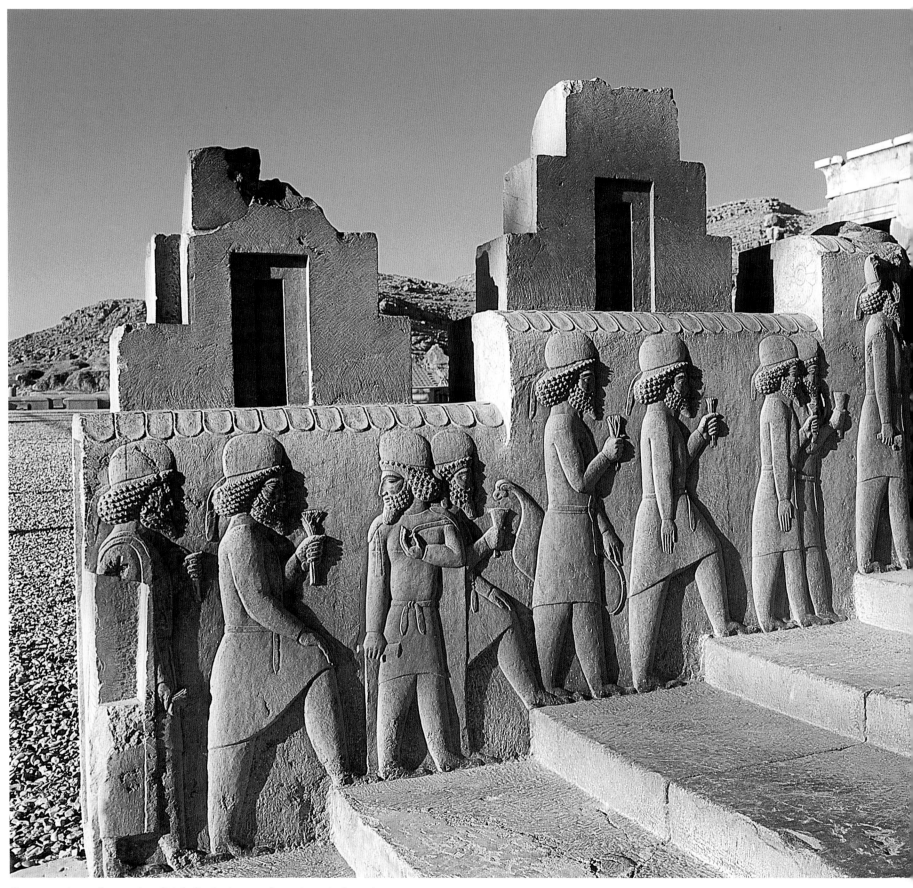

GOING UP *A carved procession of Mede dignitaries ascends a staircase in the ancient capital of Persia (Iran), Persepolis. Alexander allowed his soldiers to plunder the city, then the world's richest, in 330 B.C.; he is said to have later regretted that decision*

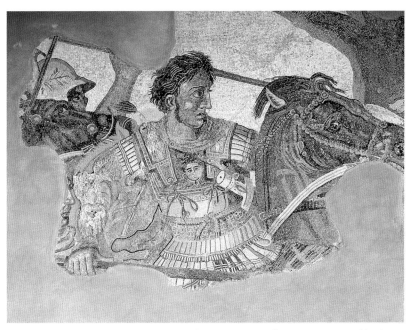

CHIPS *This detail from a floor mosaic in the Roman town of Pompeii, preserved by the eruption of Mount Vesuvius in A.D. 79, depicts Alexander at the Battle of Issus in 333 B.C.*

Alexander Sweeps All Before Him

9 His name advertises his renown, and his deeds were so remarkable that some regarded him as divine. Alexander the Great's embalmers trembled before his dead body for fear of touching a god, and he certainly acted like a god. At the age of 16 the Macedonian prince crushed a Thracian rebellion and founded a city that he named after himself, the first of many. After his father King Philip II's assassination, Alexander, all of 20, conquered Greece and won its allegiance. When Thebes revolted, he took and razed the city as an example to others; the revolts ended. He then went off to battle the dominant Persian Empire. He warmed up by defeating a coalition of satraps at the Battle of the Granicus. Next he took on Darius III, Persia's King, and defeated him twice. His first victory, in the the Battle of Issus, ended Asiatic rule in the Mediterranean. After taking Tyre and Egypt, Alexander returned to teach Darius one more lesson. His triumph over Persia at the Battle of Gaugamela in 331 B.C. was perhaps the most important battle in antiquity; it made way for the Hellenistic age, which saw Greek culture spread to Rome and across all the lands Alexander had conquered. This period of significant cross-cultural interchange lasted from Alexander's death in 323 B.C. to the reign of Rome's Emperor Augustus, from 27 B.C. to A.D. 14.

Alexander battled elephants in India, tamed the untameable horse Bucephalus, cut through the Gordian knot. His teacher was Aristotle. And he never lost a battle. When he died of a fever at only 32, his kingdom reached from Illyria in the Balkans to Kashmir in India, and from Egypt to China. Nor was he merely a brutal conquistador. His vision of empire was diverse, humanistic; he brought historians and botanists with his armies. According to Plutarch, Alexander saw all men as existing under the rule of a single god. A true exemplar of Greek civilization, he acted as if he did not merely seek to conquer all creation but also to make sense of it. All in all, Mr. Great earned his epithet.

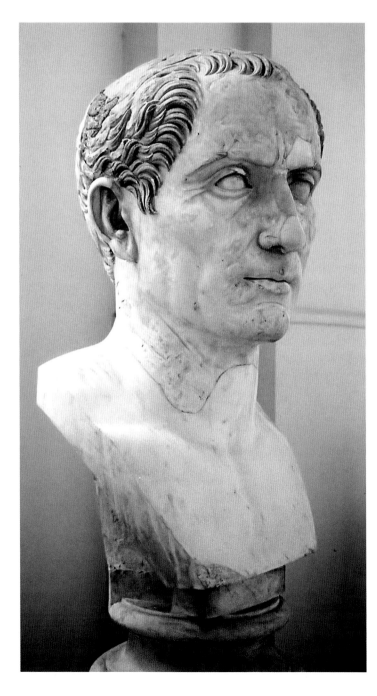

Julius Caesar Marches on Rome

10

No city has a more romantic creation myth than Rome: orphan twins Romulus and Remus, we are told, founded the city in 753 B.C. on the site where wolves had suckled them. Perhaps it was the milk, for there is a predatory aura about the great empire that rose in the center of the Italian peninsula. The Romans were wily hunters who conquered other peoples and absorbed their cultures. Their Pantheon made room for all the gods of all the peoples they vanquished, and it was stuffed.

The Romans most closely modeled themselves on the Greeks, but they preferred doing to philosophizing. Indeed, they may be history's greatest doers: the Romans built roads and aqueducts, circuses and theaters, temples and forums. They made laws and enforced them, opened trade routes and profited from them. They enforced harmony across a vast empire, which stretched at its height from Iberia to Egypt and from Britain to Asia Minor. Under this Pax Romana, western civilization reached an early pinnacle and gained an enduring legacy.

There are many turning points in such a rich saga, but perhaps Rome's most fateful moment came when the powerful, charismatic Julius Caesar led a rebellion that turned it from a republic to a monarchy. Born to privilege in 100 B.C., Caesar was driven from the city at 18 amid a political feud. But he entered the army and distinguished himself, then returned to Rome, where he curried favor with Crassus, the richest man in Rome, and married off his daughter to Pompey, the most powerful. In 59 B.C., he joined these leaders as one of the First Triumvirate that ruled Rome. He then went off to fight the barbarians in Gaul; by now a crafty and inspiring general, he vanquished them. When Pompey and other politicians, fearing Caesar's followers, called on him to lay down his command, Caesar refused. In 49 A.D. he led his armies across the Rubicon River and marched on Rome. In 65 days he had become master of Italy, and a cowed Senate voted him dictator-for-life. Five years later, freedom-loving citizens assassinated him. Rome's descent into centuries of imperial politics and follies had begun.

BUILT TO LAST *Roman engineers were highly skilled, and many of their projects endure, including the graceful aqueduct at right, begun in Rome in A.D. 38 by the Emperor Caligula. At left is a bust of Julius Caesar*

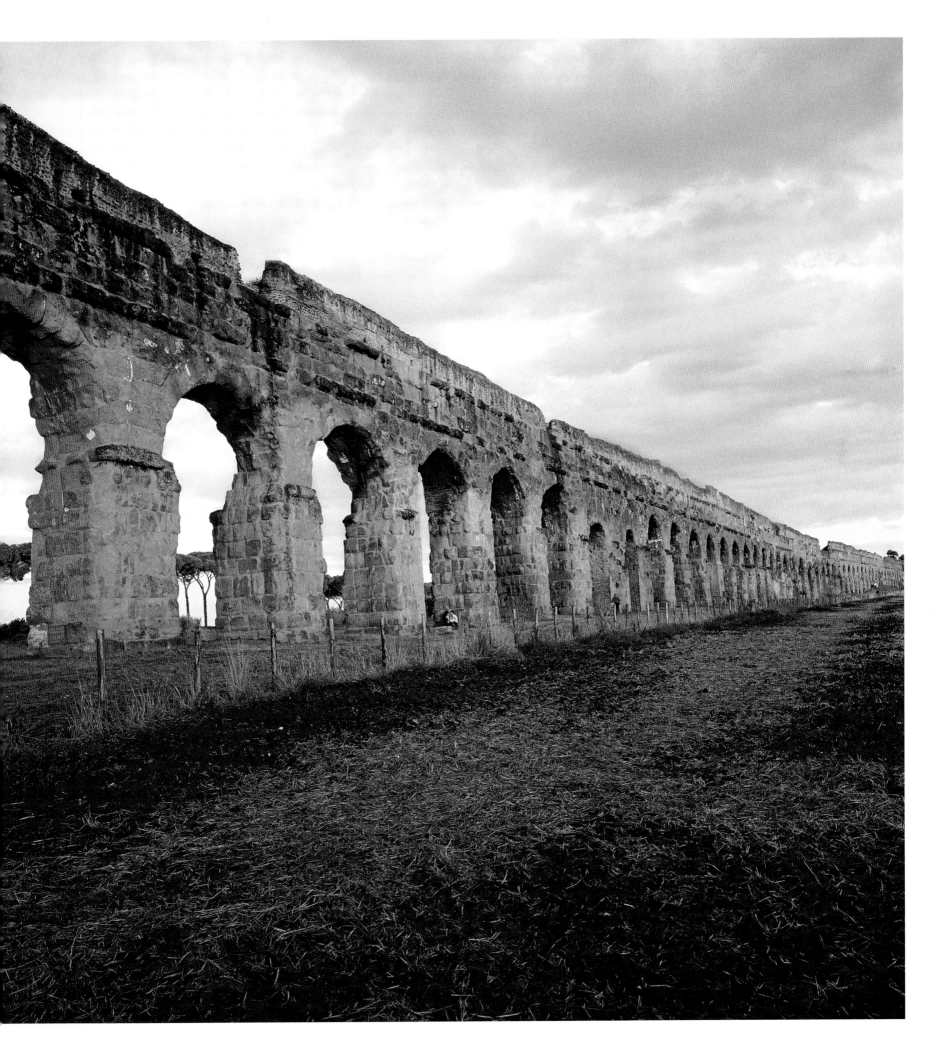

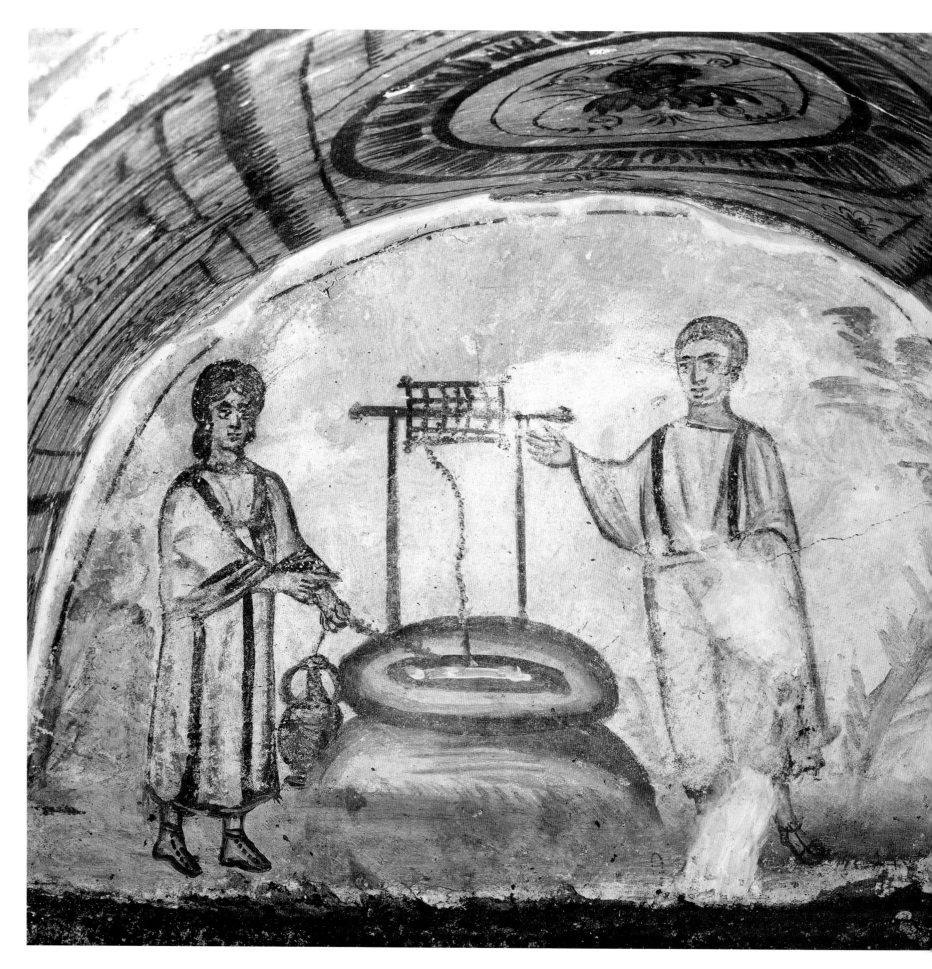

Jesus Christ Founds a New Religion

11

There is no doubt that Jesus Christ is one of the most significant individuals in history; perhaps only those other great men of the spirit, Muhammad, Confucius and Buddha, rival his influence. As a treacly but accurate Christian tone poem describes Christ's impact: "He never wrote a book. He never held an office. He never owned a home. He never had a family. He never went to college … [yet] All the armies that ever marched, and all the navies that ever sailed, and all the parliaments that ever sat and all the kings that ever reigned, put together, have not affected the life of man upon this earth as has that one solitary life."

Both Muhammad and Buddha could be described in similar fashion, but no matter: Christianity remains a central pillar of civilization, 20 centuries after Jesus, a popular, itinerant Jewish preacher in Roman-occupied Judea, was crucified and, his followers believe, rose from the dead and ascended to heaven. In its first years, Christianity was spread across the Roman world, amid deadly persecution, through the inspired testimony of the disciples who had known Jesus. Within several hundred years, Christianity became the empire's official religion. When Rome fell, the Roman Catholic Church became the repository of civilized values as well as of Christ's teachings, a role it maintained for centuries, weathering a great schism with the Eastern Orthodox Church and a Protestant Reformation that split it into a host of smaller sects.

Around the world today, some 2.2 billion Christians believe that Jesus was the Messiah promised in Judaism's Old Testament: the son of God, incarnated as a man, whose suffering and death absolve sins and promise eternal life to those who heed his message. His story is told in the four Gospels, the first books of Christianity's New Testament, which most scholars regard as true to Christ's message, if not to the exact facts of his life. They record Jesus' divine birth, teachings, miracles, death and resurrection. And they record his enduring challenge, a radical call to charity that is far easier said than done: Christians must love their enemies and forgive those who sin against them.

LEFT: CATACOMB OF VIA LATINA, ROME, ITALY—SCALA—ART RESOURCE, NY. RIGHT: CATACOMB OF PRISCILLA, ROME, ITALY—SCALA—ART RESOURCE, NY

SIGNS AND SYMBOLS *At left, a 4th century fresco at a Christian catacomb in Rome shows Christ speaking to the Samaritan woman at the well, a tale told in the Gospel of John. Above, an anchor and fish, early emblems of Christ, were painted on a catacomb tile*

Landmarks of Early Christianity

25-36 Christ is crucified in Jerusalem; the exact year of this event is unknown.

50 At the Council of Jerusalem, Peter, Christ's successor, and Paul, a Jew who had once persecuted Christians but embraced Christianity after having a divine vision, establish guidelines for the conversion of Gentiles (non-Jews) into Christianity.

52 Thomas, one of Christ's 12 Apostles, brings Christianity to India.

64 When Rome burns in a great fire, the Emperor Nero blames Christians for the event and increases persecution of them.

67 Peter, leader of the Christian church, is crucified, perhaps upside-down, in Rome.

64-67 Paul, the most active and successful proselytizer of the early church, is martyred in Rome. The exact year is not clear.

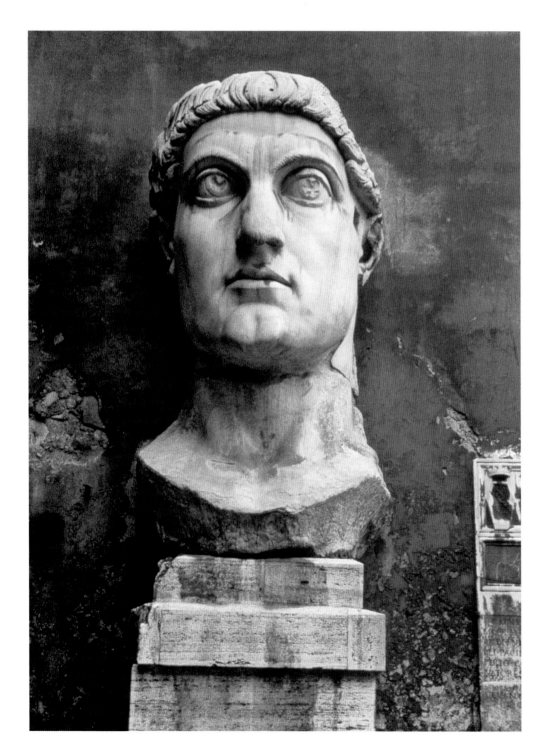

Constantine Reshapes The Roman Empire

12 There is no doubt that the Roman Emperor Constantine the Great was one of history's pivotal figures. He was an inspiring general who defeated Rome's barbarian enemies time and again. He was a masterly political strategist who united the empire's tangle of warring factions under his control. He was a major figure in the growth of Christianity: as the first Roman Emperor to embrace what had been a scorned and persecuted creed, his embrace of Christianity ensured it would not only survive but flourish. And he remade the empire by founding a new capital in the east, Constantinople.

What remains in doubt are Constantine's motives, especially in his embrace of Christianity. Was he converted as the result of a sudden divine vision? Roman Catholic legends claim that he received a sign from heaven before his victory over his imperial rival Maxentius in the Battle of the Milvian Bridge in 312. Or was he a lifelong Christian who only revealed his spiritual orientation after he rose to ultimate power in Rome, as other sources indicate? Whatever his reasons, he reversed the harsh policies of his predecessor, Diocletian, in the Edict of Milan (313), which forbade religious persecution in the empire, and he later made Christianity the official religion of Rome. He called the first major gathering of church leaders since the days of the Apostles, the First Council of Nicaea, which resolved questions of doctrine and governance in the early church.

Constantine's establishment of an Eastern Empire was his most farsighted act. In founding Constantinople in 324, he became one of history's great imperial builders, for Byzantium would survive long after Rome was reduced to ruins, preserving for history many of the invaluable tracts and teachings of the ancient world.

HEAD OF STATE *This large bust of Constantine was originally located in a basilica in the Roman Forum. It was created in the 4th century, when Constantine became the sole ruler of Rome's empire*

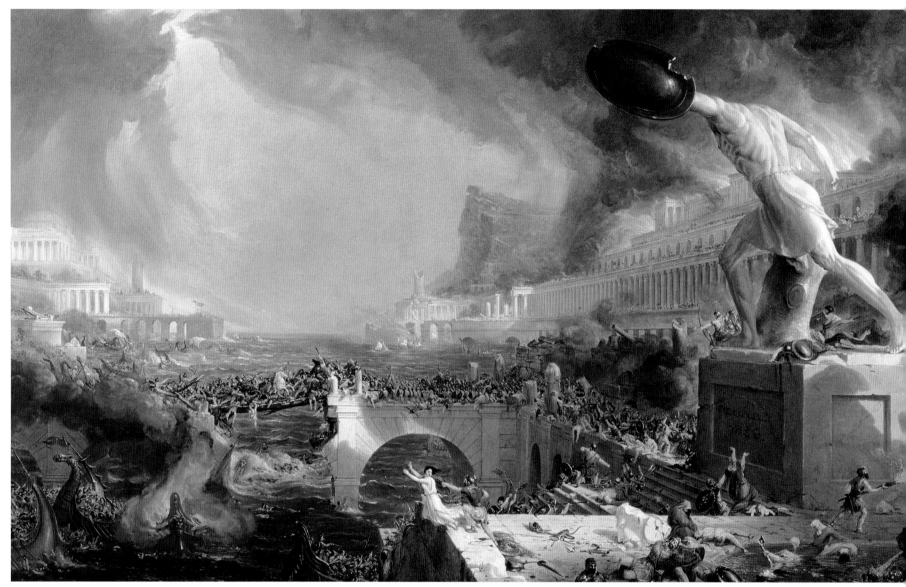

THRILLER *Rape! Pillage! Conquest! American Thomas Cole's 1836 painting of the sack of Rome offers more histrionics than history; it's the equivalent of today's blockbuster films*

Barbarians Sack Rome as the Empire Withers

13 The decline of the Roman Empire was a long process, and historians offer differing events for the empire's final fall. But in the popular imagination, there is no question: Rome can be said to have fallen on Aug. 24, 410, when Visigoth tribesmen led by Alaric I entered and sacked the city. In truth, Rome was no longer the primary capital of the empire, for power had shifted east with the founding of Constantinople, and in the Western Empire, the capital's location now shifted repeatedly at the whim of emperors and generals. For a period it was at Milan, then at Ravenna. Yet in the popular mind, Rome was still Rome. It was the world's center, the great metropolis to which all roads led, whose marble-clad monuments had dazzled visitors for centuries. When the Vandals later sacked the city, in 455, they treated its citizens more harshly. But Alaric's Visigoths, the first invaders to conquer Rome in eight centuries, bore history's message: Time's up.

With the empire in ruins, western Europe entered a long era when power no longer emanated from a central source but was exercised locally by tribal chiefs and land-owning nobles. The Roman Catholic Church emerged as the primary unifying force of a new age. Rome's political empire endured in severely truncated form, evolving into the Holy Roman Empire and enjoying periodic renascences, as when Charlemagne united much of Europe under his control around 800. Power, learning, invention and energy now passed from western Europe to the Byzantine Empire and to a new force on the world stage: Islam.

Muhammad's Teachings Shape a New Faith, Islam

14 Compared with Jesus or the Buddha, information about the life of the man who became known as the Messenger of Allah is relatively abundant, although the facts have been embellished with pious folklore. The Prophet Muhammad was born about A.D. 570 to a member of the respected Meccan clan of Hashim. By age 6, both his mother and father had died; he was raised by a poor uncle, whose herds he tended.

At 25, Muhammad accepted a marriage proposal from Khadijah, a rich Meccan widow 15 years his senior, for whom he had led a successful caravan. With his financial security ensured, he began to venture into the desert to contemplate and pray, as had other Arab seekers of wisdom before him. There, in a cave at the foot of Mount Hira, where he had spent six months in solitary meditation, a vision came to him. The Angel Gabriel roused him from his bed with the stern command "Proclaim!"

And he did. At 40, Muhammad began preaching the new faith of Islam. Like Judaism and Christianity, it insisted on a single god, Allah. His teachings met with favor from many, but local traders feared his rising influence, as did Christian and Jewish clerics. In 622, after being harassed by his foes, he and his followers escaped to Medina in a migration known as the hegira. Muhammad now began to elaborate on his new religion to a growing body of converts. Revelations came to him in trances; his descriptions of those encounters, memorized and recorded by his ardent followers, were later collected as the Koran.

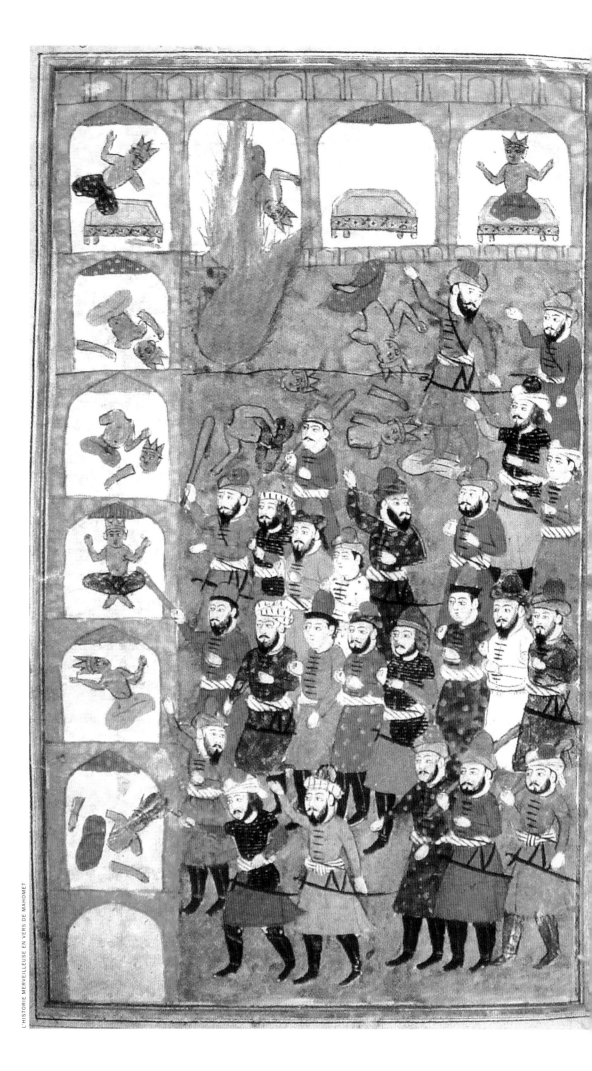

L'HISTOIRE MERVEILLEUSE EN VERS DE MAHOMET

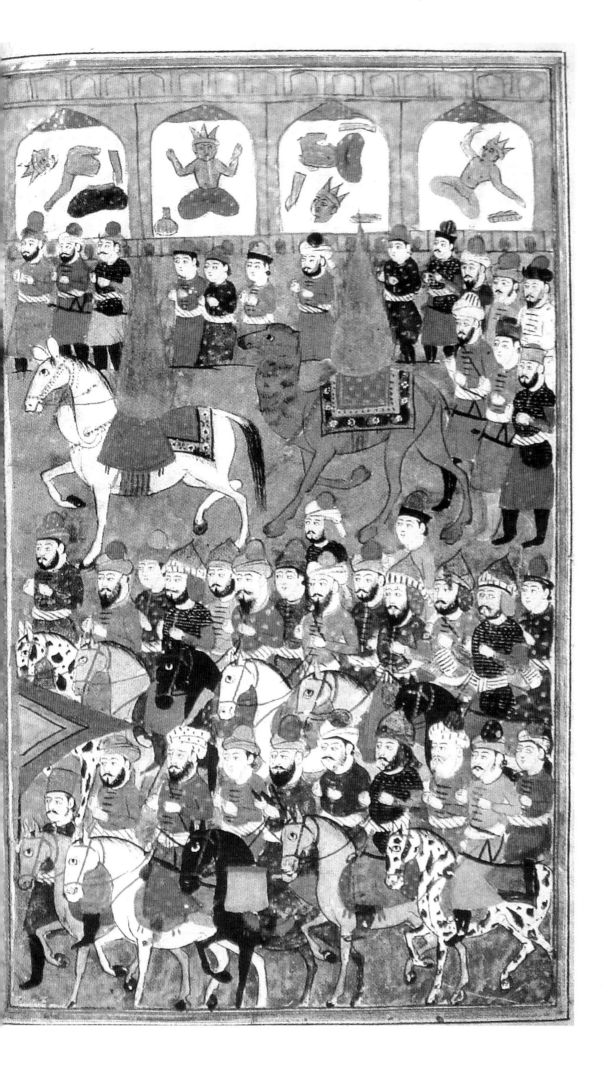

As his disciples grew in strength and numbers, Muhammad began a series of raids on Meccan caravans, which led to several indecisive battles with their avenging war parties. In 628 the Meccans agreed to let Muhammad's followers make their pilgrimage to the Kaaba, an ancient shrine believed to hold a sacred stone, possibly a meteorite; Muslims believe it is the spot where Abraham prepared to sacrifice his son Ishmael (rather than Isaac) at God's command. Two years later the Prophet led an army of 10,000 into the city, taking control in a bloodless victory.

Muhammad died in 632, but Islam's great days were ahead. A political faith with a yearning for expansion, it soon expressed a dynamic manifest destiny. The Prophet's followers burst out of the Arabian desert to conquer and create an empire whose glories were to shine for a thousand years. A cavalry of God engaged in jihad, or holy war, Islamic armies conquered the Persian Empire and much of the Byzantine, spreading the faith across northern Africa and into Spain, and through the Middle East to the Indus River. From there, devout Arab traders carried their faith to Malaysia, Indonesia, Singapore and the Philippines. Other traders introduced the Koran to numerous African tribes that lived south of the Sahara Desert.

More than a millennium later, amid a renaissance that began in the 20th century, an estimated 1.5 billion Muslims around the globe pause five times each day to face Mecca and state their credo: "There is but one god, Allah, and Muhammad is his Prophet."

ACT OF CLEANSING *An 11th century French manuscript depicts the Prophet destroying idols in the Kaaba after conquering Mecca. Per the Islamic prohibition on depicting the Prophet, Muhhammad is represented by a flame or aureole*

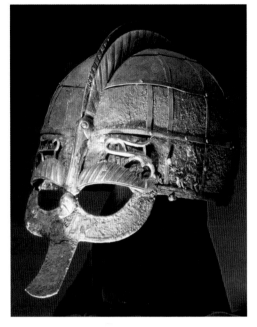

SEA-BORNE WARRIORS *Above is a Viking helmet from the 7th century, preserved in a Stockholm museum. At right is a carved relief from Gotland, a Swedish island, which depicts Viking mariners. The Norse ships were the finest in Europe at the time: sleek, quick and highly maneuverable, they operated equally well in shallow waters or on the high seas*

Viking Raiders Traverse—and Plunder—the Globe

 15 Ravagers, despoilers, pagans, heathens—such epithets pretty well summed up the Vikings for those who lived in the British Isles during medieval times. For hundreds of years after their sudden, bloody appearance in A.D. 793, when they descended on the tidal island of Lindisfarne off Britain's northeast coast and ravaged its famed monastery, these ruthless Norse raiders would periodically sweep in from the sea to kill, plunder and destroy, essentially at will. Lindisfarne was a center of learning; the beautiful illuminated manuscript known as the *Lindisfarne Gospels* had been created at the monastery earlier in the 8th century. Small wonder that many still think of these seafaring Scandinavians as little more than violent brutes. "From the fury of the Northmen, O Lord, deliver us," was a prayer uttered frequently and fervently by Europeans at the close of the 1st millennium.

But that view is wildly skewed. The Vikings were indeed raiders, but they were also traders whose economic network stretched from today's Iraq all the way to the Canadian Arctic. They were democrats who founded the world's oldest surviving parliament while Britain was still mired in feudalism. They were master metalworkers, fashioning exquisite jewelry from silver, gold and bronze. They were intrepid explorers whose restless hearts brought them to North America some 500 years before Columbus. They reached Rome, Baghdad, the Caspian Sea and Africa as well. And if they were feared, that fear played a pivotal role in reshaping Europe. In forcing people to unite and defend themselves, the Vikings helped develop nations.

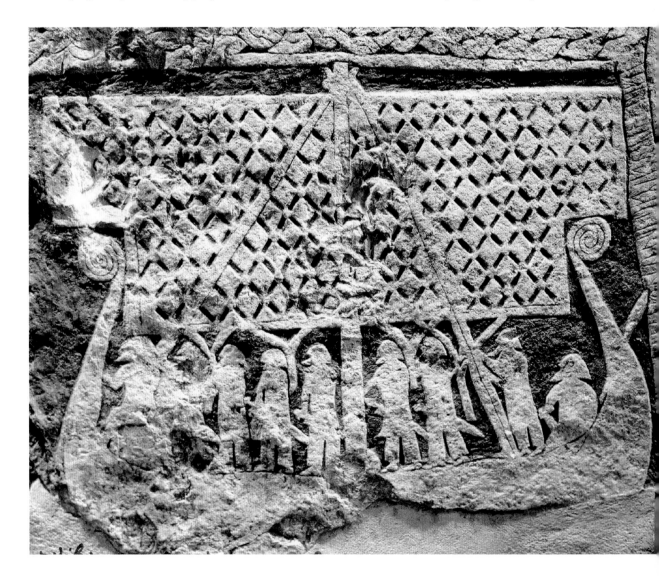

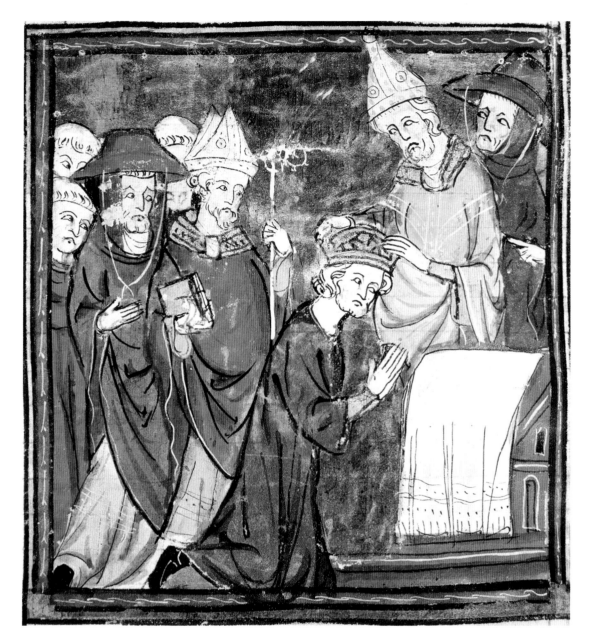

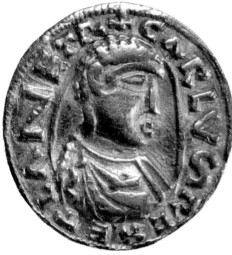

MASTER OF EUROPE *The late-14th century illuminated mansucript at left portrays the coronation of Charlemagne by Pope Leo III in A.D. 800, more than 500 years earlier. A devout Catholic, the monarch strongly supported the Pope and the church. The gold coin, minted in the Netherlands, shows him as King of the Franks and Lombards*

Charlemagne Is Crowned Holy Roman Emperor

16 The term Dark Ages lingers as a description of Europe's beginnings, as if an eclipse had blotted out civilization between the Roman Empire and the Renaissance. In truth, things were not all that black, modern scholars have discovered, and the great Renaissance was presaged by several baby ones. One such regeneration began with the reign of Charlemagne. This pivotal figure first became King of the Franks, inheriting the throne from his father King Pepin the Short and expanding his domain across central and western Europe. After he turned his attention south and conquered much of Italy, he was crowned Holy Roman Emperor by Pope Leo III in A.D. 800; it is believed he saw himself as a potential rival to the Byzantine Emperors in Constantinople.

Charlemagne (Charles the Great) largely reconstructed Rome's fallen empire across western Europe and is considered the founding father of today's Europe. But above all, he was a typical warrior-king of the Dark Ages, leaving his capital at Aachen in today's Germany to do battle with Moors in Spain, Avars in Hungary, Saxons in the Baltics and Saracens around the Mediterranean. A visionary administrator, he reformed Europe's monetary system and was the patron of the movement now called the Carolingian Renaissance, which saw a revival of art, literature, scholarship and culture. He preached the power of education and spent his last years waging a final personal struggle: to learn how to write.

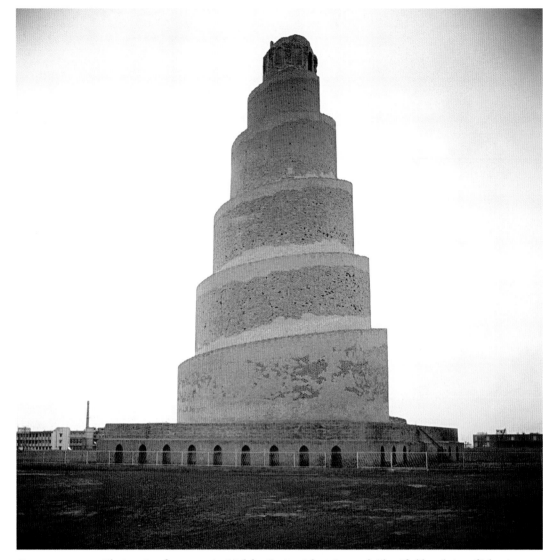

Islamic Culture Prospers in A Golden Age of Learning

17 At its height in the 8th century A.D., the empire of Islam stretched from the Atlantic beaches of Portugal to the western fringe of China. It encompassed half the known world. This Muslim superstate was the largest religious and political bloc mankind had seen since the Roman Empire under Augustus, and it had all been consolidated in a little more than 100 years after the death of the Prophet Muhammad, in 632. Civilization isn't a zero-sum enterprise, but it's fascinating that Islam's Golden Age flourished just as Europe was struggling through the Dark Ages that followed the fall of Rome.

The Koran declares, "God will exalt those of you who believe, and those who are given knowledge, in high degrees." These words inspired such caliphs as al-Ma'mun in Baghdad to set up centers of learning that attracted the best minds of the age. At Baghdad's House of Wisdom, scholars collected the most famous manuscripts from the Byzantine Empire and translated them into Arabic; eventually, these texts would help drive the Renaissance in Europe. Also in Baghdad, around 820, Muhammad ibn al-Khwarizmi wrote a treatise that for the first time used the word *al-jabr*—algebra—to describe the process of solving equations. (Europeans baffled by this new math called it "gibberish.") Arab astronomers were highly advanced; they invented the universal astrolabe, a mechanism that could be used in all latitudes to determine the times of sunset and sunrise, and a universal sundial.

Moorish Spain became a great center for the exchange of ideas between Islam and Europe, producing such major scholars as the 12th century Jewish philosopher Moses Maimonides and the Muslim sage Ibn Rushd, also known by the medieval Latin name Averroes. Learning now thrived wherever the muezzin's call to prayer was heard. But it was Baghdad, by far the planet's largest and wealthiest city, rivaled only by Constantinople, that occupied the place in human affairs once held by Athens and Rome: it was the center of the civilized world.

GLOBALIZATION *The interior of a mosque in Córdoba, Spain, right, is instantly identifiable as being of Islamic origin. But the images on this page show how Islamic design was adapted by local cultures. Above is the spiral minaret at the Great Mosque of Samarra, Iraq, built in ziggurat style in 848-51. Below is the Great Mosque complex in Xian, China, built circa 742. It is the only mosque in China that reflects that nation's traditional styles*

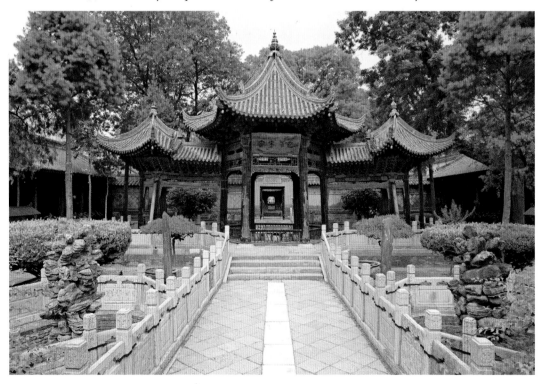

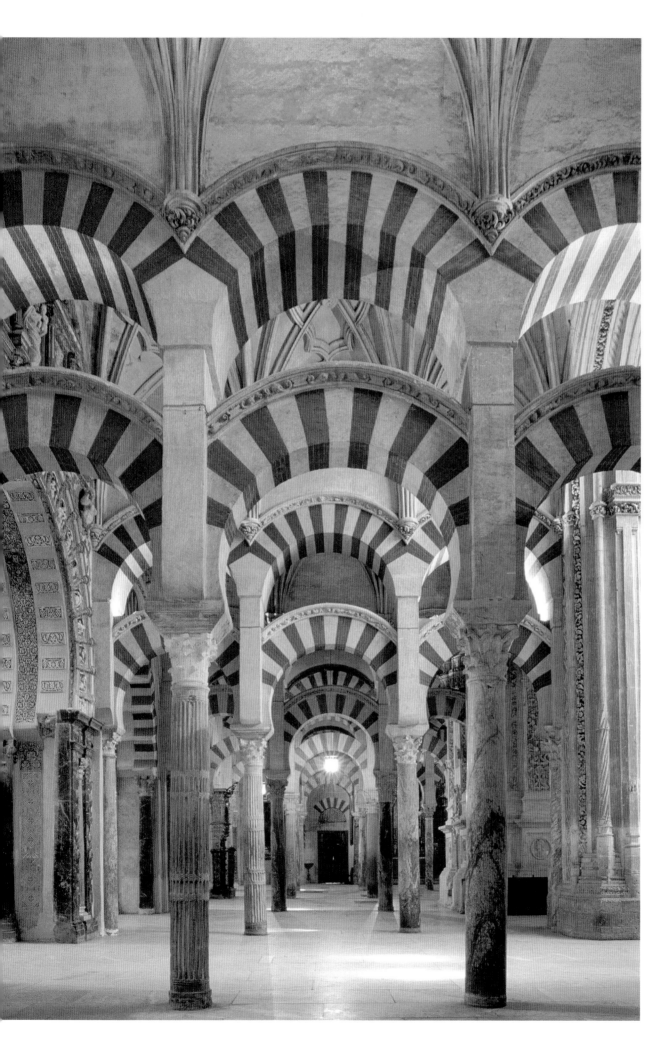

PASSAGES *This is a page from a 13th century Persian edition of a 1st century book on medicine by Greek army doctor Pedanius Dioscorides. It was first translated into Arabic in the 9th century at the House of Wisdom in Baghdad*

Highlights of a Golden Age

751 Muslims in Baghdad learn the secret of paper-making from the Chinese. Replacing papyrus, paper spurs the creation of large libraries.

circa 760 At some time during his reign (754-775), the Caliph al-Mansur founds the House of Wisdom in Baghdad; it reaches a peak of achievement under Caliph al-Ma'mun, who shifts its focus from the study of Persian texts to those of ancient Greece.

762 The capital of the Abbasid dynasty of Caliphs, early sponsors of the Golden Age, is moved from Harran in southeast Turkey to Baghdad.

780 Chemist Jabir ibn Hayyan pioneers the experimental method of science and invents such basic laboratory tools as the alembic, still and retort.

859 The University of al-Karaouine in Fez, Morocco, is founded: it is the world's first university.

880 Abu Hanifa Dinawari writes the *Book of Plants,* becoming the founder of Arab botany.

964 Abd al-Rahman al-Sufi writes the *Book of Fixed Stars,* the most detailed star catalog yet created.

A Great American Civilization Collapses

18 Writing in TIME as the turn of the 2nd Millennium approached, John Elson surveyed the world before the end of the 1st Millennium and cited Islam, China and India as the most advanced civilizations on the planet around A.D. 1000. "There were sophisticated cultures elsewhere," he noted, "notably the Maya of Mexico, but they were virtually out of touch with other civilizations—thus lacking an essential condition for being considered part of world history." Elson's judgment is harsh but fair: only in recent decades has the world begun to appreciate the achievements of the many diverse American cultures that predated the European discovery of the New World.

Put the Maya at the top of this list, for their culture reached a glorious apogee while Europe was struggling through the Dark Ages, only to experience a dramatic downfall around 800 to 900, a decline so sudden scholars call it the Classic Period Collapse. At its height, the Maya empire, a coalition of loosely related city-states, reached from southern Mexico and the Yucatán Peninsula through much of Central America. Maya scientists were advanced, particularly in the areas of astronomy and mathematics, though they never developed the wheel. Much of Maya art and history was destroyed by Spanish conquistadors eager to snuff out native culture, but the stone carvings that remain reveal a bustling, complex society. Maya religion is less appealing to modern minds: human sacrifice and cannibalism played a role in their rites.

Scholars continue to study the reasons for the sudden collapse of this bustling world, and a consensus is starting to form, based on historical climate research: a major drought, lasting many decades, sent Maya society into irreversible decline. A few islands of prosperity continued to thrive, but to the rest of the world, the Maya subsided as they had risen: unknown, unheralded and unmourned.

AMERICAN FACES *Most of these artifacts are products of the Teotihuacán culture. Located slightly west of the Maya Empire in Mexico, this society, like that of the Maya, peaked around A.D. 600 and then declined. The mask with a hinged jaw at the top left of the facing page and the brazier with three faces, representing three stages of life, were created later by Aztecs, Mexico's rulers when the Spanish arrived*

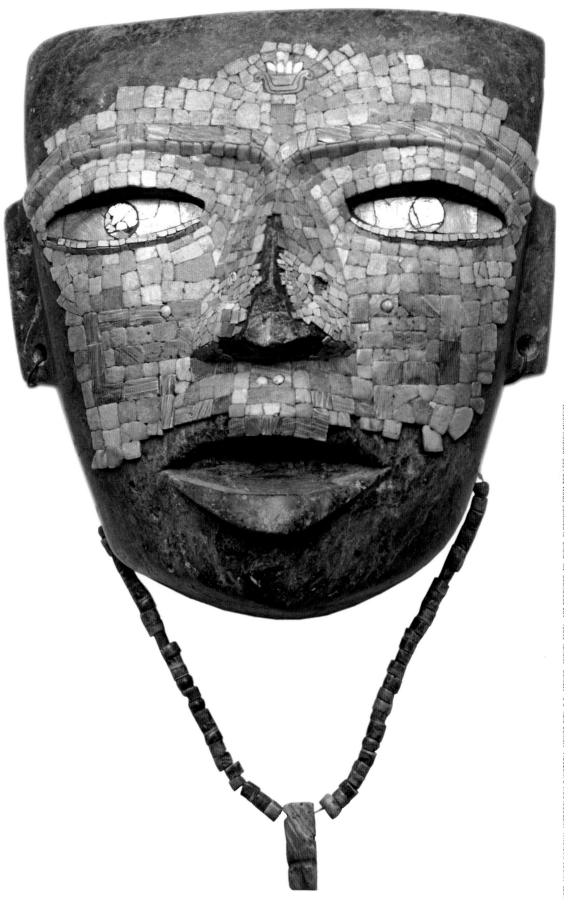

LEFT: MUSEO NACIONAL ANTROPOLOGIA E HISTORIA, MEXICO CITY, D.F., MEXICO—MICHEL ZABE'—ART RESOURCE, NY; RIGHT, CLOCKWISE FROM TOP LEFT: BRITISH MUSEUM, LONDON—ERICH LESSING—ART RESOURCE, NY; MUSEO NACIONAL ANTROPOLOGIA E HISTORIA, MEXICO CITY, D.F., MEXICO—SCALA—ART RESOURCE, NY; MUSEO NACIONAL ANTROPOLOGIA E HISTORIA, MEXICO CITY, D.F., MEXICO—MICHEL ZABE'—ART RESOURCE, NY; BRITISH MUSEUM, LONDON—©THE BRITISH MUSEUM—ART RESOURCE, NY

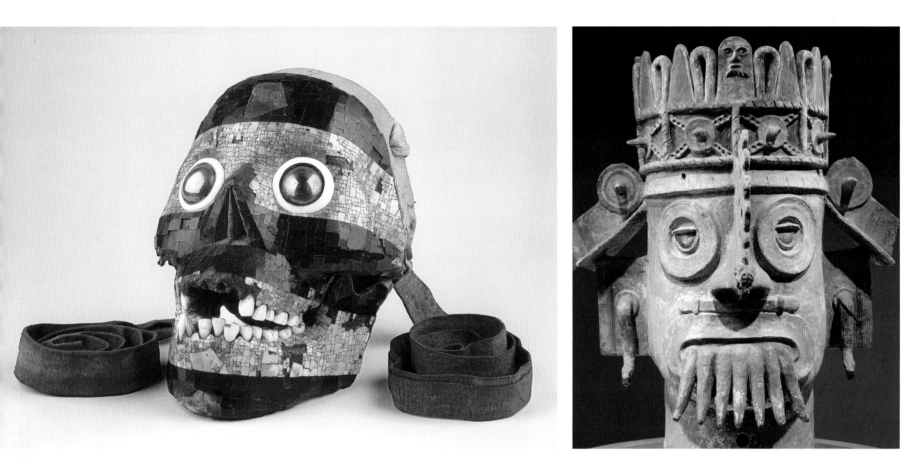

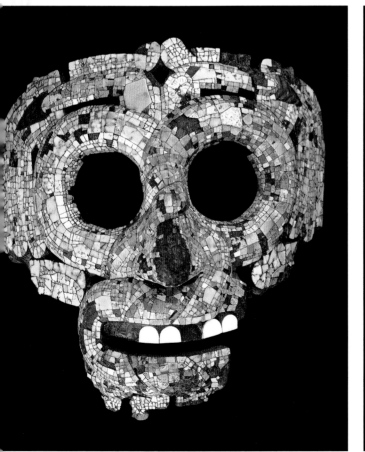

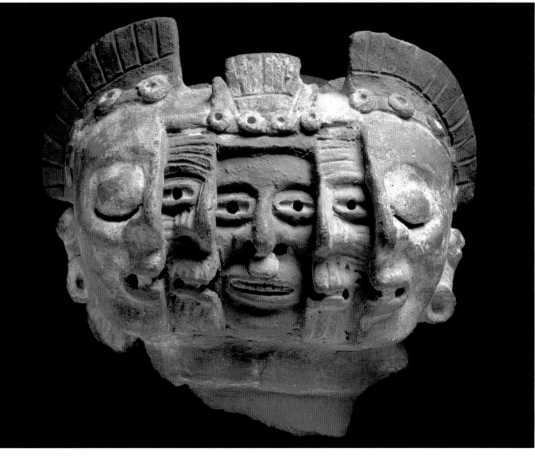

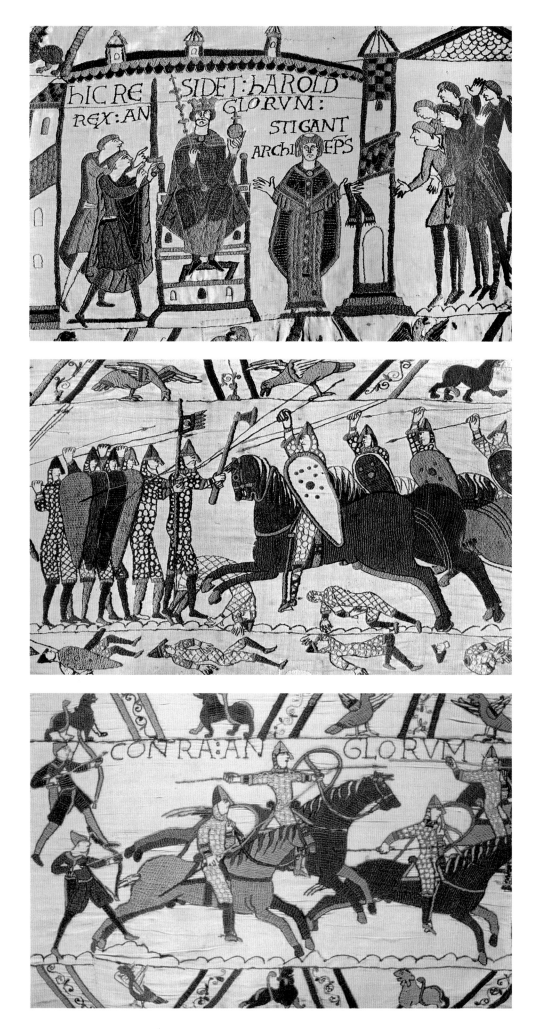

In the Battle of Hastings, A New Britain Is Born

19 In the annals of military history, the Battle of Hastings is small potatoes indeed: it involved two relatively small armies, fighting in Britain, an island in northern Europe that had never played a major role in history. The prize at stake, the throne of England, offered its occupant a lifetime of overseeing the squabbles of a clutch of competing interests, for England at the time was divided into small kingdoms ruled by strongmen representing various ethnic tribes, Angles and Saxons from Germany and Scandinavia, Picts in what is now Scotland. Even so, when England's King Edward the Confessor died in January 1066, three powerful men competed to succeed him. Edward's brother-in-law, Harold Godwinson, ascended the throne, only to be quickly challenged by William II, Duke of Normandy in France, and the King of Norway, Harald Hardrada.

The crown was King Harold II's to lose; he held the home-field advantage, and his two foes would have to invade the island to displace him. Norway's king struck first, landing in northern England in September. Harold marched his army of some 5,000 men north from the London area briskly and defeated the Norse in a battle just outside York in which King Harald was killed. Within the week, William's 5,000 Norman invaders landed on England's east coast. The two armies collided at Hastings, where Harold held a superior, uphill position. But the Normans used new technology—stirrups for their cavalrymen and crossbows for their archers—to keep the fight even. Their last stratagem won the day: feigning defeat, the Normans ran from the battlefield and the British followed, only to be surprised in the open by William's enveloping cavalry. In the melee that followed, Harold was killed and William earned the name by which history knows him: "the Conqueror."

A small battle, perhaps, but its consequences were large. King William I soon asserted his control over his new realm, forging a loose coalition of noble estates into a nation with a monarch at its head and its laws uniformly enforced. Britain had taken the first step on a path that would make it the world's greatest empire, some seven centuries in the future.

WEAVING A STORY *Created shortly after the Norman Conquest, the Bayeux Tapestry records the conflict. From top, Harold is crowned; William's cavalry attacks; French archers support the knights*

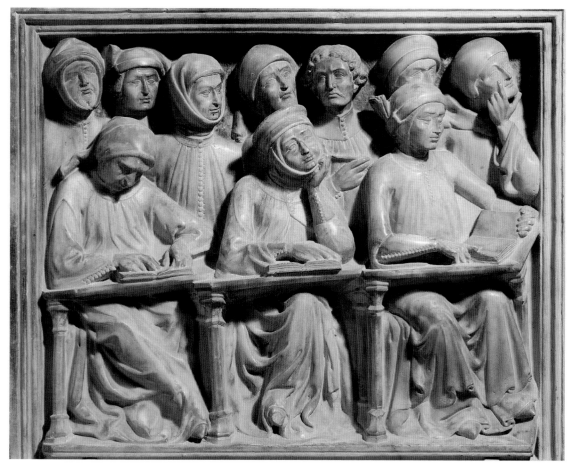

CRAMMING *This 14th century marble bas-relief of students at the University of Bologna includes female scholars*

DREAMING SPIRES *A 1556 engraving depicts Magdalen College at the University of Oxford*

Early Universities Foster an Intellectual Revival

20 In the 11th century, western Europe was just emerging from the long depression commonly known as the Dark Ages: it was ethnically riven, economically fragile and badly ruled. Roman Catholicism was Europe's unifying force, the tie that bound nobles, prelates and scholars across languages, cultures and locations. Benedictine abbeys had preserved what fragments of ancient learning the Continent possessed. Cistercian monks had cleared the land and pioneered in agricultural experimentation. So it is no surprise that one of the great pathways to a more modern Europe arose from within the church, with the founding of the first great universities, beginning with the University of Bologna in 1088. These schools of higher learning evolved naturally from long-established ecclesiastical schools that had been functioning throughout the Dark Ages. They offered a more intense focus on learning and an expanded curriculum of studies to their students.

The universities arose as the church itself was in a period of ferment: the historic schism that forever separated it into two great domains—the Roman Catholic Church and the Greek Orthodox Church—took place in 1054. In response, the active, imaginative Pope Gregory VII instituted a number of farsighted innovations in church law, the Gregorian Reforms. These new ecclesiastical laws demanded a far more learned clergy, and the universities arose to meet that need. Their impact soon extended across the Continent, as a vitalizing love of learning began to bring Europe's brightest minds into contact, and sparks were struck. These new islands of inquiry were the agents of the future and the enemies of the status quo.

A New Age of Scholarship

1088 The University of Bologna is founded.

1165 The University of Paris, now more widely known as the Sorbonne, may have existed in early form from the late 11th century, but it was formally recognized as a university circa 1160-70.

1167 The University of Oxford is believed to date from about 1096 but grew rapidly beginning in 1167, when King Henry II banned English students from attending the University of Paris.

1212 The University of Palencia becomes Spain's first institution of higher learning, but is soon overshadowed by the University of Salamanca.

1364 The Jagiellonian University, Poland's oldest school of higher learning, is founded in Krakow. Nicolaus Copernicus studied here and at the universities of Bologna and Padua.

1386 The University of Heidelberg becomes the first university in Germany.

European Crusaders Capture Jerusalem

21 Seldom have cultures clashed with such historic import as on the fatal day of July 15, 1099, when a multinational army of European Crusaders defeated an entrenched Islamic army to take control of the holy city of Jerusalem. The events that followed would poison relations between Christians and Muslims down through the ages: the exultant Europeans slaughtered the Muslim and Jewish residents of Jerusalem, plundered its shrines, raped its women.

The Europeans could not maintain their foothold in the Middle East, however. Legendary warrior Saladin retook the city in 1187—and ensured his Muslim soldiers treated Christian residents with respect. Seven more major Crusades, and many minor ones, followed. These extraordinary missions, which took place over the course of two centuries, marked the beginning of what historian J.M. Roberts called "Europe's long and victorious assault on the world." Thanks to the Crusades, Europeans developed a yearning for such oriental luxuries as silks, perfumes and rare spices. But angry Muslims eventually cut off Europeans from land routes to India and China, and the need for new avenues of trade with the Far East led to the nautical explorations of the Age of Discovery. Most important, the Crusades fostered a heightened animus between Christians and Muslims that endures: when terrorist Osama bin Laden denounces his enemies in the West, his epithet of choice—"Crusaders"—still carries the echoes of 1099.

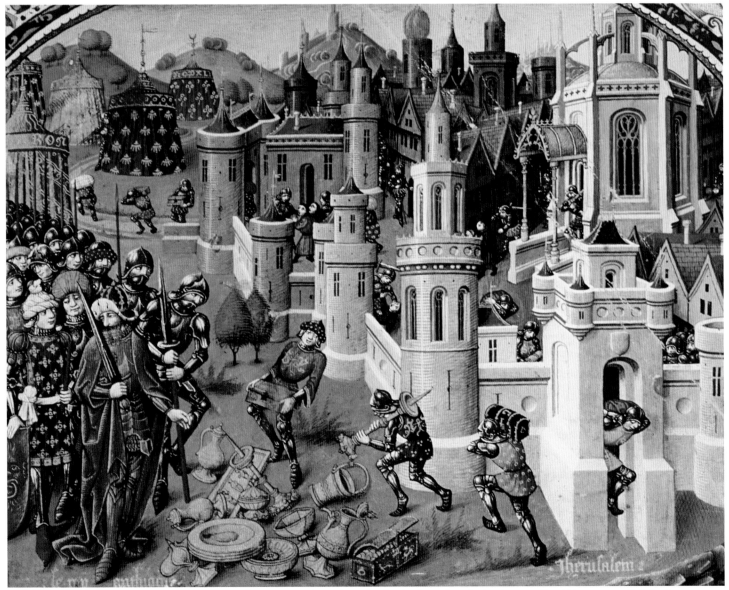

PILLAGE *This illustration from a 15th century French manuscript shows Crusaders looting Jerusalem, depicted as a medieval European walled city, in 1099*

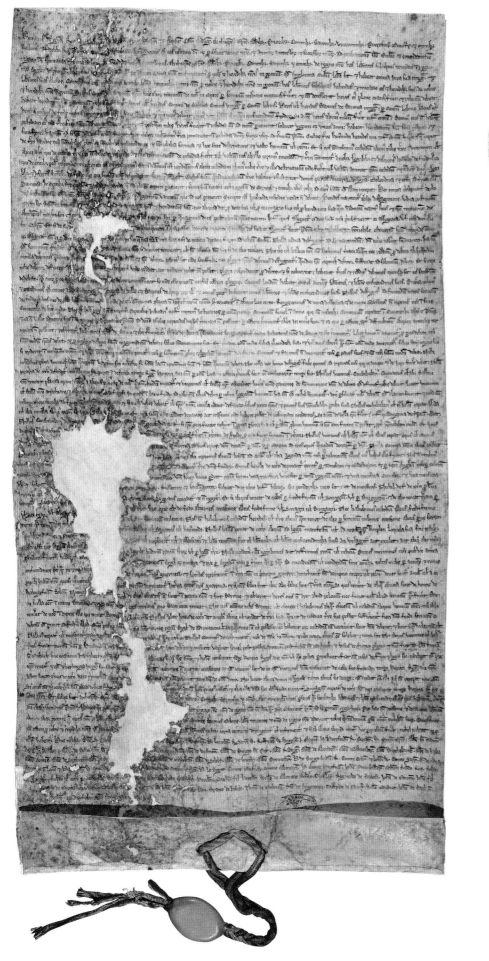

England's Magna Carta Limits the King's Power

22

European societies in the Middle Age were tightly organized hierarchies, where every person knew his or her place: priests bowed to bishops, serfs pledged fealty to landowners, and nobles knelt before their King, God's divinely anointed highest representative in the secular realm. To question the monarch's authority was to question God's authority. But to England's barons in 1215, it may have seemed that God had forsaken them rather than the other way around. King John I was a failure as a monarch; he had quarreled with Pope Innocent III, who issued an interdict barring English citizens from full participation in the Church's rites. And because John had lost important British holdings in Normandy, he now proposed a hefty tax hike to pay England's debts.

Enough! The barons revolted, and most of the citizens of England stood behind them. When the King ventured to meet the rebel barons at a field in Runnymede, outside London, he was forced to sign a document limiting his powers that came to be known as Magna Carta, or Great Charter. Legend has it that John was so incensed by this rebuke that he threw himself on the ground in a rage.

History has taken a different view, for this new statement of the social compact enunciated many of the first principles of Western democracy. In Magna Carta are embedded the seeds of due process, habeas corpus, trial by jury, the limitation of the powers of government and many of the other laws and liberties now considered fundamental to a free society.

STARTING POINT *This copy of Magna Carta was made in 1225, ten years after King John agreed to its terms. Above is the King's seal. One of Britain's least effective monarchs, he died in 1216*

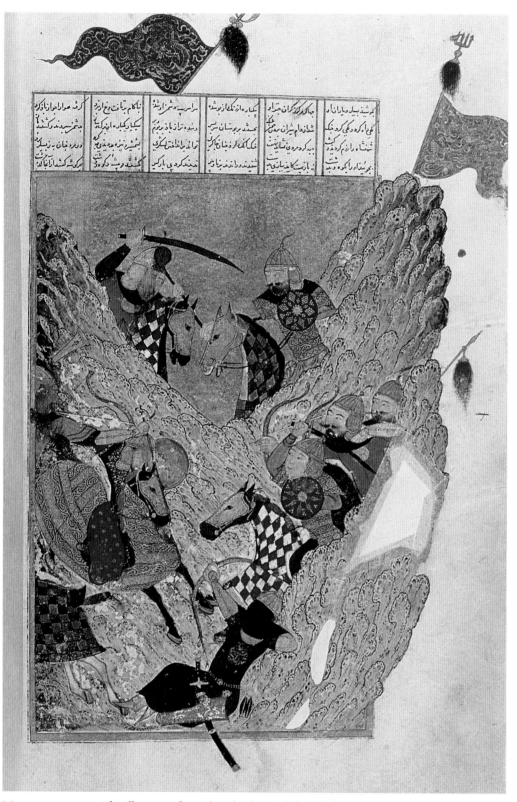

MOUNTED TERROR *This illustration from Ahmad Tabrizi's* Shahanshahnamah *(1337-38) shows Mongols battling Chinese soldiers in the mountains. The Mongol conquests did not end with Genghis Khan's death: his descendants conquered China, Korea, Persia and all of central Asia and pushed into eastern Europe*

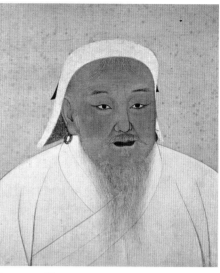

GENGHIS KHAN

Genghis Khan's Mongols Terrorize the World

23 "The greatest happiness is to vanquish your enemies, to chase them before you, to rob them of their wealth, to see those dear to them bathed in tears, to clasp to your bosom their wives and daughters." Well, at least Genghis Khan didn't lack for a mission statement. And one hopes he was happy, for he achieved his dreams a hundred times over. After the tribal leader known as Temujin was crowned in A.D. 1206 as the Mongols' Genghis Khan —"Emperor of All Emperors"— he waged nearly continuous wars of conquest against his neighbors, and their neighbors, and so on. By his death in 1227, he ruled most of the lands between the Sea of Japan and the Caspian Sea, an empire that encompassed two-thirds of the known world and far eclipsed the celebrated realms of Alexander the Great.

In enduring legend, the Mongols were a warmongering race whose only talents were for rape, murder and pillage. But scholars today regard Genghis Khan as not only a conqueror but also a supreme military strategist and talented politician, adept at forging alliances and gathering intelligence. And in the cultural collisions he ignited, history was forged. The suddenly free passage from West to East attracted merchants and adventurers whose goods and tales would change the world. Marco Polo's stories became the dreams of Christopher Columbus. The quest for a passage to Cathay, the medieval name for northern China, would propel countless explorers to serendipitous discoveries in the Americas. And eventually, a disease the Khan's minions carried, the bubonic plague, would devastate the Western world.

The Black Death Devastates Asia and Europe

24 The horror was too great to catch and hold with words, but a Welsh poet named Jeuan Gethin set down some measure of it: "We see death coming into our midst like black smoke, a plague which cuts off the young, a rootless phantom which has no mercy for fair countenance . . ." The phantom he described was bubonic plague, the "Black Death" that killed as many as 25 million people in India and China before reaching Sicily from the East in 1347. Within four years it killed 25 million more people, as much as one-third of the population of Europe.

The details are horrifying: the Rhone River was consecrated by Pope Clement VI so that corpses could be thrown into it. Tatars besieging a Crimean port catapulted the corpses of their own plague-stricken comrades over the city walls to infect the defenders. Columns of flagellants, convinced that God had found them guilty, marched through German towns whipping themselves. Jews were accused of causing the plague by poisoning wells and were burned in their ghettos. The plague weakened the authority of the Catholic Church, since priests had proved unable to protect their flocks from what was widely assumed to be God's vengeance. And by lowering the value of land—because there were few workers left to till it—and raising the price of labor, the death toll also helped bring to an end Europe's system of feudal villenage.

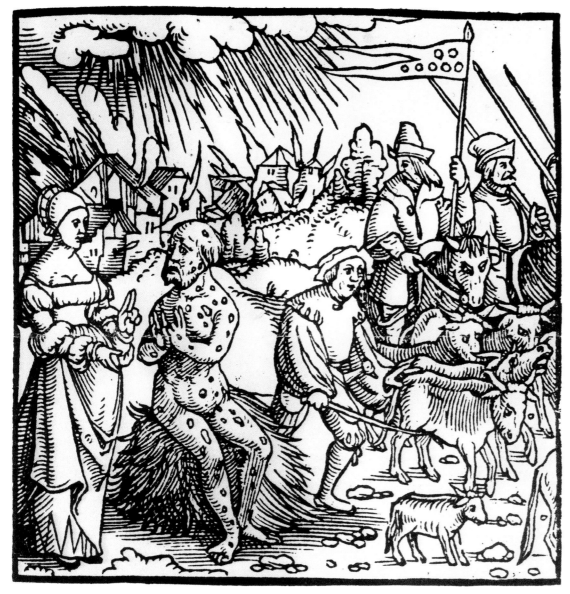

IN FULL FLIGHT *This British engraving from 1348 shows residents of an English town fleeing to the countryside to avoid contagion by the Black Death. The afflicted man at left manifests the characteristic buboes, or swellings, of the disease*

History's Deadliest Plagues

Bubonic plague The "Black Death" is a form of this disease, which is marked by high fever and the swelling of the lymph nodes into lumps, or buboes; it often causes death within two to four days. The outbreak that began in Asia and reached Europe in 1347 is believed to have killed as many as 75 million people.

Smallpox This viral-borne disease has a mortality rate of 30% to 35% in its most severe form. Smallpox was the foremost among a number of Old World diseases that ravaged the indigenous tribes of the Americas following exposure to European explorers, killing more than 80% of their populations. Smallpox is believed to have killed as many as 60 million Europeans in the 18th century alone and is estimated to have caused more than 300 million deaths in the 20th century.

Spanish flu This epidemic killed 50 to 100 million people worldwide in two years, 1918 and 1919.

Cholera History records many outbreaks of this severe bacterial infection, primarily borne in contaminated water. A lengthy epidemic in India that began in 1816 killed millions, but there is no exact toll.

The Renaissance

EUROPE'S NEW DAWN ■ THE MING DYNASTY REVIVES CHINA ■ JOAN OF ARC IS EXECUTED
GUTENBERG INVENTS THE PRINTING PRESS ■ OTTOMAN TURKS TAKE CONSTANTINOPLE
PORTUGUESE NAVIGATORS EXPLORE THE GLOBE ■ COLUMBUS ENCOUNTERS THE NEW WORLD
LUTHER SPARKS THE PROTESTANT REFORMATION ■ SPAIN'S CONQUESTS IN THE AMERICAS
TURKS BESIEGE VIENNA ■ COPERNICUS' REVOLUTION ■ EUROPEANS SETTLE THE NEW WORLD
NEWTON PROBES NATURE'S LAWS ■ PETER THE GREAT'S RUSSIA ■ BRITAIN CONQUERS INDIA
FRANCE LOSES CANADA

Sometimes history conforms to our fondness for connecting life's dots: the astronomical insights of Nicolaus Copernicus influenced Johannes Kepler, whose writings in turn influenced Isaac Newton. But what makes history a living, slippery sort of subject is the law of unexpected consequences. Consider the many ramifications of a late medieval event utterly beyond man's control. In 1347 a ship escaping from a siege of a Genoan trading post in the Crimea by Mongols and Hungarian Kipchaks landed in Sicily. Many of its refugee passengers were suffering from a hitherto unknown and fatal illness: the bubonic plague, borne by fleas, which rats carried by the millions. By the start of the 15th century, the plague had killed up to 40 million people—at least one-third of Europe's population. The Black Death profoundly influenced the course of history. It inspired a further exodus to the West of scholars from Byzantium, which was especially hard hit by the disease. The plague helped lay the groundwork for the Protestant Reformation by creating an underlying mood of skepticism about the Roman Catholic Church, whose prayers and rituals had appeared ineffective in warding off the disease. Finally, the plague left a mass of discarded and unwearable clothes. But these garments could be shredded to make rag paper, a vital element in the print revolution that was just getting under way, thanks to Johannes Gutenberg's invention of the printing press. Among the first printed texts: the Classic Greek and Roman works brought by the fleeing Byzantine scholars; their ideas of free expression and democracy challenged the absolutist monarchies of Europe and the church's theocentric view of the universe. The Renaissance may have seen the rebirth of humanism, but this revolution was driven in part by rats.

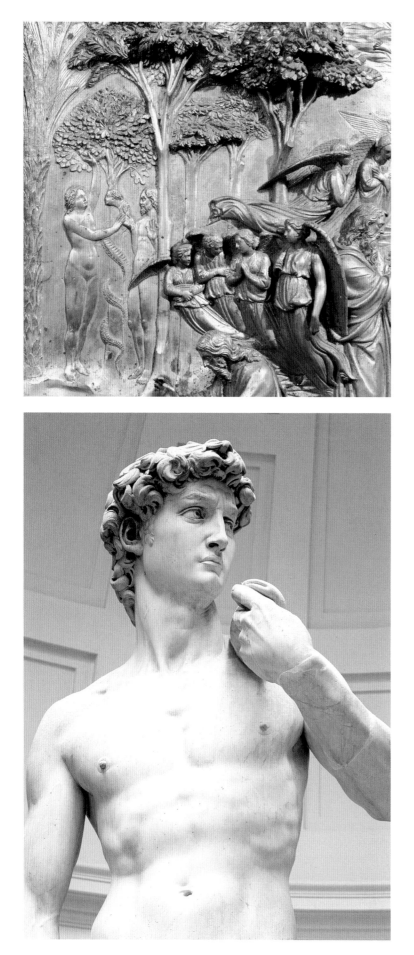

The Renaissance Shifts Man's Focus from Heaven to Earth

25 The Renaissance can't be measured as a single event: the term is used to describe an entire historical era, lasting as much as 200 years, that began in Italy but spread across western Europe. Nor did such famed Renaissance men as Michelangelo and Leonardo da Vinci think of them themselves as such: the term entered the popular lexicon in the 19th century. But the movement we have come to regard as an age of exhilarating rebirth was very real, and it manifested itself not only in the fresh surge of energy it brought to the arts but also in the innovations it fostered in science, scholarship and the social order.

Historians have identified several starting points for the Renaissance; one good place and time are Florence, Italy, in 1401, when two famous artists, Lorenzo Ghiberti and Filippo Brunelleschi, engaged in a public contest to be awarded the right to design the bronze doors for the Baptistery at the city's cathedral. Ghiberti won the prize, and his doors, like many of the famous works of the Renaissance, depict scenes from the Bible. But it is his fascination with the human figure that catches our eye. Indeed, the most distinctive aspect of this period was its new emphasis on the human rather than the divine, on this world rather than the next. Michelangelo's love of the human form led him to dissect dead bodies to discover their workings. Leonardo and many other Renaissance figures scrutinized natural forces anew, as Europeans began to sense the wonder and power of science—and of man's ability to create technologies to shape nature to his will.

Much of this new sense of human potential arose from the rediscovery of the great texts of the ancient world, particularly those of Greece, fed by the exodus of Classical scholars from Constantinople after it was conquered by Turks in 1453. In the world of pagan mythology and in the works of Plato and other Greek philosophers, figures of the Renaissance found an invigorating alternative to the long-established, long-unexamined verities of the medieval social order and the dominant Roman Catholic Church. Now they began to speak of *studia humanitatis,* the study of human life—what universities now call the humanities.

SUBLIME HUMANS *At top left, one of Ghiberti's later door panels in Florence depicts Adam and Eve from the Book of Genesis. Below, Michelangelo's* David, *completed in 1504, belongs to a later period, the High Renaissance*

LEFT, FROM TOP: LORENZO GHIBERTI—BRIDGEMAN ART LIBRARY; MICHELANGELO BUONARROTI—SCALA—ART RESOURCE, NY. RIGHT: SANDRO BOTTICELLI—IMAGNO—GETTY IMAGES

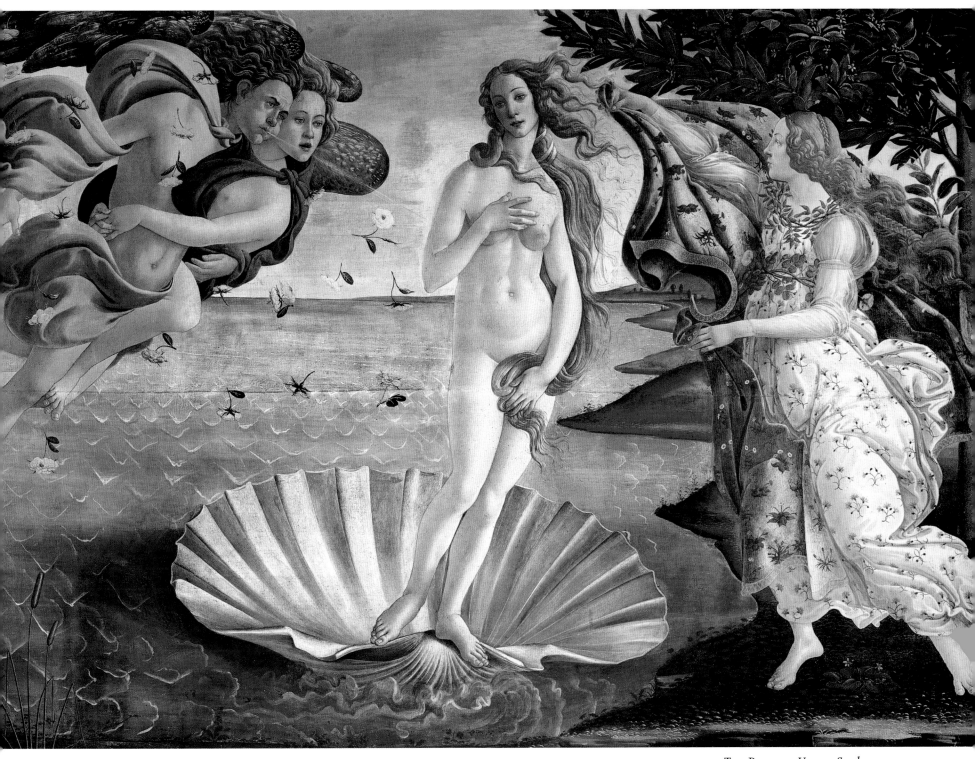

THE BIRTH OF VENUS *Sandro Botticelli's famous image, painted in 1485, captures many of the aspects of the Renaissance: a renewed interest in Classical mythology, the use of linear perspective, delight in rendering the human form and the natural world*

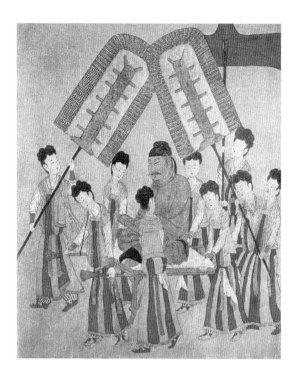

China Blooms in the Ming Dynasty

26 For much of history, China was among the world's great cultures, yet its geographical isolation often kept its most impressive achievements from making an impact on the world's other great centers of civilization. That isolation was also a matter of choice: the Chinese generally shunned the outside world, preferring to build walls to keep "barbarians" at bay. That strategy failed when Genghis Khan's grandson, Kublai Khan, conquered China for the Mongols and founded the Yuan dynasty in 1271. When that dynasty fell in 1368, the Ming dynasty took its place, ruling China until 1644.

A succession of Ming emperors now presided over a harmonious age that is a pinnacle of Chinese culture. First among equals is the Yongle Emperor (Zhu Di), who ruled from 1402 to 1424. In 1421 he moved the Ming capital from Nanjing to Beijing, and he personally supervised the renaissance of China's ancient northern capital. The 1,103-mile (1,775 km) Grand Canal linking Beijing and Hangzhou, abandoned for centuries, was restored, allowing trade to flow between Beijing and the south. The Emperor founded a new royal complex, the Forbidden City, which remains the home of China's leaders; he also sponsored the creation of an 11,000-volume encyclopedia.

Most unusually, the Yongle Emperor forced China to reach out. He dispatched Admiral Zheng He, a Muslim eunuch, on a series of voyages into the Indian Ocean and along the west coast of Africa. His armada of giant junks was several times bigger than any of the fleets Columbus commanded decades later. With more than 300 ocean-going vessels and a navy of nearly 30,000 men, Zheng He transformed China into a 15th century superpower. He exacted tribute, brought Sultans to their knees and opened trade routes that helped develop an enduring taste abroad for Chinese porcelain and silk.

MASTER MASONS *There are older walls in China, but the famed Great Wall was primarily constructed under the Ming dynasty. At the top is the Yongle Emperor, Zhu Di*

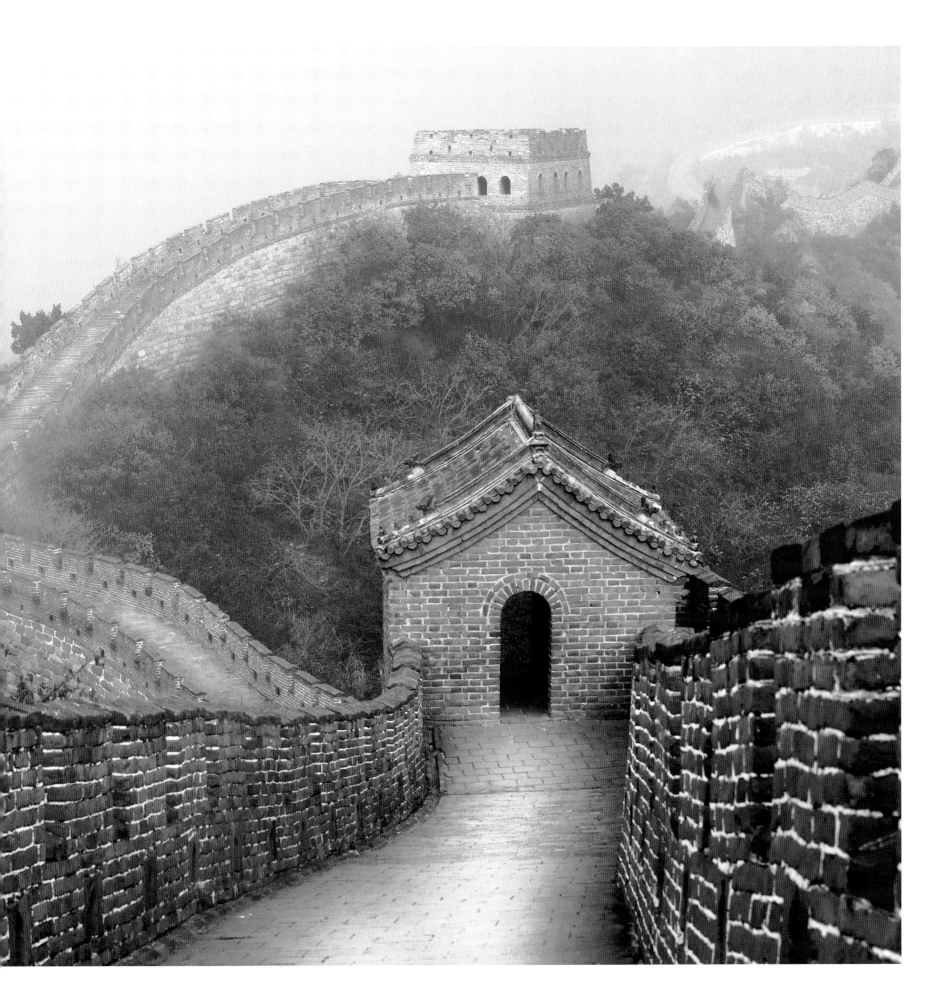

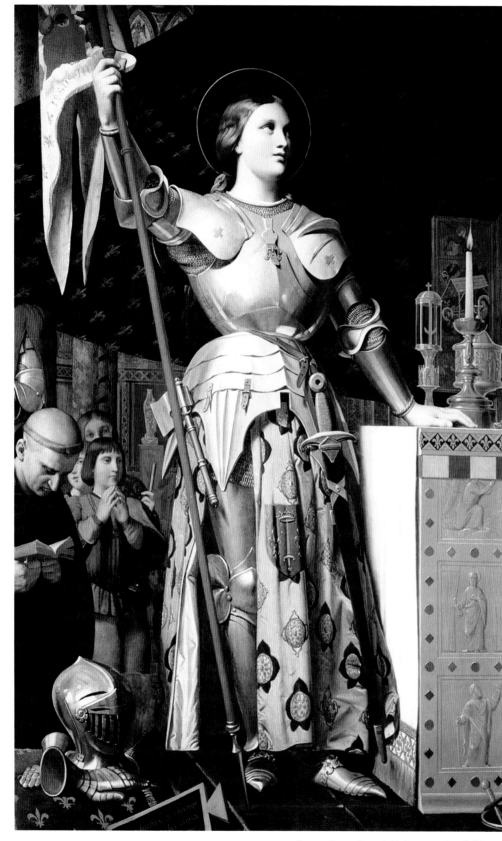

SAINT JOAN *Jean A.D. Ingres painted this Neoclassical depiction of Joan of Arc at the coronation of Charles VII more than four centuries after the mystic-warrior was burned at the stake. His 1854 portrait gives her a halo, though she was not canonized until 1920*

Joan of Arc Defies the Medieval Social Order

27 Late in the afternoon of May 23, 1430, a Burgundian archer in the service of the English captured a hard-fighting soldier of the King of France and took his prisoner back to camp. Had he captured half the French army, his commanders would have been no happier. Stripped of armor, the soldier was seen to be a handsome, well-knit girl of 18 with short-cropped dark hair. For this was Jeanne d'Arc of Domrémy, who had given France's onetime dauphin, Charles VII, his throne, after her army of worshipful male soldiers relieved the British siege of Orléans, then whipped the British in a subsequent series of battles in the Hundred Years' War.

The English now staged one of history's great show trials. At its end, the young woman who dressed in men's attire and claimed to be guided by voices from God was pronounced a heretic. On May 30, 1431, she was burned at the stake. Twenty-some years later, a remedial tribunal was held, and Joan was declared an innocent martyr. In 1920 she was canonized by the Roman Catholic Church.

Joan of Arc has never lost her grip on the world's imagination. The original legend was all ethereal voices and uprolled eyes. In *Saint Joan,* George Bernard Shaw depicted the 15th century farm girl as a rebel imp with 19th century socialist leanings. More recently, feminists have seen her as an inspiring foe of medieval male chauvinism. Her Hollywood incarnations include Ingrid Bergman, Jean Seberg, Geneviève Bujold and Milla Jovovich. To historians, however, she is a commoner who spoke truth to power, the embodiment of an idea whose time had come, the peasant striding into the council of kings and lords of the church to serve notice on the feudal system that knighthood was no longer in flower. She helped crown a King, but she also helped midwife the modern nation-state. The beneficiaries of this Joan are everyday citizens and empowered women everywhere.

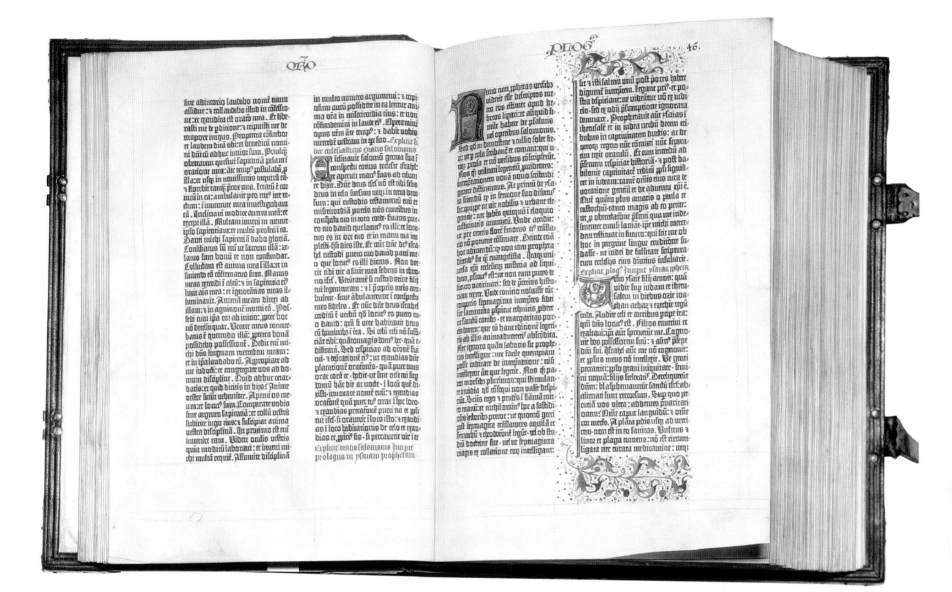

BEST SELLER *This first edition of the Gutenberg Bible boasts striking initials and illustrations added by hand; color printing was not developed until many centuries after Gutenberg. The new printing process swept across Europe: an estimated 30,000 titles were in print by 1500*

Gutenberg Invents the Printing Press

28

When a young German, Johannes Gutenberg, took up his trade, printing was a laborious business. Each new page required the creation of a new printing form, usually an incised block of wood. So he began looking for ways to make metal casts of the individual letters of the alphabet: equipped with a sufficient supply of them, a printer could use and reuse them in any order required to run off thousands of copies of each page. He solved the technical obstacles, discovering an alloy that would melt at low temperatures(so that it could be poured into letter molds) and an ink that could crisply transfer impressions from metal to paper. He rejiggered a wine press to create the force to print the impressions. *Eureka!* In 1455 visitors to the Frankfurt Trade Fair reported having seen sections of a Latin Bible with two columns of 42 lines each printed—*printed*—on each page. The completed book appeared in 1456 and eventually became known as the Gutenberg Bible.

Before print, the ability to read was restricted to society's élites and the trained scribes who handled their affairs. Affordable books made literacy a crucial skill and an unprecedented means of social advancement to those who acquired it. Established hierarchies began to crumble. Books were the world's first mass-produced items, and printing spurred the greatest extension of human consciousness ever created. It isn't over: the 555-year-old information revolution continues on the Internet, where—thanks to a German printer who wanted a more efficient way to do business—you can read all about it on your iPad.

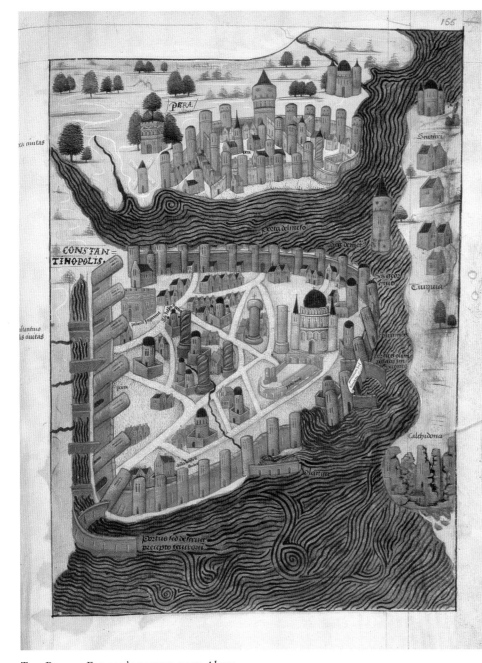

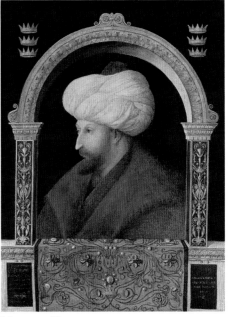

MEHMET II

THE ROMAN EMPIRE'S SECOND FALL *Above, a 15th century map shows the walled city of Constantinople, with the great church Hagia Sophia at right. The portrait of Mehmet II at top right is attributed to Venetian artist Gentile Bellini. The Sultan was only 21 when his troops conquered the Byzantine capital after a seven-week siege, ending an empire that had endured for 1,100 years*

The Ottoman Turks Put an End to the Byzantine Empire

29

The name of Osman Gazi, or Osman I, is little remembered today, but the great political entity named after him, the Ottoman Empire, straddled three continents at its height—western Asia, eastern Europe and northern Africa—and endured for six centuries. Born in 1258, Osman came of age in a time of turmoil: as Mongol tribes advanced into Asia, his father Ertugrul led his Kayi tribe in declaring independence from the Seljuk Turks. Assuming power at only 26, Osman presided over a period of energetic renaissance for the Islamic peoples of the region. As the Byzantine Empire to his west was weakening, Osman began moving his people closer to its great capital, Constantinople, and settled them on Byzantine lands. His warrior spirit attracted Islamic soldiers from across the Middle East to his cause, and the revival he led carried well beyond his death in 1326. The Ottoman Turks, now a powerful military force, captured the key Macedonian city of Thessaloniki from the Venetian Republic in 1387. Two years later the Turks defeated the Serbs in the Battle of Kosovo, taking control of the Balkans.

Christian Europe watched these developments with alarm: in what is now considered the last great Crusade, an army raised by France, Hungary and Venice tried to stop the Turks' advance, but the Christians were soundly beaten in the Battle of Nicopolis in 1396. It seemed little now stood between the Turks and the city of Constantinople, but the unexpected advance of a new group of Mongol invaders led by Tamerlane, as well as internal rivalries among the Turks' leaders, postponed the inevitable. But the Turks regrouped, and an army led by Sultan Mehmet II captured Constantinople on May 29, 1453. The Byzantine Empire, the last remnant of the great Roman Empire, had fallen. Constantinople was now Istanbul, the great basilica Hagia Sophia was now a mosque, and a mighty Islamic dynasty would rule the eastern Mediterranean for some five centuries to come.

The Portuguese Chart the Globe

30 As Christians and Muslims struggled for control of the eastern Mediterranean, in what can be considered the last great battles of the Middle Ages, a door into the future was being opened in western Europe. Lured by the exotic tales told in *The Travels of Marco Polo* (circa 1300) and by the spice, gold and slave trade controlled by Islamic traders in western Africa and the Indies, European navigators began to explore the Atlantic Ocean and the west coast of Africa, searching for sea lanes to the Indies. Portugal, led by visionary ruler Henry the Navigator, became the hub of this incipient Age of Discovery, which was made possible by advances in the design of a light, agile ship with multiple sails, the caravel, which allowed sailors for the first time to venture far across the oceans.

Under Henry's sponsorship, Portuguese mariners hopscotched their way to the Azores, the Canary Islands and down Africa's western coast. As their confidence, sailing techniques and technology improved, Portugal's navigators now opened new routes that expanded Europeans' knowledge of the globe. Bartholomew Diaz was first to round the southernmost tip of Africa, passing the Cape of Good Hope in 1488. Nine years later, Vasco da Gama became the first mariner to sail from Portugal to India. And in 1521 a ship from an expedition led by Ferdinand Magellan completed the first circumnavigation of the globe. Portugal had become a great empire, the world seemed alive with new possibilities, and Europeans had found new worlds—to conquer.

CARAVELS *This illustration of the fleet of ships under the command of Pedro Álvares Cabral, the discoverer of Brazil, was created in 1558. The triangular, or lateen, sails shown on some ships were one of the innovations that helped caravels weather the oceans.*

At top left is an astrolabe of Moorish design dating to 1300; it was used as an aid to navigation. European mariners learned much from their Islamic counterparts

Europeans Encounter a New World

31

For centuries before European cartographers first began to place tentative sketches of North and South America on their maps of the world, rumors of strange lands to be found across the Atlantic Ocean stirred dreams of exploration, adventure and conquest. Yet when the first European navigators not only made landfall on North American coasts but also settled down, planted crops and built structures able to withstand the frigid winters of Newfoundland—the news of these history-altering events did not travel across the Continent. It's not unlike the paradox of the tree falling in the forest: if a new world is located but the news of its discovery doesn't travel—it's as if it never took place.

That's just what happened after Norse mariner Leif Eriksson sailed west from Greenland sometime around A.D. 1000 in search of a verdant coast supposedly sighted earlier by a Viking sea captain. As the Norse sagas tell the story, Leif anchored in a forbidding land of rocks and glaciers, then followed the coast south to a place he christened Vinland ("Wineland," probably for the wild grapes that grew there). His party made camp for the winter, then sailed home. Lief never returned to Vinland, but other Vikings did, as their sagas recount. But for centuries, historians took the sagas to be romances, fantasies of exploration dreamed up by Norse minstrels.

Almost five complete centuries passed before a visionary Italian mariner, Christopher Columbus, obtained the financial backing of the Spanish monarchy and launched three ships on an expedition of discovery, aiming not for North America but for the East Indies, which he believed to be across the Atlantic from Europe. Embarking from Palos, Spain, Columbus made landfall in the Bahamas in 1492 and went on to explore Cuba and Haiti. This time around, the discovery took hold, as Columbus himself returned to Europe bearing proof of his find, in the form of living American Indians.

It was not until the 1960s that Norwegian scholars Helge and Anne Ingstad conclusively proved that the Norsemen discovered North America circa A.D. 1000. In a series of excavations that lasted seven years, their team unearthed the remnants of Norse buildings and possessions dating back to the time of Leif Eriksson in L'Anse aux Meadows, Newfoundland—proof that both Eriksson and Columbus deserve to rank among history's great explorers.

FOUR CORNERS *A world map created by Flemish cartographer Theodore de Bry in 1596 shows North and South America some 100 years after Columbus' first voyage. Also shown, clockwise from top left: Italian explorers Columbus and Amerigo Vespucci, Spanish conquistador Francisco Pizarro and Portuguese navigator Ferdinand Magellan*

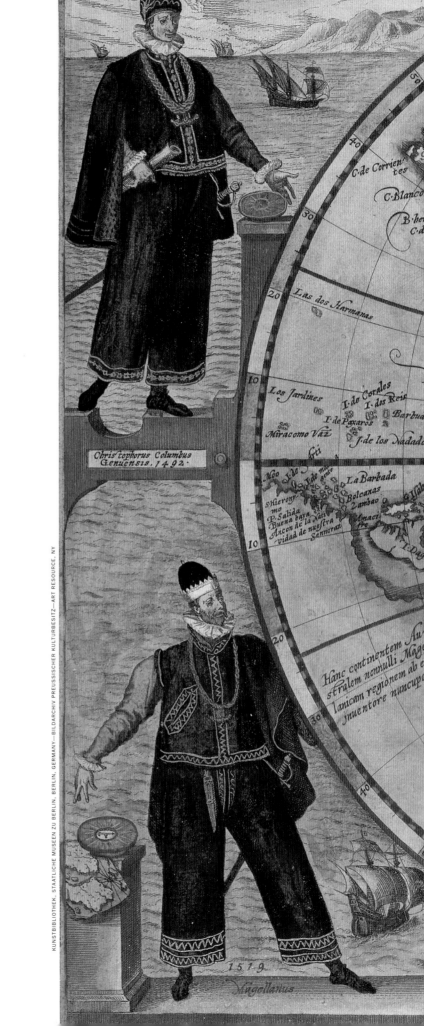

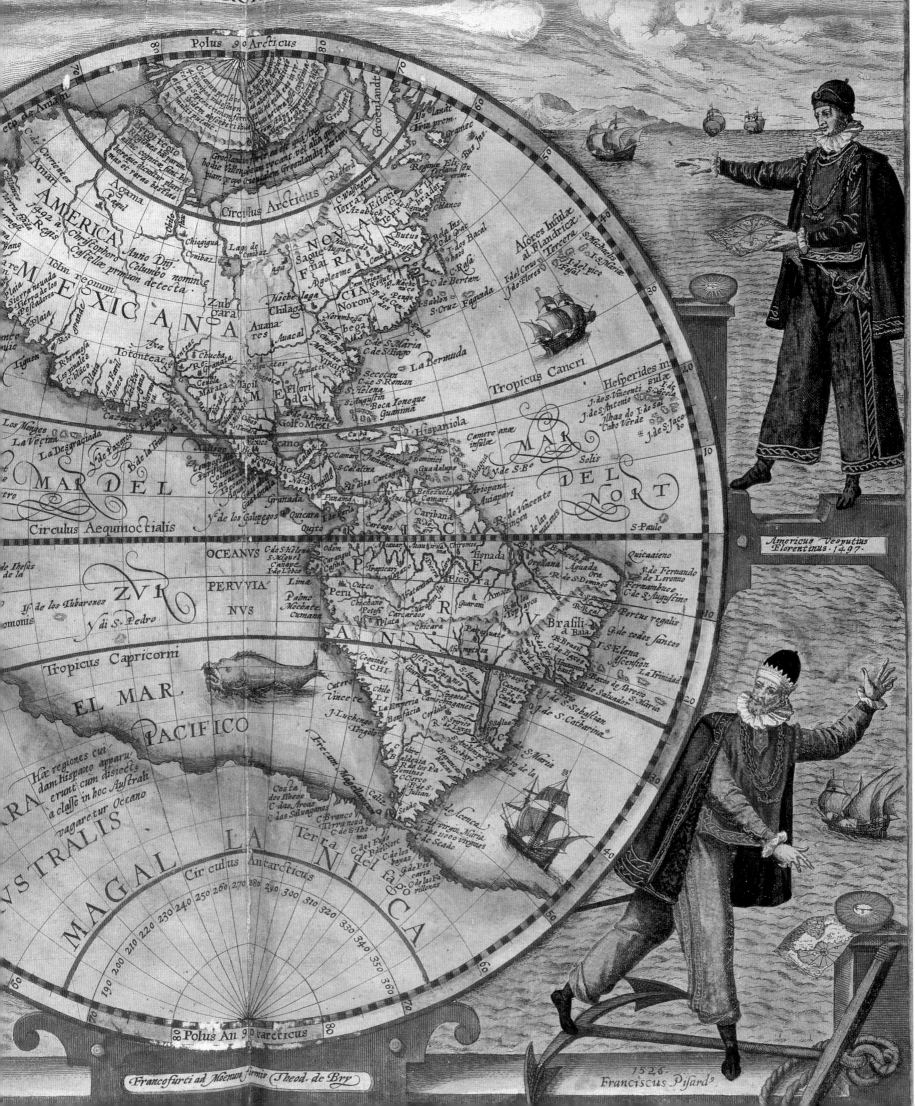

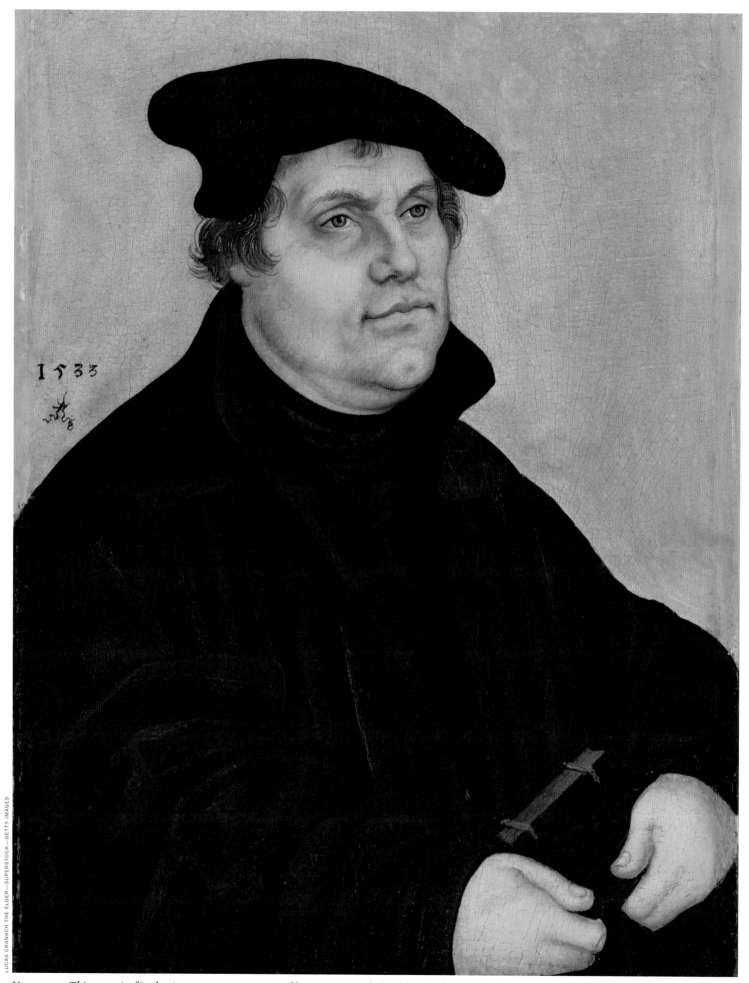

UNBOWED *This portrait of Luther in 1533, age 51, was painted by Lucas Cranach the Elder, who became a close friend of the Protestant reformer*

FLAMES AND ALMS *Two contemporary engravings show the Reformation in full swing. At left, Protestant bishops Hugh Latimer and Nicholas Ridley are burned at the stake in Oxford, England, in 1555. At right, Protestant artist Cranach depicts a corrupt Pontiff selling indulgences, an illustration in an anti-Vatican pamphlet that Luther was once erroneously believed to have written*

Luther Leads a Revolt Against Rome

32

"Arise, O Lord, and judge thy cause. A wild boar has invaded thy vineyard." So began the bull in which Pope Leo X demanded that Augustinian friar Martin Luther recant his preachings against the Roman Catholic Church's selling of indulgences as a means of buying divine favor. Luther had bravely nailed his *Ninety-Five Theses* arguing against such practices on the door of the Wittenberg Castle church in Saxony on Oct. 31, 1517. But the Vatican couldn't make the wild boar budge. "Here I stand," Luther is said to have declared at the Diet of Worms, the council called by Emperor Charles V to judge him. "I cannot do otherwise. God help me."

Luther's stand against a church that had become corrupt, arrogant and rigidly hierarchical was the first salvo in the Protestant Reformation. Inspired by his stand, reformers across Europe now found the courage to question the authority of the Vatican. And that meant questioning the entire apparatus of medieval society, which was founded upon unswerving devotion to the church and its leaders. As Luther's revolt progressed, he joined others in arguing for the use of vernacular tongues, rather than Latin, and he worked to bring education to peasants formerly excluded from schools by religious authorities.

The German rebel rejected centuries of religious dogma to argue that each person—not the church—was responsible for his or her own salvation. This insistence on the primacy of what he called "personal thinking" over received authority was the Reformation's great contribution to the modern world, paving the way for a new individualism in Western culture. As for the "wild boar," he was excommunicated, and the former friar's revolt against church teaching was so thorough that he eventually married a former nun. Luther was no saint, but by taking a stand and sticking to it, he had moved the world.

Turning Away from the Vatican

1517 Luther posts his *Ninety-Five Theses,* which strongly argue against the church's sale of indulgences, which are dispensations promising divine forgiveness for sins.

1519 Ulrich Zwingli becomes pastor of a Zurich church and begins to preach against specific church practices and teachings. His arguments find favor in Zurich, which becomes a hotbed of the Reformation movement.

1521 At the Diet of Worms, Luther refuses to recant his arguments; he is denounced and excommunicated.

1536 French cleric John Calvin publishes *Institutes of the Christian Religion,* establishing himself as a leader of emerging Protestant theology in Geneva.

1534 After Britain's King Henry VIII is excommunicated in a dispute over his right to divorce his wife, he seizes control of the Vatican's monasteries in England and forms a new religion, the Church of England, today's Anglicans.

1545 Pope Paul III calls the Council of Trent, in which the Vatican reforms some of its corrupt practices but also reaffirms many of the teachings now called into question by the Protestant reformers.

The Spanish Conquer the Americas

33 A fascinating new world, alive with wonder and danger. Vast mineral riches, ready for the taking. Indigenous peoples, branded as inferior and ruthlessly exploited. Only the details of time and place separate the tale of Spain's conquests in the Americas with the story line of the 2009 blockbuster film *Avatar.* The Spanish conquistadors who felled the great kingdoms of the Aztecs and the Incas were drawn by the quest for silver and gold, while the priests and monks who accompanied them came in pursuit of a different sort of riches: souls converted to Christianity. As a result, the first close encounters between Europe and the Americas were baptized in blood.

When a band of ragged and exhausted Spanish conquistadors first beheld the lake-encircled capital of the Aztecs, one November morning in 1519, they were stunned by its grandeur. A shining metropolis of more than 200,000 people, as large as Europe's greatest cities, Tenochtitlan boasted an immense royal palace, where Aztec nobles stood guard in jaguar-head helmets and feathered robes. In its marketplaces, vendors offered jungle fruits and rare herbs and skillfully wrought creations of silver and gold. "The magnificence, the strange and marvelous things of this great city … [are] so remarkable as not to be believed," Hernán Cortés wrote back to Spain's imperial court.

In the Spaniards' eyes, such marvels demanded conquering. And within only a few years, conquer they did. Cortés in Mexico and Francisco Pizarro in Peru brought down mighty empires with only a few men, by force of their horses, cannons and muskets—all new to the natives—and by their deceptions and brutalities. They also had an invisible ally: Old World diseases such as smallpox and measles, for which the natives had no defenses, may have killed as many as 80% to 90% of the American tribes. Cortés controlled Tenochtitlan by 1521; Pizarro took power over the Inca empire in Peru in 1533. And for the two centuries that followed, a Spain grown wealthy on the riches of the New World became the greatest power in Europe.

MIGHT MAKES RIGHT *This 16th century manuscript depicts the torture of two Aztec leaders by Spaniards seeking silver and gold. Above is a two-headed serpent ornament, part of the treasure presented to Hernán Cortés, initally taken for a god by the Aztecs*

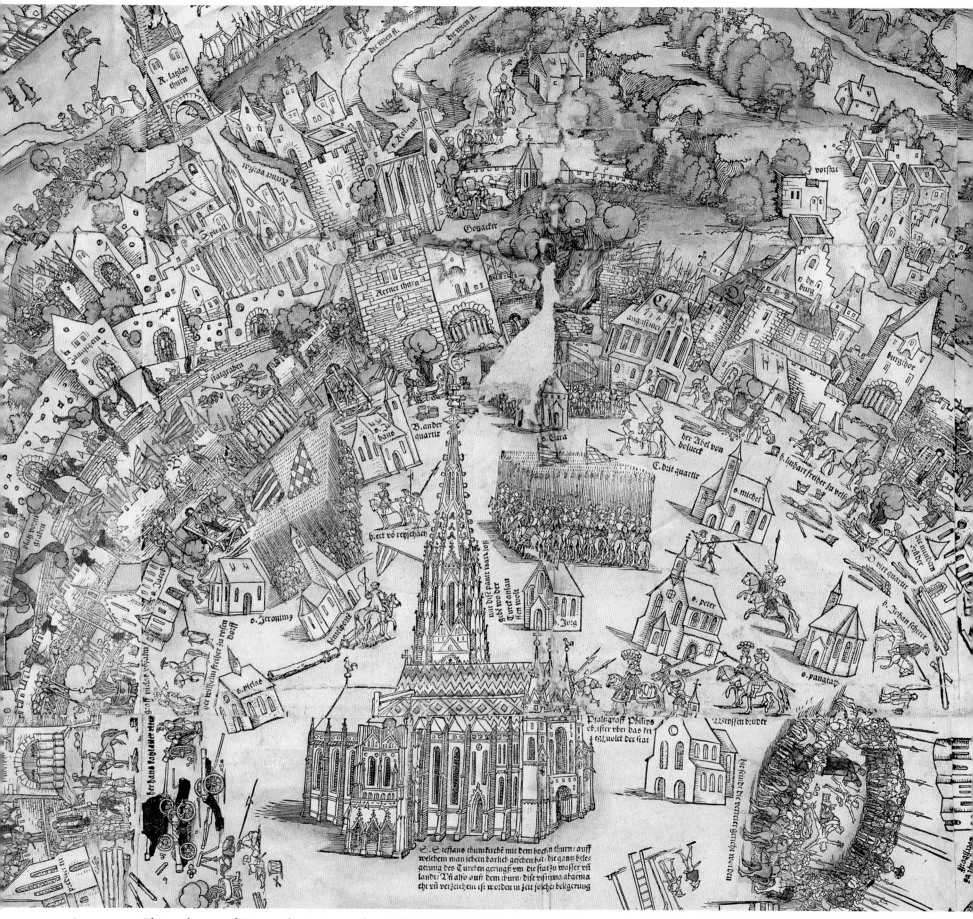

AERIAL VIEW *This woodcut map of Vienna under siege in 1529 shows St. Stephen's Cathedral, headquarters of the Austrian resistance, at its center. It was made by Nikolaus Meldemann in 1530*

HEADSTRONG *Suleiman the Magnificent, circa 1530, the year after his setback at Vienna*

The Ottoman Advance Is Turned Back at Vienna

34

After the Ottoman Turks conquered Constantinople in 1453 and made it their capital, they found they had acquired a taste for empire-building. The next several centuries would find them expanding their power in all directions, as they became the absolute rulers of the eastern Mediterranean, Middle East and northern Africa. Kingdoms, sultanates, principalities and and duchies: all proved helpless in the face of the Turks' powerful armies and mighty fleets of warships. To the south and east, the Persians were defeated in 1514; Syria fell in 1516 and Egypt in 1517. (Baghdad eventually followed, in 1534.) The Ottman navy now controlled the eastern Mediterranean, the Bosporus and the Red Sea, and the Turks also dominated the overland trade routes to Asia and India.

The empire reached an apogee under the reign of Suleiman the Magnificent, who ruled from 1520 to 1566. He turned his sights to the north, defeating a Serb army at Belgrade. This thrust brought the Ottomans into conflict with the Hapsburg Empire, led by King Charles V of Spain. To the horror of all Europe, Suleiman now reached a rapprochement with France, the enemy of the Hapsburgs. In 1526 Suleiman won a major victory over King Louis II of Hungary, sending that nation into a long period of weakness and partition.

Now a great goal in the heart of Europe beckoned the Turks: Vienna. As Christian Europe quaked, Suleiman laid siege to Austria's capital in 1529. When he was repulsed, it ended a century of steady expansion by the Turks. Suleiman attacked Vienna again in 1532; again he was rebuffed. The Ottoman Empire had reached its western limits in Europe.

Copernicus Moves the Earth

35

Once upon a time, geography was shaped by divinity. Medieval cartographers placed Jerusalem at the center of their maps: after all, this was where Christ had preached and died. In like fashion, Earth was undoubtedly the center of the universe, for this was the world created by God for man. As for the sun, it was clear to everyone with eyes that it circled the earth once every 24 hours. Everyone, that is, except for a young Pole, Nicolaus Copernicus (the Latinized version of his name). A polymath whose brilliance was apparent from an early age, Copernicus drank deep from the new sources of learning that were flooding Europe at the end of the 15th century. Born in 1473, he studied at today's Jagiellonian University in Krakow but also spent several years as a student in Italy, first at Bologna and later at Padua.

Through diligent study of ancient manuscripts—and the skies—Copernicus created a thesis he knew would be controversial: despite appearances, and in violation of the long-accepted notions of Greek astronomer Ptolemy, Planet Earth is not the center of the universe; moreover, it revolves around the sun rather than vice-versa. Copernicus entertained and tested these radical ideas for decades before publishing them in his masterwork, *On the Revolutions of the Heavenly Spheres,* in 1543, the year he died.

In retrospect, the publication of these theories has been called the starting point of modern science. In overturning centuries of received opinion through unflinching doubt and empirical observation, Copernicus pushed mankind from center stage in the universe and opened the door to the power of skepticism and inquiry, the great tools of science.

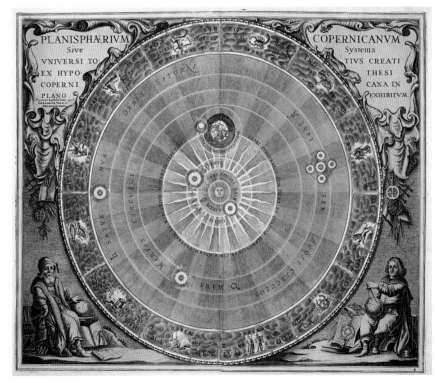

SOLAR POWER *This engraving of "Copernicus's Planisphere," drawn by Andreas Cellarius in Amsterdam in the 17th century, shows the earth and planets revolving around the sun*

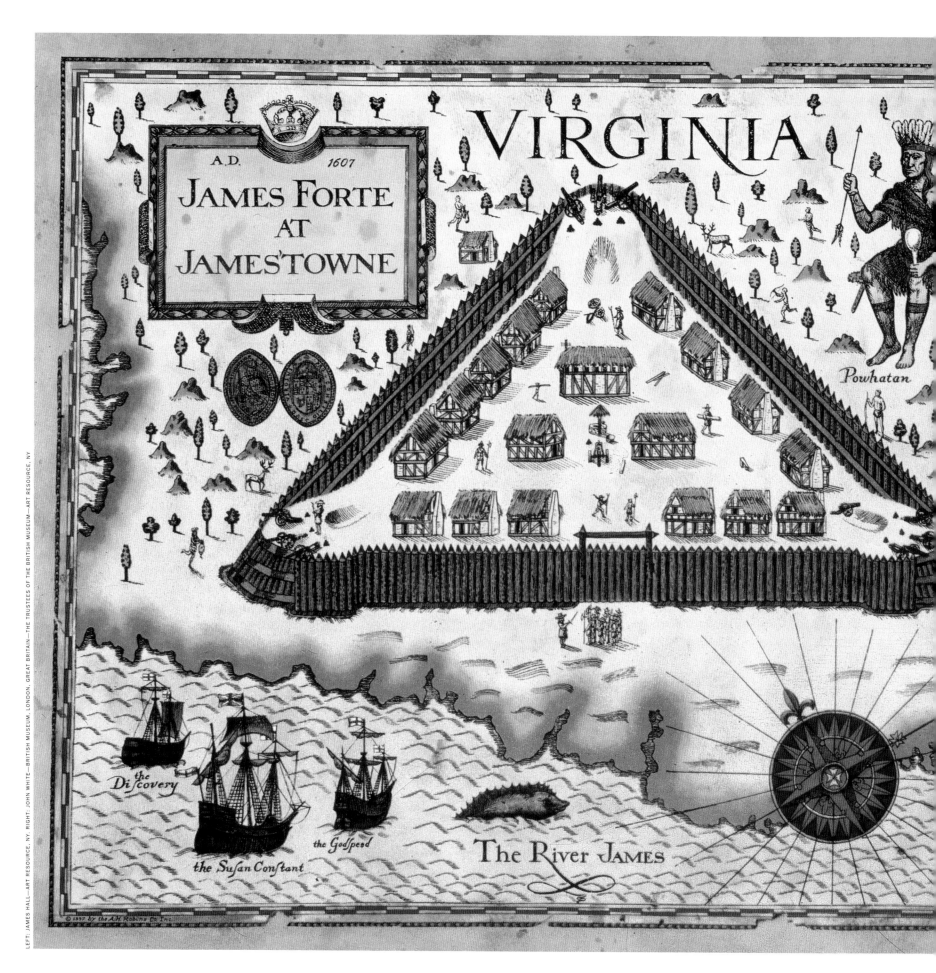

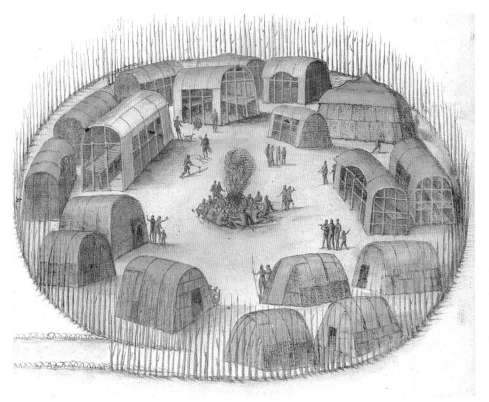

CHARTING THE LAND *The map of the Jamestown colony at far left was drawn by settler James Hall in 1607; it shows the triangular fort erected by the British to keep the local Powhatan tribe at bay.*

At near left is a sketch of an Algonquin village in the Carolinas made by Briton John White, governor of the Roanoke colony, in 1585. White left the colony in 1587 to return to England; when he came back in 1590, he found none of the settlers alive

Europeans Settle the Americas

36 Spain was the first European nation to establish a major presence in the Americas, initially concentrated in the Caribbean, Mexico, today's Florida and Peru. Europe's other imperial powers followed, in fits and starts: the Portuguese settled in Brazil, while the Dutch established a colony along the Hudson River in 1624, and French explorers traveled the waterways into Canada's interior and down the Mississippi River.

The British were late-comers: their first settlement, the Roanoke colony, failed shortly after its founding in 1585 in today's North Carolina. It was not until 1607 that the first lasting British settlement was established at Jamestown in the new colony of Virginia. In 1619 the New World's first involuntary settlers arrived: 20 black slaves from Africa disembarked at Jamestown. In 1620 the *Mayflower* made landfall in today's Massachusetts; its passengers founded the second lasting British colony in North America. The Dutch foothold wouldn't last, but the broad pattern of the Americas was set: South America and Mexico were Spanish lands; today's U.S. and Canada were British and French.

The immigrants to the Americas were drawn by diverse agendas, which shaped their interactions with the indigenous peoples. The Spanish settlers came seeking wealth and converts, and they intermarried with the native Indians to create an entirely new culture. The French and British, some driven by dreams of riches and others by the lure of religious freedom, came to view North America's Indians as savages to be displaced. The future of the New World would involve this patchwork of disparate races—indigenous Indians, African blacks and European whites—in a complex struggle to form new social orders.

Exploring North America

1497 Backed by Britain, Genoese native Giovanni Caboto (John Cabot) lands in North America, most likely on the island of Newfoundland.

1513 Spaniard Juan Ponce de León explores Florida and the coast of the Gulf of Mexico.

1524 Italian Giovanni da Verrazzano, sponsored by France, explores the east coast of North America from the Carolinas to Newfoundland.

1539-42 Spaniard Hernando de Soto and a large party explore areas in today's Carolinas, Alabama, Georgia, Tennessee, Mississippi, Louisiana, Arkansas and Missouri.

1603-08 France's Samuel de Champlain helps found the Acadia colony and explores the Great Lakes region. He founds Quebec City in 1608.

Newton Clarifies Gravity, Light and Motion

37 Isaac Newton famously compared himself to a boy on the seashore, playing with pebbles, "whilst the great ocean of truth lay all undiscovered before me." That's a wonderfully humble comment, but it obscures the extent to which Newton helped drive a revolution that is still under way: the use of incisive inquiry to discover new truths about reality. Growing up as the Age of Reason was in full swing, the prodigy from Lincolnshire drew inspiration from the new scientific method practiced by such predecessors as Copernicus, Galileo and the Britons Francis Bacon and Robert Boyle—the "giants" whose shoulders he claimed he stood upon.

Newton began his rigorous interrogation of the natural world while an undergraduate at Cambridge; within 20 years, he fundamentally altered our view of the universe, making seminal contributions in optics (he deciphered the nature of light), in mechanics (he asserted his famous Three Laws of Motion and explained universal gravitation) and in mathematics (he invented the calculus, though German mathematician Gottfried Leibniz also did so independently). His *Principia Mathematica,* published in 1686, put forth his theories of gravity and motion; it has been called the fundamental work for all of modern science. To aid his study of light, he built the world's first reflecting telescope, the model for thousands of scopes to come. Forget picking up pebbles—Newton was surfing on the ocean of truth.

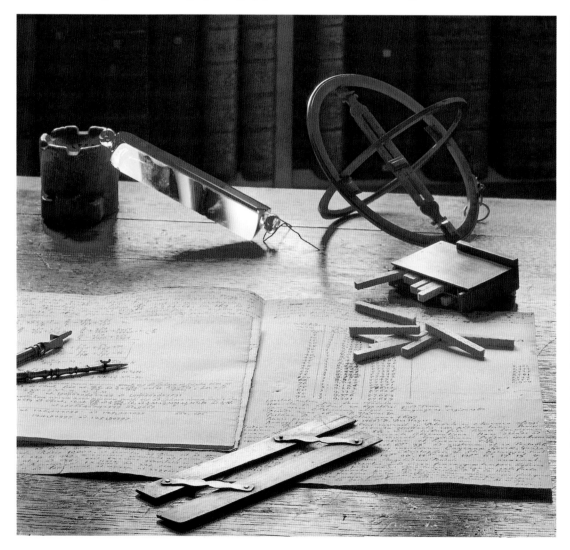

TOOLS *At left are some of the instruments Newton used in his investigations of light, mechanics and gravity, as well as some of his original manuscripts, all preserved at Trinity College, Cambridge, where much of his research was conducted. Above, Newton is depicted by German artist and astronomer Hermann Goldschmidt in a portrait painted long after the polymath's death*

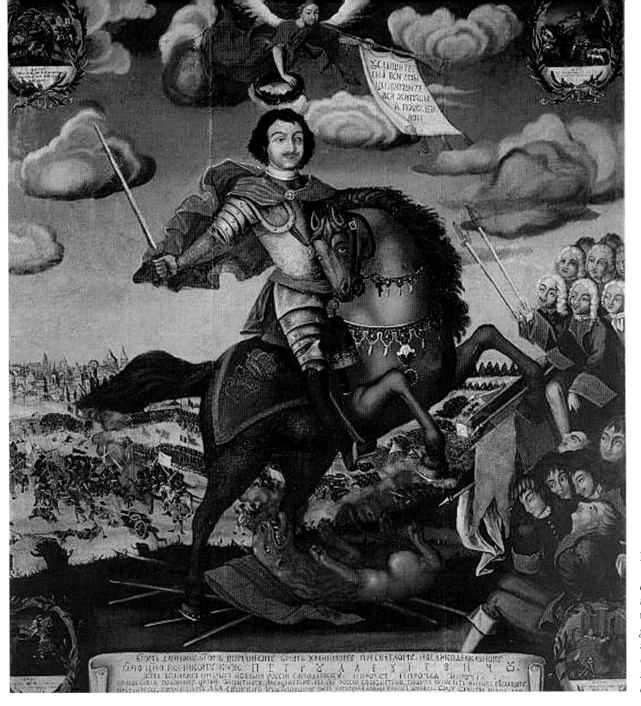

LARGE AND IN CHARGE
This contemporary anonymous painting shows the Apotheosis of Peter I, the Great. *The Tsar's greatness extended to his size: he stood a remarkable 6 ft. 8 in. tall in an era when most adult males topped out at well below 6 ft.*

Peter the Great Forces Russia to Look West

38 What was so great about Peter the Great? Above all, the answer lies in his vision: after taking the reins of Russia, Czar Peter 1 dragged his feudal, backward, self-absorbed nation into the modern world, seemingly single-handedly. In the process, he also vastly expanded the territory of his land, thanks to his victories in a series of ongoing wars with the Ottoman Empire to the south and Sweden to the north and west.

Groomed for greatness, the royal prince was taught by liberal tutors brought from Europe by his father, Czar Alexis. Due to palace politics, he was forced to bide his time under the regency of his authoritarian half-sister, Sofia, before he could assume full control of Russia in 1696. Determined to make his nation as modern as its European counterparts, the restless Czar reformed the army, built the first Russian navy, reorganized the Russian Orthodox Church, adopted the Julian calendar, even forced his ministers and soldiers to abandon their traditional garb and wear modern styles.

Above all, Peter yearned for a warm-water port to serve as Russia's gateway to the world. On a grand diplomatic journey to Europe's capitals, the Czar halted his travels to study new shipbuilding methods, hands on, in the Netherlands. Upon his return he founded a new capital city for his kingdom, St. Petersburg, on land he had wrested from Sweden. The Swedes had become his great rivals; after years of war, he finally defeated them in 1721. In the Treaty of Nystad that followed, Sweden ceded control of vast territories in the Baltics to Russia, confirming what all now knew: Peter the Great had made Russia great.

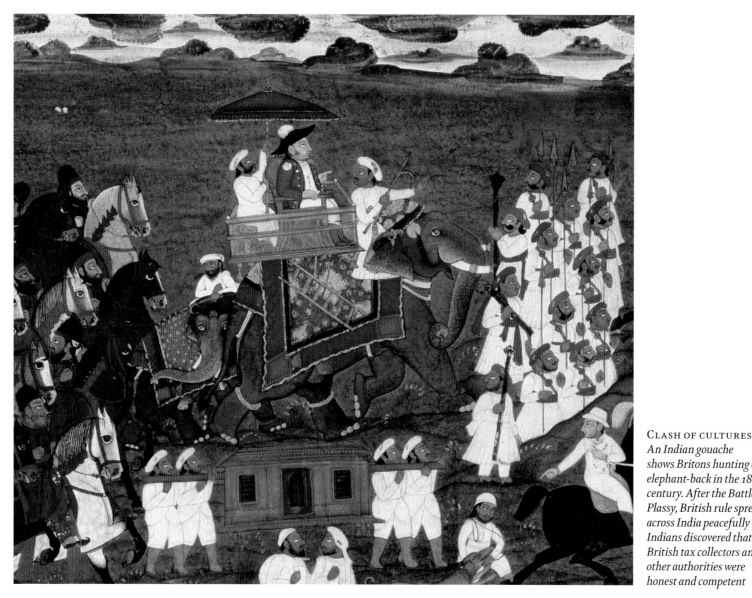

CLASH OF CULTURES
An Indian gouache shows Britons hunting on elephant-back in the 18th century. After the Battle of Plassy, British rule spread across India peacefully as Indians discovered that British tax collectors and other authorities were honest and competent

The British Take Control of an Empire in India

39 By the 18th century, European colonialism had become the strongest force on the planet. The age of the early explorers and navigators, rich in marvels, had given way to a new era rich in wealth, as Europe's great powers began the systematic settlement and exploitation of far distant lands, working through large merchant trading companies. The Dutch East India Co., the British East India Co. and Hudson's Bay Co. were among the world's first great megacorporations. Their agents often exercised quasi-governmental authority in the foreign ports where they traded with locals. As these growing empires reaped the riches of overseas trade, they poured their wealth into the navies that now became key to maintaining power. In this manner, such relatively small nations as Britain and the Netherlands used their expertise in shipbuilding and sailing to exercise enormous control over people and events in the East Indies, Africa and the Middle East.

In this feverish contest for power and wealth, history could turn on the outcome of a single battle. One such contest, the Battle of Plassy, came near Calcutta on June 23, 1757, when Briton Robert Clive, leading only 3,000 men, outgeneraled the Nawab of Bengal, Siraj ud-Daulah, who commanded an army of some 50,000 troops and batteries of artillery led by his French allies. Clive won the day—and won one of history's greatest prizes: Britain's Raj soon extended across the entire subcontinent. For almost two centuries to come, Britain would remain the greatest empire on the planet, thanks to the wealth of its colony in India.

A Battle in Quebec Shapes a Continent's Future

40 In two short years at the end of the 1750s, Britain won two battles that would make it the world's foremost colonial power. The first came in India in 1757; the second came on Sept. 13, 1759, when British and French armies clashed in Quebec to decide which nation would control the destiny of Canada—and, indeed, of North America. Many more British than French citizens had settled in the New World, and the two cultures were now clashing in the frontiers along the Mississippi River to the west of the British colonies, in territories long claimed by France. (When the jousting erupted into the French and Indian War in 1755, one participant in skirmishes near today's Pittsburgh was a young military officer from the colony of Virginia, George Washington.)

Late in the 1750s, British Prime Minister William Pitt dispatched thousands of troops to America, seeking a final battle with the French that would decide the fate of the lands along the Mississippi and in Canada. The showdown came in Quebec, the city whose towering location on bluffs along the St. Lawrence River makes it the gateway to the interior of Canada. Here British Major General James Wolfe fooled the French, lodged in a strong position in a fortress atop the bluffs, by spiriting landing parties around their position and launching a surprise attack. In the brief Battle of the Plains of Abraham, the British prevailed. Both Wolfe and French General Louis-Joseph de Montcalm were killed, but the battle was decisive. The French gave up their claims to the Mississippi lands, and the British took charge of Canada, though the French influence in Quebec has endured, preserving Canada's unique multicultural heritage.

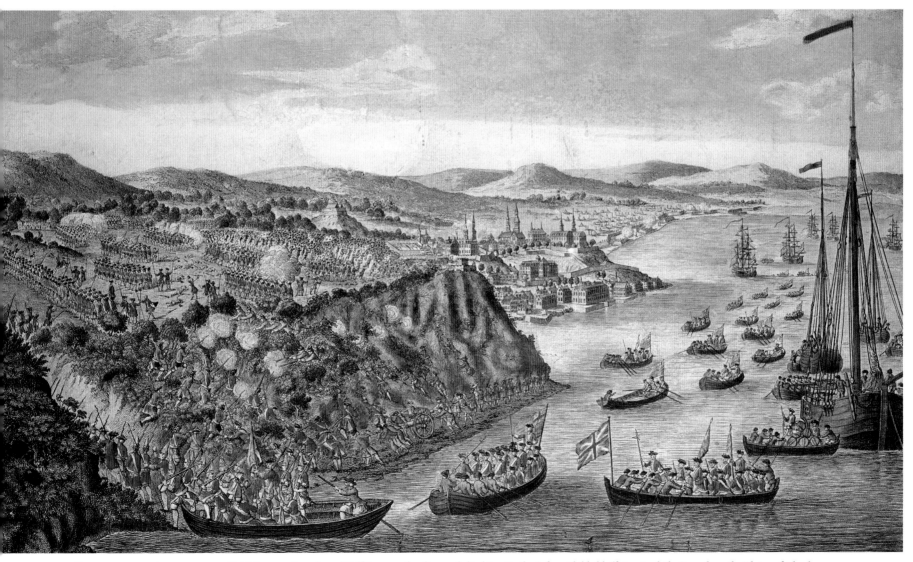

BATTLE ROYAL *A contemporary British engraving shows Wolfe's troops landing and climbing Quebec's formidable bluffs to attack the French on the Plains of Abraham*

The Age of Enlightenment

CAPTAIN COOK CHARTS THE SOUTH PACIFIC ■ STEAM DRIVES THE INDUSTRIAL REVOLUTION
THE U.S. DECLARES INDEPENDENCE ■ THE AGE OF ENLIGHTENMENT ■ REVOLUTION IN FRANCE
APPEAL FOR WOMEN'S RIGHTS ■ RISE OF NAPOLEON ■ EXPLORATION OF AMERICA'S WEST
NAPOLEON'S DEFEAT ■ ADVENT OF THE RAILROAD ■ CRUSADE TO OUTLAW HUMAN SLAVERY
INVENTION OF PHOTOGRAPHY ■ BIRTH OF THE TELEGRAPH ■ 1848: YEAR OF REVOLUTIONS
JAPAN OPENS ITS DOORS ■ DAWN OF THE STEEL AGE ■ DISCOVERY OF NEANDERTHAL MAN
DARWIN POSITS NATURAL SELECTION ■ AMERICA'S CIVIL WAR ■ MENDEL PROBES HEREDITY
MARX ADVOCATES SOCIALISM ■ SUEZ CANAL OPENS ■ PASTEUR'S GERM THEORY
BISMARCK UNIFIES GERMANY ■ BELL INVENTS THE TELEPHONE ■ EDISON'S LIGHT BULB
THE CINEMA IS BORN ■ FREUD INVESTIGATES THE UNCONSCIOUS ■ MARCONI PERFECTS RADIO

istory is the record of a changing world. And as we enter the Age of Enlightenment, history seems to accelerate, as the rate of change itself increases. In the Renaissance scientists first began to demystify the world, identifying the natural laws that made the universe tick. Now that era of pure research gave way to an era of application, as the steam-powered Industrial Revolution reshaped life, begetting factories, railroads and cities. Old ways of agriculture, regulated by the sun, gave way to urban ways regulated by the clock. As British historian Hugh Thomas put it, "The essential characteristic of our times (that is, the years since 1750) is the manufacture of goods for sale outside the neighborhood concerned, in a factory, and by a machine." The social order was demystified as well, as the old regime of noble precedence gave way to a radical new philosophy: all men are created equal. Moreover, as Thomas Jefferson's Declaration of Independence argued, each person possesses certain "unalienable rights," including the right to overthrow governments that deny them life, liberty and the pursuit of happiness. In this new age, philosophers envisioned the universe as a great machine, with God as its controlling engineer. And man himself, they argued, was also a kind of machine, whose work could be scientifically regulated. One beneficial side effect of this vision was a more rigorous and effective approach to medicine. But mechanistic views also led to the dark, satanic mills that William Blake and Karl Marx railed against. The Age of Enlightenment was powered by science, reason and humanism, but too often it released humans from old chains only to replace them with new ones.

CAPTAIN JAMES COOK

British Explorers Chart the Pacific

41 Officially, when H.M.S. *Endeavour* set sail from England in 1768 under the direction of a seasoned Yorkshireman, Captain James Cook, the ship was embarking on a purely scientific expedition. Cook's party, which included the young botanist Joseph Banks and other scientists, had been sent into the Pacific to observe the transit of the planet Venus across the face of the sun, in order to collect data to help astronomers calculate the distance between Earth and the nearest star. But in fact, the *Endeavour's* cruise was also a matter of empire. The French had just lost Canada and, with an urge to make up for it somehow, were searching for the great new continent, *Terra Australis Incognita,* that was believed to lie in the South Pacific between New Zealand and South America. French explorers like Louis-Antoine de Bougainville were looking for the same territory, and the Britons' idea was to claim it first for King George III.

When Cook returned to England in 1771, Australia was very much *cognita,* thanks to his efforts, as were a host of South Pacific island paradises, like Tahiti, that had never before been charted by Europeans. If Cook's tour was primarily driven by Britain's quest for territory, he conducted it in humane fashion. His enlightened dealings with the South Pacific natives were a good century and a half ahead of his time. A further boast: none of his crew died of scurvy, then the sailors' plague, thanks to Cook's forward-looking belief in antiscorbutics, the acids that prevent the disease.

Europeans were stunned by the extent of Cook's revelations. His adventures in sociology proved far more stimulating than his achievements in geography, for the island women the Britons met proved eager for the transports, if not the transits, of Venus. "The men will very readily offer the young women to strangers, even their own daughters, and think it very strange if you refuse them," Cook reported. The news of islands where sex and sin seemed to have nothing to do with each other was to have a bemusing effect on poets, artists, sailors and everyday citizens for generations afterward. Cook was to go on two more voyages, charting Oceania, the Antarctic and Alaska before he was slain and dismembered by Hawaiian natives in 1779.

FIRST ENCOUNTERS *At top is a sketch of* Heberdenia bahamensis, *a form of magnolia first collected by Joseph Banks. Below is a painting of a scarlet Hawaiian honeycreeper, a type of finch, made by William Ellis on Cook's third voyage to the Pacific. At top right are drawings of a priest and chief of the region's indigenous people, made by Sydney Parkinson on Cook's second voyage.*

At right is William Hodges' painting of Captain Cook's two ships on his second voyage, Resolution *and* Adventure, *at anchor in Tahiti. Hodges' pellucid image depicts a seeming Garden of Eden, a prelapsarian world of breathtaking innocence and beauty*

An Heiva, or kind of Priest of Ytolee-Etea, &c. the Neighbouring Islands.

The Head of a Chief of New-Zealand, the face curiously tataowed, or mark'd, according to their Manner.

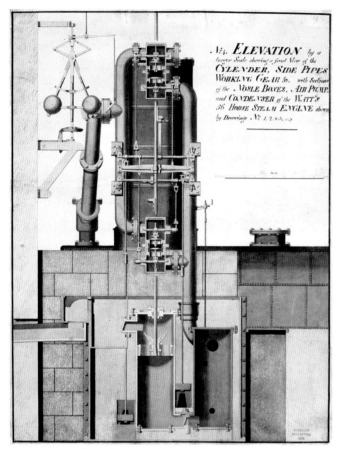

PIPING HOT *This 19th century elevation shows the components of a Watt steam engine that could generate as much as 56 horsepower*

A New Engine Heats Up an Era of Innovation

42 We generally conceive of historical epochs in visual terms, but if any period deserves a sound track, it's the Industrial Revolution. Here was history as cacophony: it was an age of burbling turbines, rattling locomotives, whirring textile looms, clattering collieries and clanking ironworks. The machine that brought the world-changing process sputtering to life was that hissing transformer of water and heat into mechanical power, the steam engine. One early such device was built in 1712 by a Devonshire ironmonger, Thomas Newcomen—improving on a design by Thomas Savery—to remove water from local tin mines. His reciprocating engine used steam to drive a piston that moved a suspended beam up and down; it worked a pump that removed the water. Such "miner's friends" spread across the British Isles, but the Industrial Revolution may truly be said to have picked up a head of you-know-what when a young Scotsman, James Watt, strongly improved Newcomen's engine in 1776 by adding a separate condenser, resulting in a version that was faster and far less expensive to operate. Working with partner Matthew Boulton, Watt made further mechanical advances, creating a circular engine that easily operated a driving wheel.

Hiss ... clang! The Industrial Revolution was off and running—on steam power. Textile mills were first to adapt the new engines, while Cornishman Richard Trevithick hatched the brilliant notion of putting a steam engine on rails in coal-mine tramways. His "portable steam engine" was the first locomotive. Steam was now the driving wheel of a revolution in human events, as the production of goods moved from hands to machines and from cottages to factories. The world was suddenly hurtling at a surprising new pace into the modern age. *All aboard!*

GOTHIC ARCH, IRON TRUSS *One of the great landmarks of the Industrial Revolution is the Iron Bridge over the River Severn at Coalbrookdale, England, as seen in a photograph from the late 19th century. The bridge, the world's first to use iron rather than wood or brick to support its span, was completed in 1779. It still stands*

Defying Britain, America Declares Independence

43 The words that have driven the history of modern nations were written by a 33-year-old Virginian, Thomas Jefferson, on a small lap desk of his own design in a rented second-floor room of a house on Philadelphia's Market Street in June 1776. One block away lived the man who would help edit his text, the brilliant polymath Benjamin Franklin. Their world seems small in retrospect, but the document they produced, the U.S. Declaration of Independence, has moved millions since it was first ratified by the Second Continental Congress on July 4.

Jefferson's ideas reflect all the electrifying currents of the Age of Enlightenment, most notably the concept of natural rights first propounded by British philosopher John Locke, who saw society as a contract between government and the governed that was founded on the consent of the people. "Jefferson wrote the magic words of American history, the 55 words in the Declaration that begin 'We hold these truths to be self-evident, that all men are created equal,'" said his biographer Joseph Ellis, a professor of history at Mount Holyoke College and the author of *Founding Brothers* (Knopf; 2000). "That promise and those words are probably the most important words in American history—and possibly all of modern history."

Indeed, Jefferson's assertion that all men "are endowed by their Creator with certain unalienable rights, that among these are life, liberty and the pursuit of happiness" struck a chord in human hearts that has never stopped resounding. Those words became the rallying cry of French revolutionaries, of marchers who followed Mohandas Gandhi and Martin Luther King Jr., of Soviet dissidents and Nelson Mandela, and, as of 2010, of Tea-Party protesters—who might be surprised to be reminded that Jefferson's terms also inspired V.I. Lenin, Ho Chi Minh (who tried to quote them to President Woodrow Wilson at the Versailles Conference in 1919), Mao Zedong and Che Guevara. A few words consigned centuries of hierarchies to history's dustbin.

CALL TO ARMS *The manuscript of the Declaration shows Franklin's handwritten edits of Jefferson's text. Jefferson called some truths "sacred and undeniable"; Franklin made that "unalienable," an assertion of rationality over religion*

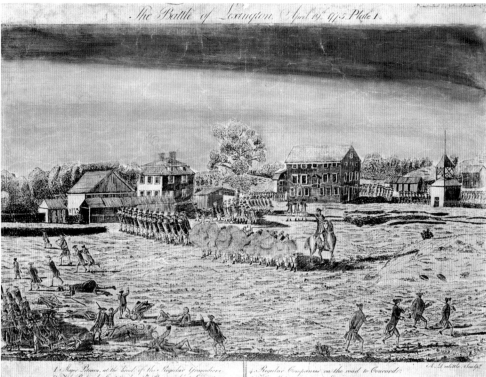

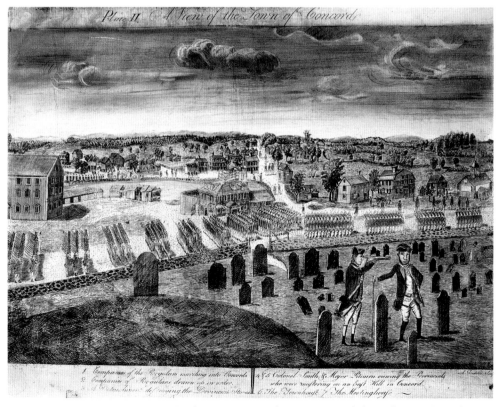

FROM PROTEST TO WAR *As Britain's colonies in America began to resist rule from afar, British regular troops clashed with American "Minutemen" on April 19, 1775, in two skirmishes in Massachusetts, the first at Lexington (top) and the second at Concord (bottom). Seventy-three Britons and 49 Americans died*

Before the Declaration

1764 Britain's Sugar Act raises levies on colonial commerce, and Americans protest.

1765 Britain passes the Stamp Act and the Quartering Act, leading American colonists to boycott English goods and form a Stamp Act Congress.

1766 Under pressure, Britain is forced to repeal the Stamp Act.

1767 The Townshend Acts impose new, onerous taxes on the American colonists.

1768 Britain sends troops to enforce order in Boston, chief city of the most rebellious colony.

1769 The Virginia Resolves oppose taxation of the colonies without representation.

1770 Five colonists are killed in the Boston Massacre; the Townshend Acts are repealed.

1773 Britain's Tea Act takes effect; colonists protest it in the Boston Tea Party.

1774 The Coercive Acts, dubbed the Intolerable Acts by colonists, punish Massachusetts. The First Continental Congress meets in Philadelphia.

1775 In skirmishes at Lexington and Concord in Massachusetts, American colonists first take up arms against British soldiers.

FLORA *A page from Elizabeth Blackwell's* A Curious Herbal *(1737-39) shows salvia leaves. Botany was a favorite endeavor of the time*

An Enlightened Age Looks to the Future

44 When German philosopher Immanuel Kant published his seminal essay *What Is Enlightenment?* in 1784, the historical epoch he was discussing was so far advanced that it had already been given a name, and the movement would run its course by the year 1800 or so. Yet this moment in history represented a high point in the Age of Enlightenment, for its principles had found embodiment in the American Revolutionary War, won by the colonials in 1783. Those principles would also summon the people of France to revolution in 1789, but they would be betrayed in the Reign of Terror.

So: What is Enlightenment? It can be described as a long-runnning intellectual quest driven by a host of brilliant thinkers in nations across Europe who sought to cast off long-accepted views of society, politics and religion. It was a sort of secular Reformation, or intellectual Renaissance, in which shibboleths unchallenged for centuries—the divine right of kings, the primacy of aristocrats and prelates, the stratification of society into social classes that dictated one's destiny—were all challenged. The great tool of the Enlightenment was reason, a scalpel used to expose the hollowness of contemporary institutions. Its signature pursuit was science, whose rigorous empiricism stood in stark contrast to the unexamined dogmas of the past. And among its enduring products are the U.S. Declaration of Independence and the Bill of Rights of the U.S. Constitution.

The Enlightenment was even nurtured in new ways. Journals, essentially the first magazines, helped spread the call to reason. Encyclopedias became the bibles of intellectuals, showcasing the latest scientific findings. Coffeehouses and salons served as meeting places where free-thinkers could exchange ideas. So, increasingly did the new Masonic Lodges that were sprouting all around Europe at this time, attracting its leading minds—minds that embraced the freedom to inquire and the freedom to doubt. For, as Voltaire said, "doubt is not a pleasant condition, but certainty is absurd."

IMMANUEL KANT, GERMAN PHILOSOPHER

VOLTAIRE, FRENCH AUTHOR AND WIT

JOSEPH PRIESTLEY, BRITISH SCIENTIST

KNOWLEDGE, CODIFIED *The* Enyclopedia, *created by France's Denis Diderot and a team of scholars, was published in Paris in 1751. At right, a page explains the process of laying tile*

READ ALL ABOUT IT The Spectator *was founded by Britons Joseph Addison and Richard Steele in 1711. Though short-lived, the journal spawned countless imitators*

CONFAB *Enlightenment thinkers were inspired by the fascinating new explorations into such natural phenomena as electricity that were characteristic of the time. Above is a sketch of Benjamin Franklin's "electrical apparatus," a rudimentary battery created by one of the leading figures of the Age of Enlightenment.*

At left, members of the Birmingham Jacobin Club gather to discuss projects to improve their British Midlands city. Many such voluntary groups of like-minded individuals were formed at this time. This group's members were self-made men of the rising middle class who operated outside the sphere of London power circles

EXECUTION, MECHANIZED *At left, France's queen, Marie Antoinette, is beheaded by the guillotine. Estimates of those executed in this fashion now run from 17,000 to 20,000. At right, a contemporary engraving portrays the arrest of King Louis XVI and Marie Antoinette on Aug. 10, 1792*

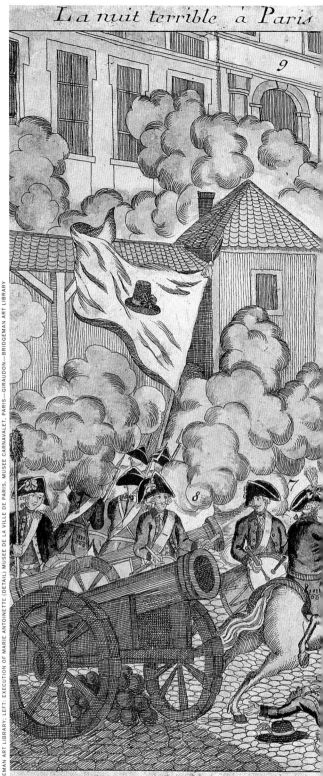

In France, Revolution Devolves into Terror

45 At the end of the 18th century, France was ripe for revolution. Here was a deeply stratified society: its intellectuals had helped spark the Enlightenment, but the vast majority of its people lived in poverty and squalor, while a small minority of wealthy nobles, landowners, Church leaders and royals enjoyed lives of conspicuous languor and waste. At the apex of this pyramid scheme of inequality was King Louis XVI. An estimated one-tenth of the kingdom's wealth was spent every year in upkeep for his over-the-top palace at Versailles, outside Paris. At the base of the pyramid were *les misérables,* millions strong and deeply affected by the wave of excitement that swept the world as the cause of freedom and equal rights for all defeated society's old order in the American Revolution.

Toss in government debt, high taxes and a severe shortage of food, and something had to give. In a single year, 1789, a series of events lit rebellion's torch. In May, the uneasy King summoned a rare meeting of the legislature, the Estates-General. In July, Parisians attacked a government fortress, the Bastille. In August, the Estates-General, now calling itself the National Assembly, defied the King and passed the Declaration of the Rights of Man and of the Citizen, calling for an end to royal authority and the recognition of universal equality and human rights. In 1792 the French Republic was proclaimed; in 1793 the King was executed. Foreign enemies, fearful of the contagion of revolution, threatened France, and the revolution's energies were diverted into foreign wars. Back at home, the intense political passions unleashed by the revolution gave birth to the Reign of Terror, as mass executions at the newly invented guillotine culminated with the beheading of Maximilien Robespierre, the radical behind the Terror. The hated old regime's authority had been forever overthrown, but the specter of mob rule has tainted the glory of France's revolution down through history.

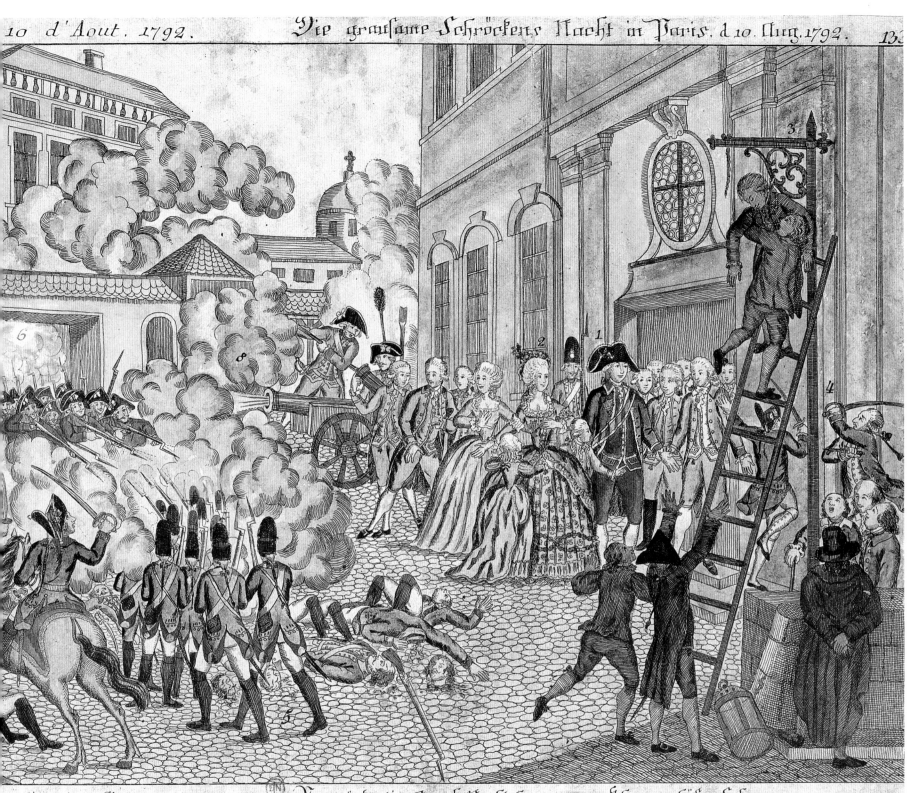

audité des Clups
on le dethronise!
ssemblée Nationale; et cherche.
ageuse, s'ecrie sans peur.
rcés la!
, de mes enfans.
anterné,
é et delivré de leur rage.
onna, le tocsin, et tout fut allarmé.
ge vers le château
toute la ré si stance.
etoient perdus,
nons,
pargne rien.

Nun rückt die Greuel Nacht heran, der Klappen böse Schaaren,
Schreyt frech man setz den König ab, sie toben wie Barbaren.
1. Der König flieht zur Nation, sucht Rettung für sein Leben.
2. Die Königin aber ganz beherzt, ruft ohne furcht und beben.
Hier ist die Brust, was schuldig bin, Nimt Dolch sie durch zu bohren.
Nur den Gemahl und Kinder laßt, am Leben ungeschohren.
Ein Mitglied von der Nation, wird schon 3 Laternisiret.
Doch noch zu rechter Zeit errett, und ihrer Wuth entführet.
4. Der Guarde Hauptman selbst verwundt, Gelitten, Lerm geschlagen,
Und die 5. Marseller fiengen an, aufs Schloß voll wuth zu jagen,
Ihm gienge das Gemetzel an, und alles wiederstehen "
Der Tapferen 6 Schweizer half hier nichts, Sie musten untergehen.
Es eilt die 7 Reuterey herbey man richtet die 8 Kanonen,
Man plündert, Thuillies steht im Brand? Kirk, nirgends war kein schonen.

73

A Radical Voice Calls for Women's Equality

46 The enlightened gentlemen who challenged the established order in the liberating Age of Reason failed to note a singular contradiction: the era's appeals for universal rights for human beings omitted one-half of those beings. That's a large oversight, but it reveals the extent of the social and legal inequalities that had been women's lot in almost every human society up to that time. In 1792 a headstrong, idealistic young British woman, Mary Wollstonecraft, fired the first salvo in what would become a long march to women's equality when she published her seminal call to arms, *A Vindication of the Rights of Woman.* Wollstonecraft had served as a tutor to well-born children before deciding to support herself by her writing, a brave show of independence at the time. Her book argued that women had been systematically oppressed through history, primarily by being denied the benefits of education.

Wollstonecraft's manifesto met with a mixed reception. But after she died 11 days after giving birth to her second child in 1797, her husband, William Godwin, published a biography of his wife that proved far too frank for its time. He chronicled her deep feelings for two close female friends, her passionate affair with an American lover and the illegitimate birth of their child, as well as her suicidal tendencies. All in all, the revelations tainted Wollstonecraft's ringing assertion of rights for women, and progress in this area would not come for centuries. But the alarm had been sounded.

PIONEER *Wollstonecraft, painted by John Opie in 1797. Her call for equality reflected Enlightenment ideals, while her personal life reflected the passions of a new Romantic era that emphasized personal liberation*

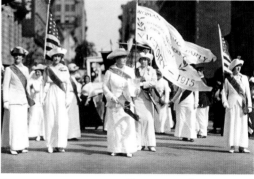

DEMONSTRATING *U.S. suffragists parade in New York City in 1915; they would win the right to vote in 1920*

Marching for Women's Rights

1792 Wollstonecraft publishes *A Vindication of the Rights of Woman.* It is a sequel to her 1790 polemic *A Vindication of the Rights of Men,* written in sympathy with the French Revolution. She also travels to France, where she has a passionate affair with American Gilbert Imlay, by whom she would have an illegitimate daugher.

1848 Some 300 American women (and men) meet at the Seneca Falls Convention in upstate New York and issue The *Declaration of Sentiments,* calling for equal rights for women, including the right to vote.

1869 U.S. women form the National Woman Suffrage Association and begin lobbying for a constitutional amendment to grant women the right to vote.

1906 Finland becomes the first European nation to extend full voting rights to women.

1920 The 19th Amendment to the U.S. Constitution guarantees American women the right to vote.

1928 Women are awarded the franchise in the U.K., following decades of protests by suffragists.

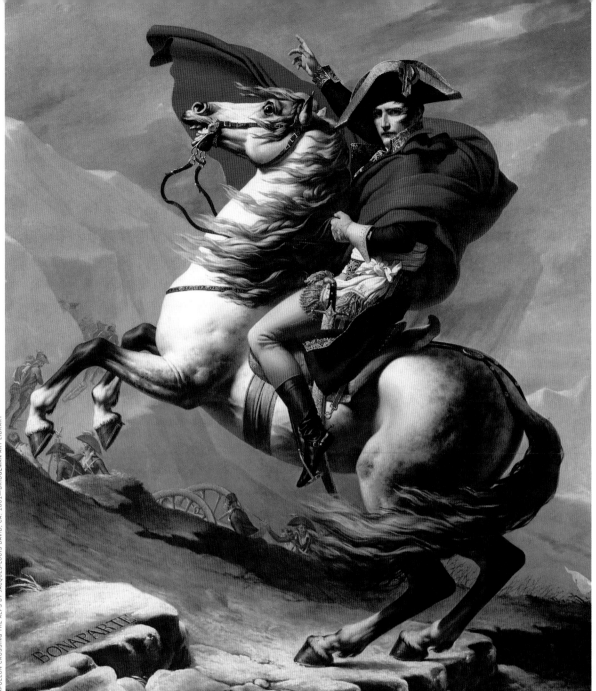

NAPOLEON CROSSING THE ALPS BY JACQUES-LOUIS DAVID, CA. 1801—BRIDGEMAN ART LIBRARY

CHARGE! *Jacques-Louis David's painting of* Napoleon Crossing the Alps *before the Battle of Marengo in 1800, in which his armies again beat those of Austria, is one of history's great works of propaganda art. In Napoleon, the Age of Englightenment met the will to power: he took hundreds of natural scientists with him on his campaign in Egypt, aimed at asserting a French presence in a British-controlled region*

A Tumultuous Time Forges a Leader: Napoleon

47 Nature abhors a vacuum. So it's not surprising that as the French people were caught up in a bloody whirlpool of revolution from which they seemed unable to escape, a strongman emerged to fill the void in leadership. Napoleon Bonaparte was one of history's originals, a man of great capacities who created his own destiny, rising from an uneventful boyhood on the island of Corsica to become the unquestioned ruler of Europe. Short but self-confident, charismatic in his intellect and exercise of leadership, he became a brilliant field general who was beloved by his men. He was also a classic man on horseback who bears comparison with Alexander the Great, Julius Caesar and Adolf Hitler in his pride, ambition and accomplishments, all well served by his sheer power of command.

His rise was phenomenal, its speed intensified by his troubled times. After the young military man distinguished himself by ending a British siege of Toulon in 1793, he was summoned to Paris, where his alacrity in putting down a royalist uprising in October 1795 led to his appointment as a general in a French campaign against Austria. Brisk, inspiring and decisive, he led his army to victory over the Austrians in northern Italy, then moved into Austria itself: soon, France controlled northern Italy, the Papal States, Venice and much of the Netherlands. After leading a French expedition to Egypt that proved a dead end, Napoleon returned to Paris, where, in a series of deft political maneuvers, he became First Consul, the unquestioned ruler of France. Rule suited him, he found—so much so that in 1804 he crowned himself Emperor of France, while the Pope stood by. Europe was on notice: from the blood of a revolution gone awry, Napoleon had made France the Continent's greatest power.

Lewis and Clark Open the American Frontier

48 It's bracing to recall that little more than 200 years ago, the western frontier of the U.S was the Mississippi River. Beyond it lay—well, what? That question suddenly demanded an answer, for in 1803 President Thomas Jefferson had concluded the Louisiana Purchase, acquiring 800,000 sq. mi. of territory west of the Mississippi from Napoleon's France. Jefferson, a man of the Enlightenment, was brimming with curiosity. What new flora and fauna might be discovered on an expedition that would chart these uncharted lands? What new Indian tribes might be encountered? And how would the Mexicans in the Southwest and the British, who claimed land in the Pacific Northwest, respond to U.S. expansion?

Jefferson longed to be the Adam who would name the wonders of this new Eden, but, otherwise engaged, he chose his aide Meriwether Lewis to lead the Corps of Discovery. Lewis, scholarly, brooding and urbane, in turn called on his friend William Clark, a genial outdoorsman, to accompany him. The explorers embarked from St. Louis with a party of some 45 hale young men on May 14, 1804. Clark's black slave, York, was among them; he would fascinate the Indians they encountered. Their journey took them across the Great Plains to the Pacific Coast in today's Oregon; a young Shoshone woman, Sacagawea, served as an essential pathfinder for much of the journey. When they returned to St. Louis, on Sept. 23, 1806, after 28 months of hardship and hardtack, buffaloes, butterflies and buttes, the West had passed from fable to fact. America's continental destiny was ensured.

UNSPOILED *The Corps of Discovery traveled into the West via waterways like this one, now called the Clark Fork river, in today's Montana. At left is a typical page from one of the 13 journals scrupulously kept by Lewis and Clark. They sent Jefferson specimens from their journey, which he later proudly displayed at his home in Virginia, Monticello*

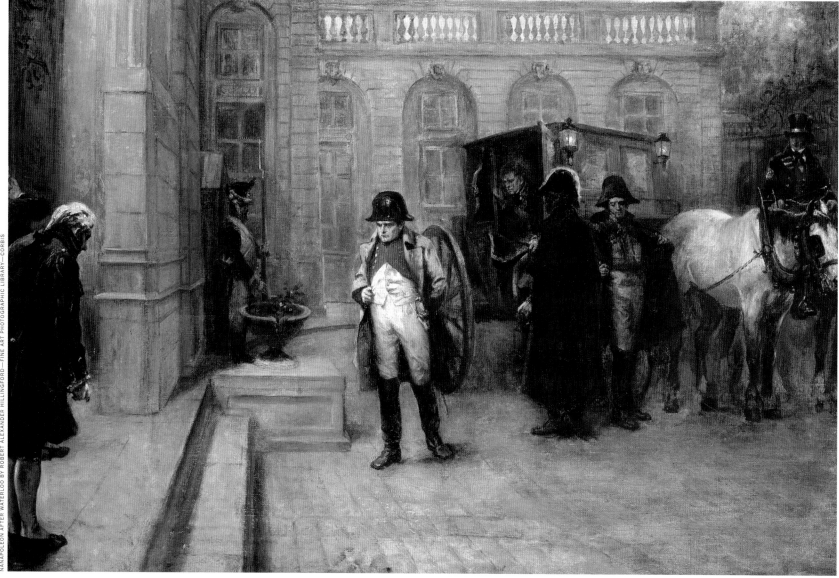

LAST BOW *British artist Robert Alexander Hillingford painted a dejected* Napoleon After Waterloo *in the mid-19th century, decades after the leader's fall*

Napoleon Is Defeated and Leaves the Stage

49 "The crowd that follows me with such admiration," Napoleon once opined, "would run with the same eagerness were I marching to the guillotine." Indeed, by 1804, when he crowned himself France's Emperor, all Europe was divided into two camps, Napoleon's admirers and his detractors. One suspects the great man didn't really mind which side one took, as long as he was the center of attention. His career was as divided as its observers: his enemies denounced him as a power-mad despot, yet he hewed to many Enlightenment principles. His Napoleonic Code, widely enforced across Europe, was a major advance in the social contract, and he gave strong support to science and the arts.

A series of foreign coalitions tried to dislodge Napoleon's grasp on power, but his mighty and progressive war machine kept racking up victories in the first decade of a new century. His dreams of empire carried him too far in 1812, when he launched a massive invasion of Russia that ended in the defeat of his Grand Army. He was beaten at last by a Prussian-Austrian-Russian-Swedish coalition at the Battle of Leipzig in 1813; the next year he was forced to abdicate and was sent into exile. In a fascinating endgame, he soon escaped, mustered an army once more and seemed prepared to dominate Europe again, until defeat by a British-led coalition at the Battle of Waterloo in today's Belgium in 1815 ended his brilliant career. He would die in exile in 1821, at only 51. Love him or hate him, he had forced Europe to enter a new, more modern age, closing the door on the 18th century.

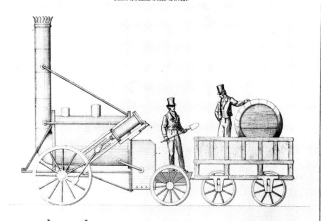

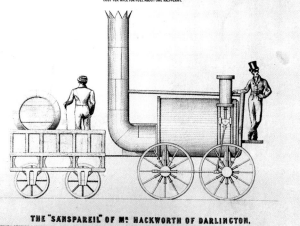

1829.

GRAND COMPETITION

of

LOCOMOTIVES

on the

LIVERPOOL & MANCHESTER RAILWAY.

STIPULATIONS & CONDITIONS

On which the Directors of the Liverpool and Manchester Railway offer a Premium of £500 for the most improved Locomotive Engine.

I.

The said Engine must "effectually consume its own smoke," according to the provisions of the Railway Act, 7th Geo. IV.

II.

The Engine, if it weighs Six Tons, must be capable of drawing after it, day by day, on a well-constructed Railway, on a level plane, a Train of Carriages of the gross weight of Twenty Tons, including the Tender and Water Tank, at the rate of Ten Miles per Hour, with a pressure of steam in the boiler not exceeding Fifty Pounds on the square inch.

III.

There must be Two Safety Valves, one of which must be completely out of the reach or control of the Engine-man, and neither of which must be fastened down while the Engine is working.

IV.

The Engine and Boiler must be supported on Springs, and rest on Six Wheels; and the height from the ground to the top of the Chimney must not exceed Fifteen Feet.

V.

The weight of the Machine, WITH ITS COMPLEMENT OF WATER in the Boiler, must, at most, not exceed Six Tons, and a Machine of less weight will be preferred if it draw AFTER it a PROPORTIONATE weight; and if the weight of the Engine, &c. do not exceed Five Tons, then the gross weight to be drawn need not exceed Fifteen Tons; and in that proportion for Machines of still smaller weight—provided that the Engine, &c. shall still be on six wheels, unless the weight (as above) be reduced to Four Tons and a Half, or under, in which case the Boiler, &c., may be placed on four wheels. And the Company shall be at liberty to put the Boiler, Fire Tube, Cylinders, &c., to the test of a pressure of water not exceeding 150 Pounds per square inch, without being answerable for any damage the Machine may receive in consequence.

VI.

There must be a Mercurial Gauge affixed to the Machine, with Index Rod, showing the Steam Pressure above 45 Pounds per square inch; and constructed to blow out at a Pressure of 60 Pounds per inch.

VII.

The Engine to be delivered complete for trial, at the Liverpool end of the Railway, not later than the 1st of October next.

VIII.

The price of the Engine which may be accepted, not to exceed £550, delivered on the Railway; and any Engine not approved to be taken back by the Owner.

N.B.—The Railway Company will provide the ENGINE TENDER with a supply of Water and Fuel for the experiment. The distance within the Rails is four feet eight inches and a half.

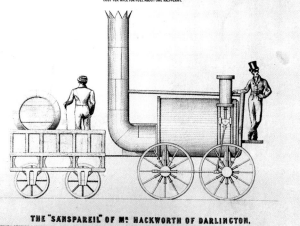

TOP: HULTON ARCHIVE—GETTY IMAGES; BOTTOM: THE LAST OF THE COACHES—NATIONAL RAILWAY MUSEUM—SSPL—GETTY IMAGES

Stephenson's *Locomotion* Revolutionizes Travel

50 With the advent of the Industrial Revolution, there is an unmistakable sense of acceleration in the pace of human life and events. The new technologies of the era suggested to many that humanity was now rushing pell-mell into the future. In the first decades of the 19th century, two remarkable new technologies, the railroad and the telegraph, combined to drive this novel, powerful pulse of energy. As scholar Daniel Walker Howe observes of these "twin revolutions" in his Pulitzer-prize-winning study of the U.S. at this time, *What Hath God Wrought* (Oxford; 2009), "Their consequences certainly rivaled, and perhaps exceeded in importance, those of the revolutionary 'information highway' of our own times."

British inventor Richard Trevithick was the first man to put a steam engine on tramways in mines. But the man who can be considered the father of the railroad was George Stephenson, a can-do mechanical engineer from outside Newcastle-upon-Tyne. Stephenson replaced the wooden rails on old tramways with stronger, flanged iron rails, and he solved the problem of the locomotive's excessive weight by putting more wheels beneath it to distribute the load. On Sept. 27, 1825, his new engine, dubbed *Locomotion,* hauled an 80-ton load nine miles in two hours, reaching a speed of 24 m.p.h. on one stretch. Adding to its burden were a batch of dignitaries and friends of Stephenson, enjoying the view from the world's first railway passenger car, the *Experiment.*

What had Stephenson wrought? His new technology created subsequent revolutions in commerce, city life, travel and warfare. The world no longer moved at the clip-clop pace of the power of one horse—though the echoes of that earlier, more placid age endure in the name we still use to measure motive power.

OLD AND NEW *Amid a transportation revolution, a mail coach, clearly a relic from a previous age, is put on rails in this circa 1850 lithograph. Above is a newspaper account of the sort of event that earlier became a fad in Britain: a contest between locomotives*

79

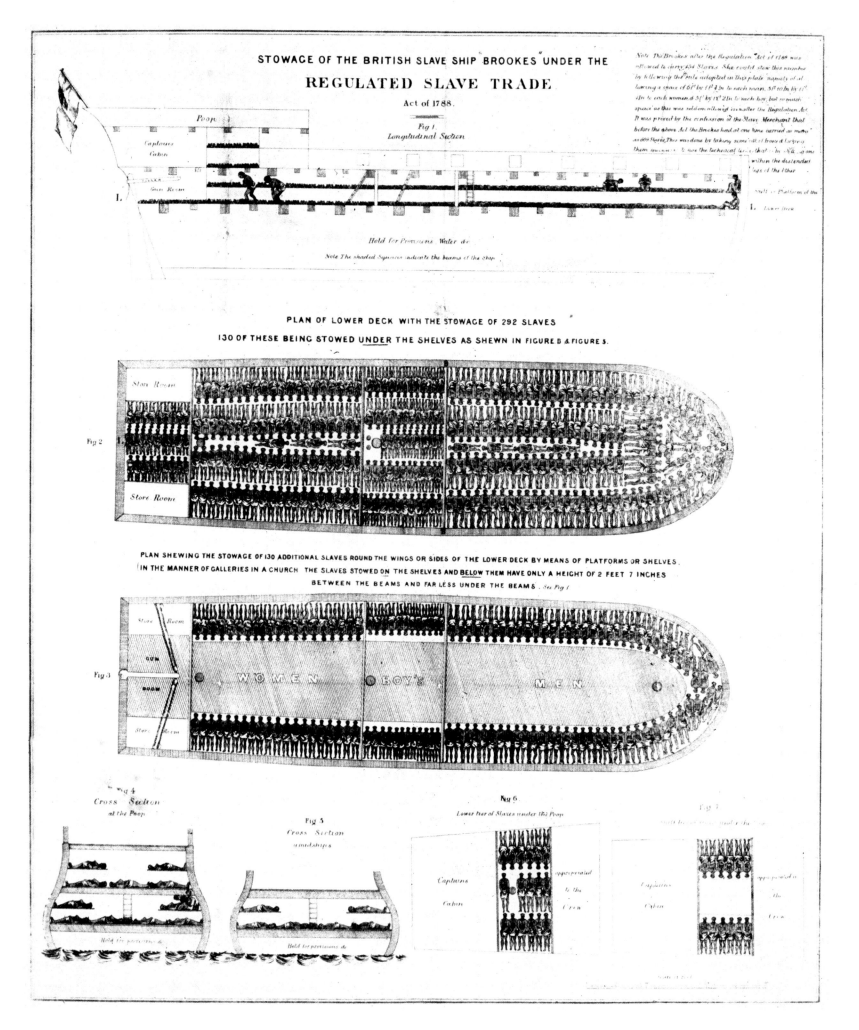

STOWAGE OF THE BRITISH SLAVE SHIP "BROOKES" UNDER THE

REGULATED SLAVE TRADE

Act of 1788.

PLAN OF LOWER DECK WITH THE STOWAGE OF 292 SLAVES

130 OF THESE BEING STOWED UNDER THE SHELVES AS SHEWN IN FIGURE D & FIGURE 5.

PLAN SHEWING THE STOWAGE OF 130 ADDITIONAL SLAVES ROUND THE WINGS OR SIDES OF THE LOWER DECK BY MEANS OF PLATFORMS OR SHELVES.
IN THE MANNER OF GALLERIES IN A CHURCH THE SLAVES STOWED ON THE SHELVES AND BELOW THEM HAVE ONLY A HEIGHT OF 2 FEET 7 INCHES
BETWEEN THE BEAMS AND FAR LESS UNDER THE BEAMS. Se Fig 1

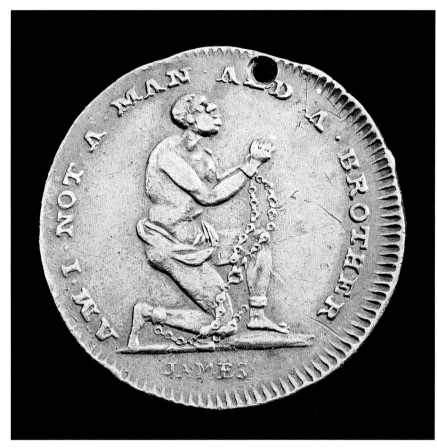

HORROR AND HOPE *The medal above, which became an icon of the abolitionist movement, was issued in 1787 by famed British ceramicist and industrialist Josiah Wedgwood. The illustration on the facing page shows how human cargo was organized on British slave ships*

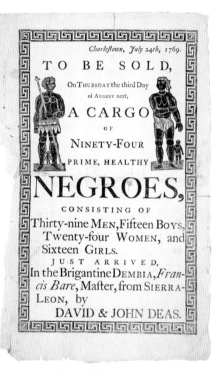

FOR SALE *A broadside advertises a slave auction in 1769 in Charleston, S.C.*

Abolitionists Begin to Outlaw Slavery

51 "It may seem strange," Abraham Lincoln observed in his Second Inaugural Address in 1865, "that any man should dare to ask a just God's assistance in wringing their bread from the sweat of other men's faces ..." Perhaps, yet for the vast majority of recorded history, this truth was not self-evident. Many humans felt no shame in buying and selling other humans, in treating them as inferiors, in forcing them to work for no wages and in raping female slaves. This system of oppression was enforced through fists, whips, chains, clubs and executions; it was widely recognized in constitutions and legal documents; it was sanctioned from hundreds of pulpits.

Slavery is as old as civilization; indeed much of civilization was built by the work of slaves. It most often has been based upon racial and ethnic discrimination, intensifyng its corrosive power in human affairs. For centuries the business of slavery was centered in Africa, where vicious traders conducted extensive raids into the interior and returned to the coast to ship human chattels to hundreds of ports across the world. But as Enlightenment figures began to assert the radical notion that all men are created equal, slavery came under attack around the globe. In the U.K., William Wilberforce led a successful campaign to abolish slavery across the British Empire. In the U.S., the "peculiar institution" was so deeply rooted in Southern culture that it took a deadly civil war to bring it to an end.

Slavery has never entirely disappeared, but it has mutated. As of 2009, the United Nations estimated that more than 5.7 million children worldwide were being held in debt bondage, while an estimated 1 million girls each year were being forced into lives of prostitution as sexual slaves; these are the dominant modern manifestations of human slavery.

Slavery's Decline and Fall

1794 The controlling Revolutionary party, the Jacobins, outlaws slavery in France.

1807 Goaded by William Wilberforce and fellow abolitionists, Britain's Parliament outlaws the slave trade in most parts of the British Empire. Slavery itself would finally be outlawed by the Slavery Abolition Act of 1833.

1861 Russia's Czar Alexander II frees his nation's serfs. These peasant farmworkers were not technically slaves, but they owed a feudalistic allegiance to the czar.

1863 U.S. President Abraham Lincoln issues the Emancipation Proclamation, setting free all slaves not under control of the Union and its forces in the Civil War.

1865 Slavery is specifically outlawed in America by the 13th Amendment to the U.S. Constitution.

1948 Slavery is expressly forbidden by the United Nations in the Universal Declaration of Human Rights.

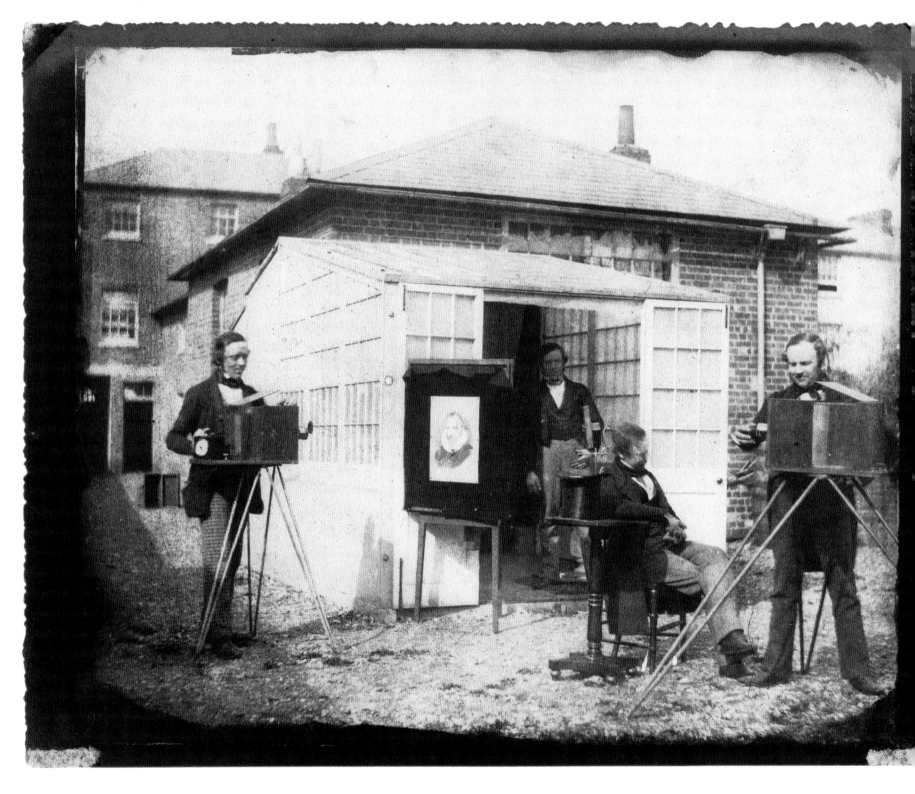

Photography Stops Time to Document Reality

52 In the 19th century, an army of inventors and tinkerers began turning the groping, often inchoate explorations of pioneering 18th century scientists into exciting new technologies. One such breakthrough was photography, an outgrowth of experiments into light-sensitive chemicals. The first master of the new medium was a retired French army officer, Joseph Niépce. In 1826 he combined a camera obscura—an optical device already known for centuries whose convex lens captured an image in a box—with a pewter plate covered with bitumin, a light-reactive material. Result: an image of outbuildings and a pear tree in his courtyard. Soon Niépce joined forces with painter and theatrical designer Louis-Jacques-Mandé Daguerre, who improved and

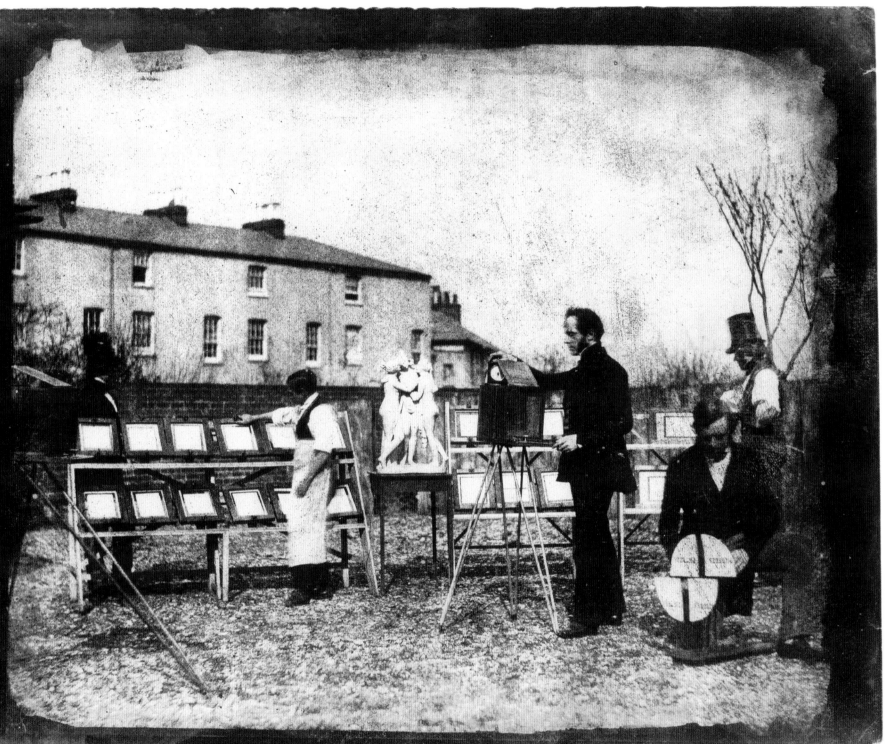

EXPOSURES *Photography was a medium capable of recording its own development. Above, photo pioneer Talbot, standing at right with camera, works with assistants outside his studio in Reading, England, in 1846*

shortened Niépce's process in 1839 by using different mixtures of chemicals to coat the plates and register the patterns of light. Daguerreotype photographs quickly became a popular rage in Europe and America. Yet photography was not yet fast enough to capture movement; Daguerreotype subjects generally look severe because their facial expressions had to be held unchanged if their faces were to register clearly.

Daguerre's rival in the early days of photography was a Briton, William Henry Fox Talbot, who was first to expose photos on paper rather than metal. Even more important, he invented the process of shooting negative images, in which light and dark areas are reversed, allowing for the printing of an unlimited number of positive duplicates. Freezing time in its flight, photography offered a new way to record reality. The development of this potent new form of communication is one of history's great dividing lines. No longer would we have to conjecture about the look of the past; an unblinking eye was now trained upon it.

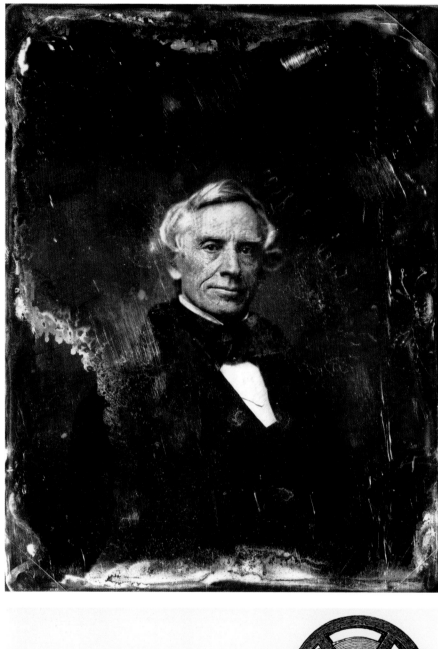

The Telegraph Erases Distance

53 Throughout history, time and distance had imposed strict limitations on human endeavor. But in the 19th century, both these seeming absolutes began to yield to the power of new technologies.

Photography defied time to record the flow of life, preserving a record of the past for citizens of the future. And when railroads came along, their speed abolished old limitations on travel: for the first time, humans could cover a distance faster than the fastest horse could carry them. These trends were accelerated near the midpoint of the century, when a clutch of innovators across the globe worked to perfect a new form of communication that quickly revolutionized human affairs: the telegraph.

The idea of speedy long-distance communication was not new: Napoleon had employed chains of semaphore stations to transmit messages. Now inventors vied to send messages in the form of electrical current moving over a wire. Aided by increasing understanding of the flow of electricity, including advances in electromagnets and relay switches, European inventors—led by Germans Baron Paul Schilling and Carl Gauss and Britons William Cooke and Charles Wheatstone—succeeded in transmitting messages in the form of electrical currents. In an early example of how the new technology abolished distance, a murder suspect was apprehended in 1845 after a telegram using the Cooke-Wheatstone system outpaced the train he was riding on, alerting authorities to his arrival.

In America, the telegraph was co-developed by Samuel F.B. Morse and Alfred Vail, whose electromagnets boosted the power of the current and who developed the famed dot-dash code to represent the alphabet (some early European telegraphs used one wire for each letter). In 1844 Morse transmitted a message from the U.S. Supreme Court chamber in Washington to Baltimore, the stately biblical quote WHAT HATH GOD WROUGHT. We prefer the test message sent in 1846 by engineers opening the first commercial telegraph line in the U.S., set up along a railway right-of-way in Pennsylvania: WHY DON'T YOU WRITE, YOU RASCALS?

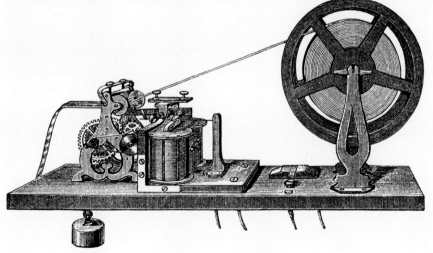

INSTANT MESSAGES *At top, inventor Morse holds still for a fashionable Daguerreotype portrait. At bottom, an 1843 wood engraving of a Morse/Vail telegraph; in early versions, the system recorded impulses on tape, but operators soon learned to "read" the series of clicks by ear*

Europe's Also-Rans Erupt in a Year of Revolutions

54

Seventy-two years after Thomas Jefferson's stirring call for universal human rights in the American Declaration of Independence and 59 years after the overthrow of the monarchy in the French Revolution, the ordinary citizens of Europe were still too busy pursuing bread to pursue happiness. Their mingy lives offered scant liberty and little equality.

But, increasingly, they had fraternity. And, in a single year, 1848, they rose up again to protest their lot, serving notice on the powers that be—monarchs and legislators, prelates and nobles—that their lot was unacceptable. They were revolting against both the old order and the new, for this was an age when technology was outpacing society. Life was rapidly urbanizing, but the new factory systems didn't pass along their benefits to all. Increased literacy and cheap newspapers opened minds; authority figures closed them. Now everyday citizens demanded the right to vote, the exercise of free speech and free assembly, a larger share in the profits they helped create. The revolutions began in Sicily and France: by year's end they had rocked Denmark, Austria, Hungary, Swizerland and the various states of Germany and Italy. The rebels won some battles and lost others, but they had sounded the alarm: change must come.

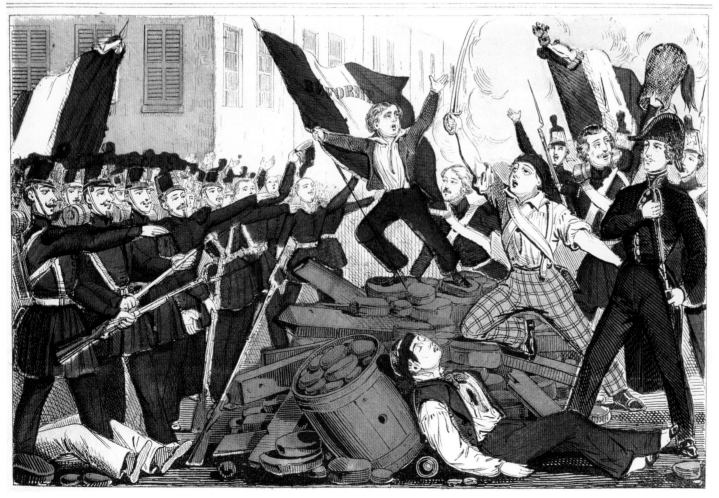

RÉPUBLIQUE FRANÇAISE.

Combat du peuple parisien dans les journées des 22, 23 et 24 Février 1848.

ONCE MORE UNTO THE BARRICADES *A contemporary poster shows Parisians battling government troops in February 1848*

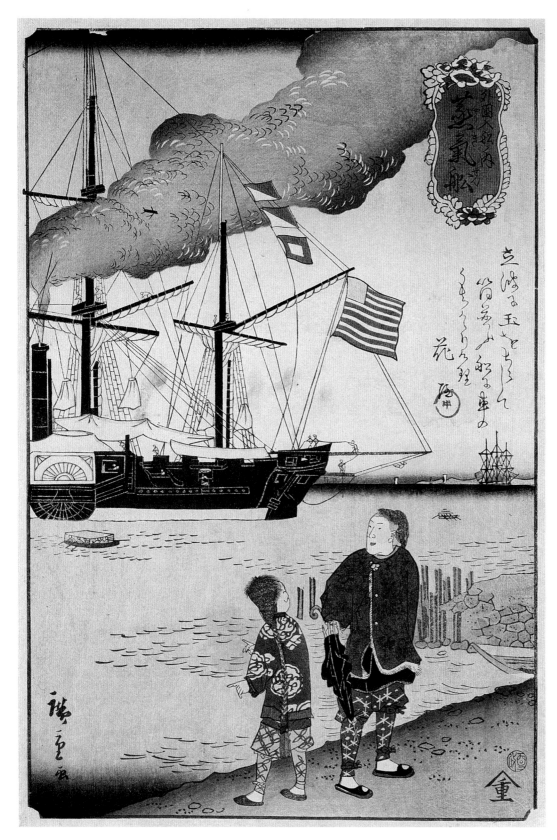

PACIFIC OVERTURES *An 1861 woodcut shows U.S. ships in a Japanese harbor. The Japanese envied Western technology, while Americans and Europeans were fascinated by Japan's exotic arts and feudal culture*

Japan Opens Its Doors To the Western World

55 Perhaps no people have experienced such a high degree of culture shock as did the Japanese in the last half of the 19th century. For more than 200 years, under the policy of *Sakoku,* the rulers of the Tokugawa shogunate kept the island chain in hermetic isolation, limiting foreign trade to direct dealings with a few specific traders from China and the Netherlands at tightly restricted "gateways." Few Japanese were allowed in these precincts and all were forbidden to leave the country, so Japanese citizens had little knowledge of the outside world—and the outside world had little knowledge of Japan. That was the idea, for the nation's rulers deeply feared the cultural imperialism they observed across Asia, where Spanish and Portuguese missionaries eagerly pursued converts to Christianity. Many attempts to open Japan to trade, beginning in the late 18th century, had failed.

Then, in a hurry, Japan collided with the modern world. On July 8, 1853, U.S. Admiral Matthew Perry sailed a fleet of four warships into Tokyo Bay; their big guns provided a convincing show of force. In the next few years, Japan signed the Treaty of Kanagawa (1854) and the Treaty of Amity and Commerce (1858), which granted the U.S. access to Japan, on unequal terms. The shogunate's worst fears had been confirmed, and its weakness, now exposed, soon brought it down.

A new era, the Meiji Restoration, began in 1868. The nation's new rulers, refusing to accept subordination to the West, left Japan's feudal ways behind. They downgraded the samurai class, sponsored rapid industrialization, instituted land reforms, built a modern military and nursed imperial dreams of their own. Eighty-eight years after Perry's 1853 show of force, a militant Japan returned the favor, leaving its calling card at Pearl Harbor.

Forging the Spine of a New Age

56

Human history is made of metal. From the Copper Age to the Bronze Age to the Iron Age, one of mankind's defining characteristics—the ability to make tools—has been driven by advances in metallurgy. One such great leap forward came in 1856 when prolific British inventor Henry Bessemer perfected a process for refining iron into steel inexpensively.

Bessemer's breakthrough was driven by the accelerating demands of industry. Iron, the sturdy building material of the early phase of the Industrial Revolution, was proving to be not strong enough to carry the burdens that engineers were placing upon it, as a succession of bridge collapses in Britain proved. Steel—stronger, purer and far more durable—was the metal of the future, but it was cumbersome and expensive to produce. Bessemer's new converting system solved that problem. By blowing a powerful blast of air through molten pig iron, his process oxidized the weakening impurities that distinguish iron from steel while the steel was forming. Previous systems had involved a dangerous operation in which impurities floated to the surface of molten iron as slag and had to be skimmed away.

The Bessemer converter became the workhorse of a dynamic new era of progress. Strong, affordable steel became the essential building block of the skyscraper, the automobile, the railway and highway bridge and the modern city. Bessemer's own city, Sheffield, became known as Britain's "Steel City" and long prospered as a result.

HOT! *In this 1876 engraving, a converter at top is burning off impurities to refine iron into steel. Below, molten steel is poured into molds to cool and form ingots*

A Skull Expands Our Vision of the Past

57

Quarrying for limestone on a summer day in 1856, German workmen had blasted open a small cave on the side of a gorge called Neanderthal (Neander Valley), near Düsseldorf, and were digging up the cave floor with pickaxes when they came upon a strange skull and sturdy bones. Setting the skeletal remains aside, they kept digging, never dreaming that their discovery would spark confusion, dismay and debate.

The discovery of a new human species that was not in the line of modern man, *Homo sapiens,* confounded Victorian scientists. At the time, Charles Darwin had not yet published *On the Origin of Species,* and evolution was still only a hazy conjecture among a handful of scientists. Along with Darwin's theories, and the ongoing discovery of the fossilized bones of ancient animals—named dinosaurs, or "terrible lizards" by Briton Richard Owen in 1842—the discovery of the Neanderthals forced scientists to rethink the extended history of our species and our planet.

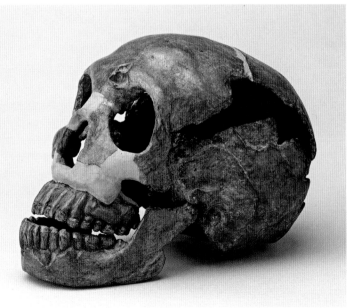

CRANIUM *This reconstructed skull of a Neanderthal,* Homo neanderthalensis, *shows the big jaw of this early hominid, whom scientists now say was far more intelligent than was once thought*

LOCAL COLOR *Unusual animals of the Galápagos Islands observed by Darwin include, clockwise from top left: blue-footed boobies, marine iguanas and Sally Lightfoot crabs, Great Frigate birds and Galápagos tortoises. Right, Darwin in later years*

Unveiling a New Blueprint for Life on Earth

58 It could have been no more than a lark, an upper-class British graduate's equivalent of the Grand Tour. But naturalist Charles Darwin's five-year voyage on a British cartographic ship, H.M.S. *Beagle,* which he began in 1831 when he was only 22, changed the face of modern science and our understanding of human existence. After stops to chart the coast of South America, the *Beagle* explored the Galápagos Islands, an isolated volcanic archipelago straddling the equator. It was there that Darwin noticed that each island contained identical species of finches whose beaks differed in size and structure. From this observation Darwin later extrapolated his theory of natural selection, the evolutionary process by which organisms with certain superior adaptive characteristics tend to survive and pass on those qualities. He continued this research when he returned to England, and in 1859 he released his magnum opus: *On the Origin of Species by Means of Natural Selection.*

Darwin's theories proved to be among history's most divisive ideas. Victorians mocked his argument that all species of life descended from common ancestors: Was his grandfather an ape? His arguments that survival favors the fittest spawned a host of bogus theories of eugenics and racial superiority, including those of Adolf Hitler. And because his premises do not posit God's hand in creation, they have been attacked for more than 150 years, most recently by advocates for faith who argue that this world shows all the hallmarks of "intelligent design," i.e., divine creation. Indeed, Darwin's ideas, now overwhelmingly accepted by scientists, helped create an enduring chasm between science and some religions: a 2005 TIME poll found that 54% of Americans did not believe that human beings had evolved from earlier species.

A Great Civil War Ends Slavery in America

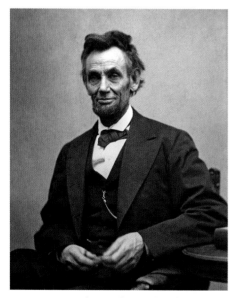

LINCOLN *A moderate who sought to heal wounds, he was shot dead just as the war ended*

59

To understand the four-year war that divided the U.S., driving 11 Southern states to secede from the Union and ending with their defeat—at a cost of an estimated 600,000 lives—consult the words of President Abraham Lincoln. In his Second Inaugural Address, delivered in 1865, he referred to the period before the war broke out, in April 1861, noting that "one-eighth of the whole population were colored slaves, not distributed generally over the Union, but localized in the southern part of it. These slaves constituted a peculiar and powerful interest. All knew that this interest was somehow the cause of the war." The South, said Lincoln, was fighting to "strenthen, perpetuate, and extend this interest"; the North was fighting to restrain it.

And fight they did, in a great conflict that ended with the debilitating defeat of the agrarian, lightly populated South at the hands of the superior technology and wealth of the far more populous North. In many ways, the war was a battle between old ways and new: valiant cavalrymen were tilting at locomotives; vast, sleepy, cotton-growing plantations were at war with the pulsing factories of the Industrial Revolution; slavery was battling emancipation. Lincoln framed the conflict in terms of the revolutionary ideas of Thomas Jefferson, saying that America had been founded in the radical notion that all men are created equal. "Now we are engaged in a great Civil War, testing whether that nation, or any nation so conceived and so dedicated, can long endure." Some sores still fester, even after 150 years, but the Union has endured.

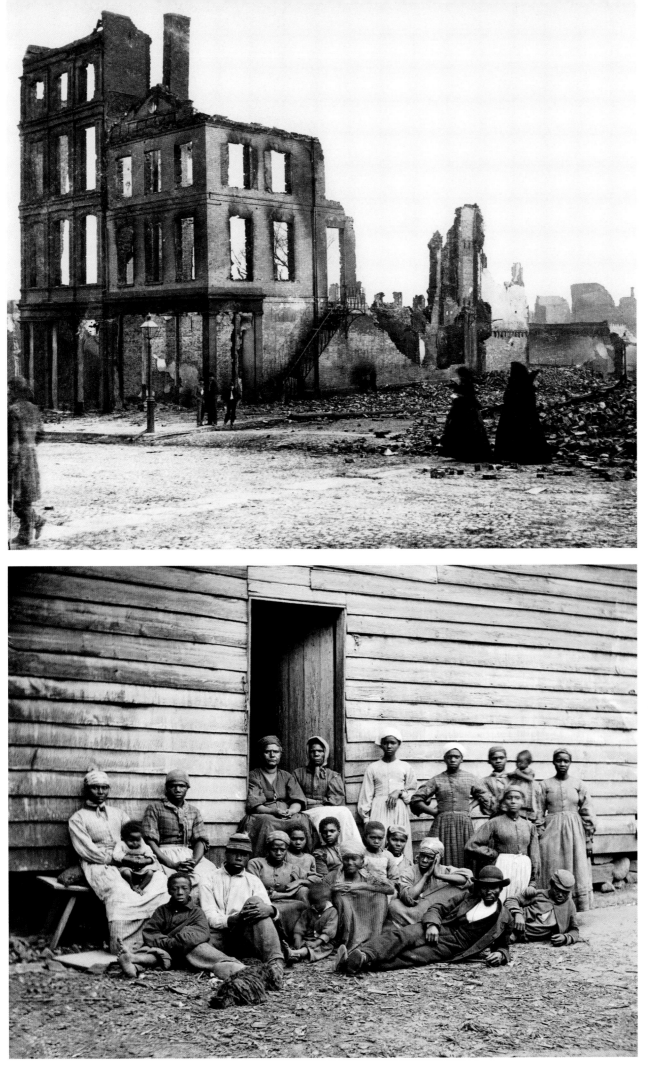

VICTORS, VANQUISHED, LIBERATED
At top left, Northern armies parade in victory in Washington D.C. after the South surrendered in April 1865. At top of right page, the South's capital city, Richmond, Va., was utterly devastated by Northern attacks, primarily in the last weeks of the war. The rival capital cities were located only 107 miles from each other. At left, slaves held in custody by Northern soldiers, considered "contraband" under the rules of the war, gather in Cumberland Landing, Va., in 1862

An Obscure Monk Divines The Mysteries of Inheritance

60 The great pioneer of genetic theory is Gregor Mendel, an Augustinian monk and natural-history teacher in Brünn (now Brno, Czech Republic), who began his revelatory experiments with peas in the monastery garden. Mendel found that the parent plants transmitted their characteristics to their descendants in a predictable, mathematical way. When purebred red-flowered peas, for instance, are crossed with white-flowered ones, all the seeds grow into plants with red flowers. But when these red hybrid plants are crossed with each other, one-fourth of their offspring bear white flowers. Mendel concluded that the reproductive cells of peas contain factors (now called genes) of two kinds: dominant and recessive. The gene for red-floweredness is dominant; the gene for white-floweredness is recessive.

Mendel's observations proved that inside the cells of plants—and presumably animals too—is a mysterious mechanism, incredibly small, that rules heredity in accordance with precise mathematical laws. In 1866 Mendel published a paper to this effect in the *Proceedings of the Brünn Society for Natural Science,* but nothing happened: the world was not ripe for his ideas. In 1868, when he was appointed abbot of his monastery, his scientific career came to an end. His work was rediscovered early in the 20th century, and its elegant simplicities gave birth to a fruitful new field of science.

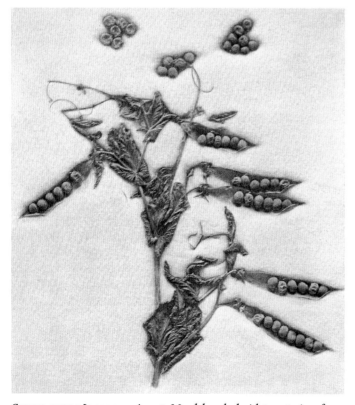

COLOR CLUES *In one experiment, Mendel worked with two strains of peas, yellow and wrinkled, at top left, and green and round, at top right*

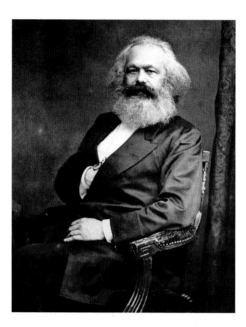

Marx Publishes *Das Kapital*

61 Surveying the global economic meltdown that brought nations to their knees in 2008 and '09, FORTUNE magazine's Peter Gumbel noted in TIME, "Hovering out there in the fog, unavoidably, is the towering specter of Karl Marx, the grandfather of political economists, whose damning critique of capitalism's inadequacies played an outsized role in world history for a century after his death in 1883." Marx's utopian predictions about the eventual triumph of socialism were dead wrong, Gumbel argued; indeed, the policies carried out in his name in the 20th century brought misery and death to millions in countries ranging from Russia to China and many more. But communism's grim history, said Gumbel, can obscure the trenchant analysis of the failings of a market-based economy that made Marx's voice so valuable.

A witness to the rapid industrialization of the 1800s, Marx was moved by glaring inequalities between rich and poor that are more topical than ever today. He thought work should bring personal fulfillment, and that labor should not be treated as a simple commodity—foreshadowing current debates over outsourcing and poor working conditions in developing countries. He wondered whether the middle class would be squeezed out of existence. And he identified how profits were taking an ever bigger share of the economy at the expense of wages, just as they are once again today.

The first volume of Marx's magnum opus, *Das Kapital,* was published in 1867. He did not live to complete the work; the last two volumes were edited by his colleague, Friedrich Engels, with whom he had published his great call-to-arms of class struggle, the *Communist Manifesto,* in a bellwether year: 1848.

CLASS ACT *Above, Marx in later years. He was moved by the plight of Europe's underpaid and relentlessly exploited workers, like these residents of the Glasgow slums, who were photographed in 1868 by Thomas Annan*

The Suez Canal Opens

62 For centuries, people with big dreams entertained a wild surmise: Could humans create a waterway to unite the Mediterranean Sea with the Red Sea? Such a channel would allow ships to pass from the Mediterranean into the Indian Ocean, avoiding the long, treacherous passage around the Cape of Good Hope in southern Africa and thus radically shortening travel time from Europe to East Africa, India and Southeast Asia.

History's great strivers—pharaohs, Roman rulers, Napoleon—dreamed of such a passage, even tried to create it. But all failed. It took a young French diplomat, Ferdinand de Lesseps, to get the job done. In 1858 he formed a private corporation, the Universal Co. of the Maritime Suez Canal, to create such a channel.

De Lesseps faced engineering challenges, constant funding woes and thorny diplomatic hurdles (Britain and Turkey opposed French control of the canal, though the British eventually helped operate it). But he prevailed, and on Nov. 17, 1869, the French yacht *Aigle,* with France's Empress Eugénie aboard, led a convoy of 46 vessels south from Port Said along the canal's 100-mile (160 km) length to meet Egyptian warships, steaming north, at Ismaïlia.

The canal is perhaps the foremost example of what today's scientists call geoengineering, the reshaping of the planet to suit human ends. Its opening accelerated both world trade and the European colonization of Africa. In 1956 Egypt's leader, Gamal Abdel Nasser, wrested control of the canal from France and England, and in the last weeks of the year, a statue of De Lesseps that had stood at Port Said for 60 years was dynamited by Egyptian nationalists. The era of European colonialism in the Middle East had passed.

POPPERFOTO—GETTY IMAGES

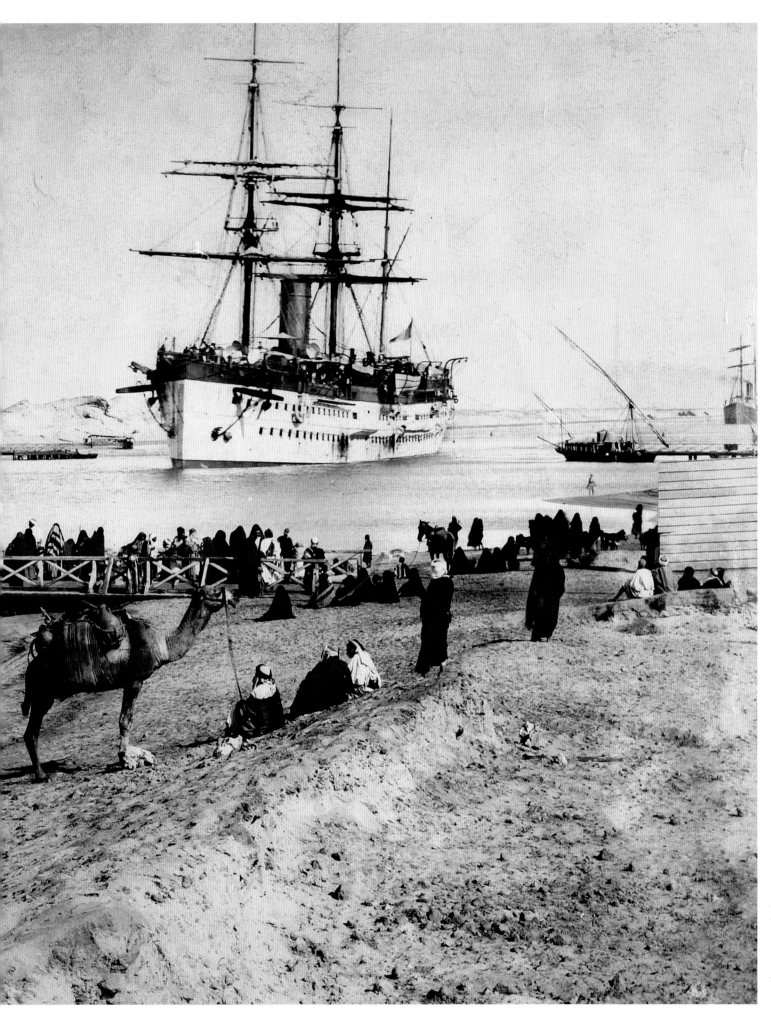

PASSAGES *In 1870, a year after it opened, the canal offered a portrait in the history of transportation, from the camel to the steamship. After Egypt took control of it in 1956, the canal continued to be a political flashpoint; it was closed for years after Arab-Israeli wars in the 1960s and '70s*

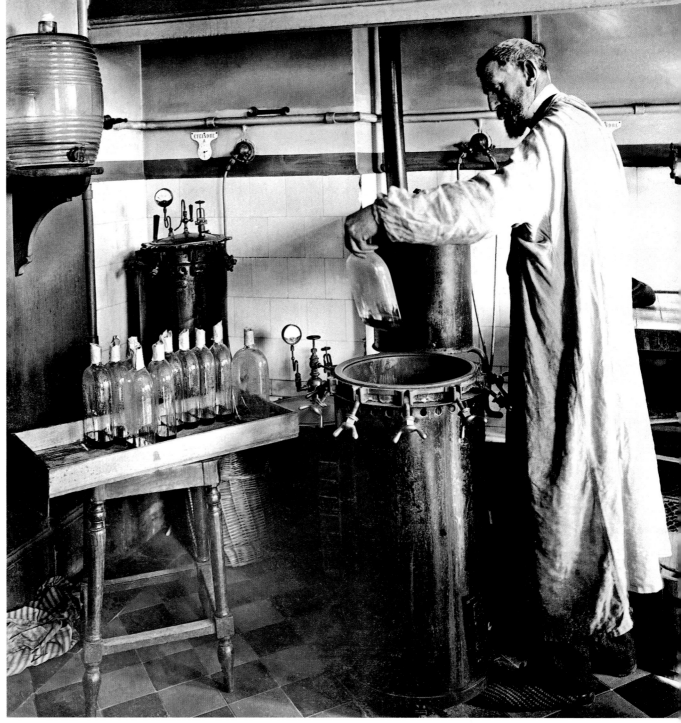

SMALL WORLD *At right, Pasteur in later years; he died in 1895 at 72. Below is a cholera bacterium, as seen through a modern electron microscope. Pasteur, more than any other scientist, awoke the world to the spread of disease by such bacteria. Allying himself with British surgeon Joseph Lister, Pasteur became a forceful and effective advocate of antisepsis in the practice of medicine*

Pasteur Confirms Germ Theory

 Born to a poor family in eastern France, Louis Pasteur grew up to become the explorer and cartographer of microscopic realms. He secured a place in the history of medicine as the chief creator of germ theory, as one of the pioneers of vaccination, as an advocate for antisepsis in hospitals and as the creator of the process to prevent spoiling in beverages that bears his name, pasteurization. He disproved the theory of spontaneous generation, the spurious belief, dating from the Greeks, that living matter can arise from inanimate matter.

Pasteur devoted himself to studying how diseases are caused and transmitted—and can be stopped from spreading. In the 1860s he conducted a series of experiments on sealed containers of beverages, confirming that the bacteria that infected them came from spores found in airborne yeast. These experiments ruled out spontaneous generation, even as they helped confirm germ theory. Realizing that microorganisms were responsible for the spoiling of milk, beer and wine, in 1864 he invented a heating process, now called pasteurization, to reduce their numbers. When an accident in his laboratory exposed chickens to bird cholera and made them immune to the disease, he developed a vaccine to do the same. Another of his vaccines was the first to prove effective against rabies. Yes, it was happenstance that led to his cholera breakthrough, but Pasteur had an answer for that. "Chance favors only the prepared mind," he declared.

Bismarck Unifies Germany

STRONGMAN *The "Iron Chancellor" in 1901; though he loved wearing uniforms, he was not a military leader*

64

The man who created modern Germany took his marching orders from the past. Otto von Bismarck, the Prussian who would force a loose coalition of Germanic states into a mighty new nation, the Second Reich, believed in the divine right of kings. He supported the monarchy when ordinary Prussians challenged it in one of the European revolutions of 1848. At the time, the wealthy young landowner opposed the call for the unification of Germany's small independent states, one of the rallying cries of the rebels. But as he moved up in the ranks of the Prussian legislature and then served as a diplomat in both Russia and France, Bismarck began to adopt the hard-headed realism that has been christened Realpolitik. Disdainful of the power of Austria and envious of the sheer might of Russia, France and Britain, he realized that Germany could only become their equal by uniting and thus beefing up its forces—in his stern phrase, "by iron and blood."

Appointed Prime Minister of Prussia in 1862, he used his gifts as diplomat and executive to force Germany's unification, with Prussia as its leading state. In 1866 he provoked and won a war with Austria, humiliating his ancient enemy and taking control of many of its holdings; in 1870 he led a successful war against France, gaining power over the region of Alsace-Lorraine. Bismarck had triumphed, and Germany had become the strongest nation on the Continent.

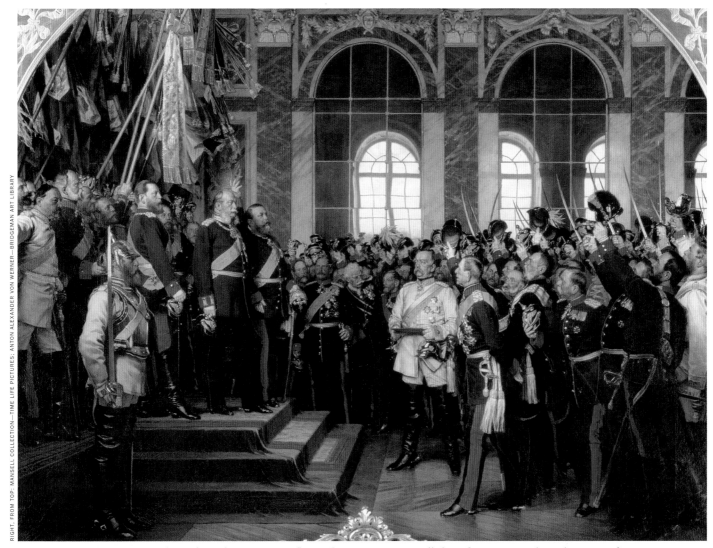

CROWNING MOMENT *Bismarck stands in white at center, reflecting his power, as King Wilhelm I of Prussia is proclaimed Emperor of Germany in 1871*

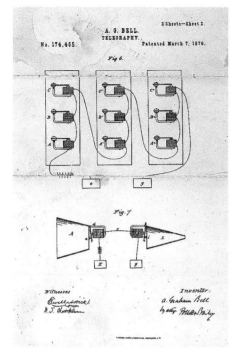

SOUND IDEA *Above is the design Bell filed in February 1876 for his prototype of a telephone, which he had not yet perfected. Note that he referred to this early version of a phone as an improvement in "telegraphy." At right, Bell opens the first long-distance line from New York City to Chicago in 1892. Phone technology improved rapidly—and continues to do so*

Bell Sends a Voice Through a Wire

65

As the power of electricity began to revolutionize every aspect of society, a new challenge beckoned: If telegraph wires could transmit pulses of electricity that formed messages, could the human voice be sent across a wire? The man who resolved that question, Scots-born Canadian Alexander Graham Bell, was a student of sound who had been a teacher of the deaf. He framed the problem to his assistant, Thomas Watson, in the spring of 1875: "If I can get a mechanism which will make a current of electricity vary in its intensity as the air varies in density when a sound is passing through it, I can telegraph any sound, even the sound of speech."

Bell solved the problem within a year: he first heard the sound of Watson plucking on a spring in the next room on June 2, 1875, but the two men could not consistently duplicate their success. Even so, Bell filed for a patent on his telephone design on Feb. 14, 1876, only hours before a close rival, Elisha Gray, filed his own request. Not long after, Bell made a breakthrough on the transmission of sound, finding that by immersing a wire in a conducting liquid to vary its electrical resistance, he could produce an undulating current that in turn could trigger a diaphragm to produce waves duplicating human speech. The familiar tale that the first phone message involved Bell's calling Watson after spilling battery acid is probably apocryphal, but Watson did hear Bell's voice over a wire for the first time on March 10, 1876. With a notable assist from Thomas Edison, who quickly improved the diaphragm, the phone soon conquered the world.

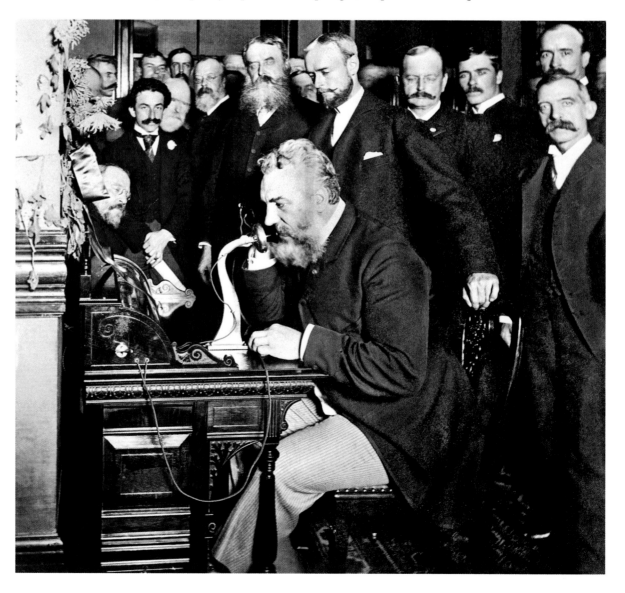

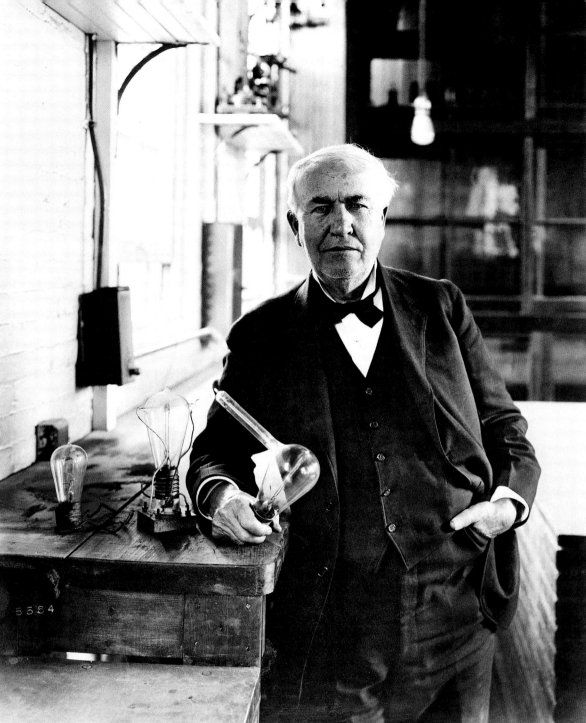

5584

ILLUMINATING *At left, Edison poses in the 1920s, holding one of his original incandescent lamps. His sketch of an 1880 version is below. He began his career by making significant improvements to stock tickers and telegraph transmitters, and much of his research involved communications and recording. A tough, elbows-out businessman, he engaged in long duels with other inventors, including George Westinghouse, over their rival early systems for transmitting electricity*

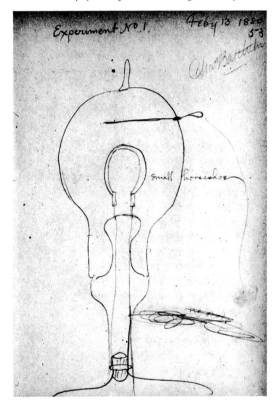

Experiment No. 1. Feby 13 1880

small horseshoe

Edison Perfects the Incandescent Light

66

After British scientist Humphry Davy made a strip of charcoal glow by passing an electric current through it in 1809, inventors around the world raced to be the first to convert electricity into light. For more than 70 years, they studied the compositions of filaments, housed them within protective glass globes, even reduced the air pressure in the globe to make the filament burn more brightly. Yet the resulting "light bulbs" proved inadequate: they were too bright or too hot, too large or too fragile, and almost all were very short-lived.

Enter Thomas Edison, the American technical wizard. He succeeded where others had failed because he began by reinventing the process of invention. Edison brought an Industrial Revolution approach to research, deploying teams of engineers to attack a problem and working methodically through all possible permutations of a solution to achieve success. The key to the incandescent light was the filament, and Edison's "Insomnia Squad" tested more than 1,600 types of filament before trying bamboo, then tested more than 1,000 varieties of bamboo before finding the best species for his new bulb. He achieved success in 1879, though he never stopped improving his product. His "Invention Factory" went on to pioneer the phonograph, the cinema and many other modern technologies. A new age in science was beginning, signaling the end of a long era in which inventors were solitary geniuses, working alone.

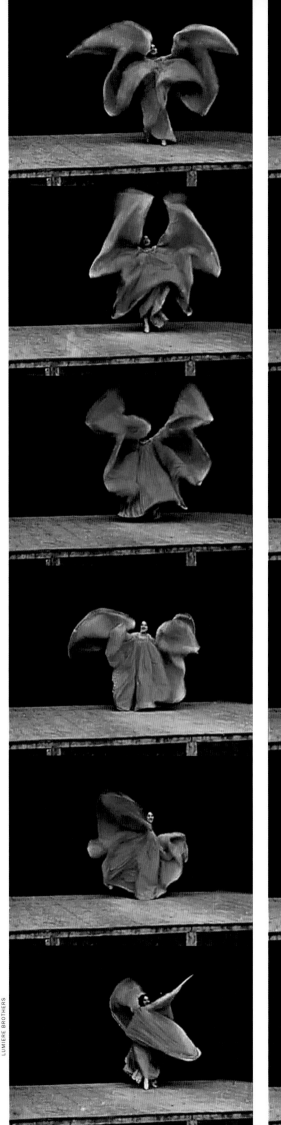

LUMIÈRE BROTHERS

Moving Pictures Capture Life's Swirling Pageant

67 The history of the cinema begins with a host of fascinating objects—playthings, really—that managed to render an illusion of movement: Victorians enjoyed Zoetropes, Praxinoscopes and other nifty gadgets that turned multiple images into brief, animated scenes. British photographer Eadweard Muybridge took the process one step further: funded by U.S. railroad tycoon Leland Stanford, he set up a series of cameras at ground level on a race track in California in 1872 and strung trip wires across a horse's path. The shutters tripped in sequence, yielding a strip of photos that, when run together quickly, captured motion on film for the first time.

Thomas Edison and colleague William Dickson soon built a Kinetograph, a camera that took rapid-series pictures on a continuous strip of celluloid film. They were viewed on a Kinetoscope, an arcade device that showed a back-lit strip of film about 30 seconds long to an individual viewer. Price: 5 cents.

The Kinetoscope garnered lots of nickels in its day, but a conceptual breakthrough soon made it look humdrum. The aptly named French brothers Auguste and Louis Lumière made the Kinetoscope obsolete in 1895, when they exhibited the first moving pictures shot with their Cinématographe, a hybrid camera-projector, in Paris. Projection was their breakthrough. Using a powerful lamp to back-light the celluloid images, the brothers displayed them onto a big screen, providing the larger-than-life visual oomph that remains cinema's greatest attraction. Projection also converted the "movies" into a group experience, like the theater. When Parisian audiences first saw a mammoth locomotive come speeding out of a formerly blank wall, some viewers screamed in horror. Perhaps they knew what was coming.

TWIRLS *At left, the Lumières filmed this "Danse Serpentine" in 1896, then hand-colored each frame to achieve the effect of changing hues. The film was first projected in 1896*

Coming attractions
At top, styles have changed, but this poster for the Lumière brothers' cinema house depicts a scene familiar to any moviegoer. The film was titled: The Sprinkler Is Sprinkled.

At left are Auguste, standing and Louis, crocheting. The image is an example of another of their inventions, a color process for photography they called the Autochrome

101

Freud Explores the Mind's Inner Frontiers

68

More than a century after they first began percolating through Europe, Sigmund Freud's theories remain controversial. Acolytes bend the knee, while critics assail the icon—but on one thing all parties agree: Freud's ideas have left a lasting mark on society. His fundamental insight—that all humans are endowed with an unconscious mind in which potent sexual and aggressive drives, and defenses against them, struggle for supremacy, as it were, behind a person's back—has struck many as a romantic, scientifically unprovable notion. His insistence that erotic desire starts not in puberty, but in infancy, still offends the respectable. His dramatic evocation of a universal Oedipus complex seems to many more a literary conceit than a scientific thesis.

No matter: Freud opened the doors to the unconscious with the publication of *The Interpretation of Dreams* in 1900, and they will never be shut. The brilliant young Jew, born to poverty in 1856 in today's Czech Republic, concluded in medical school in Vienna that the most intriguing mysteries lay concealed in the complex operations of the mind. By the early 1890s, he was specializing in "neurasthenics," studying severe hysterics who taught him much, including the art of patient listening, which he developed into psychoanalysis. As the noted historian and writer Peter Gay noted in his essay naming Freud as one of TIME's most influential people of the 20th century, Freud's vision is that "civilized living is a compromise between wishes and repression—not a comfortable doctrine. It ensures that Freud, taken straight, will never become truly popular, even if today we all speak Freud."

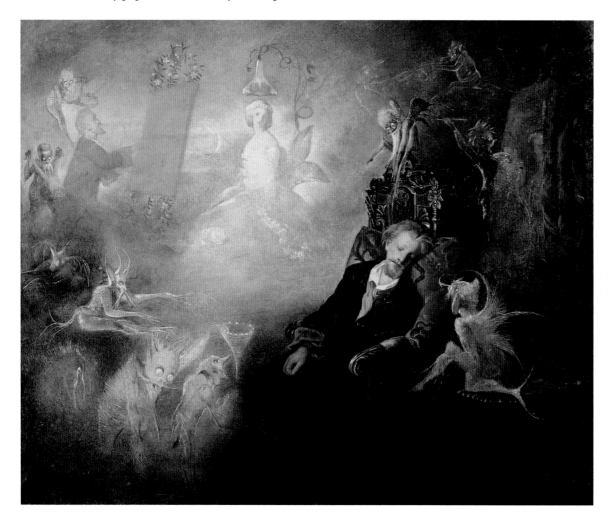

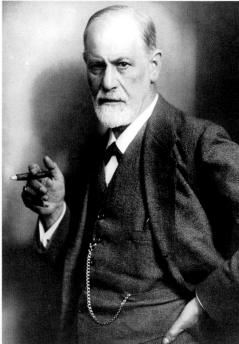

BEYOND THE RATIONAL *Above, Freud poses for a portrait in 1921. Though known as the father of psychoanalysis, he did not use the term until well into his career, at 40. At left is* The Artist's Dream, *painted in 1857 by Briton John Anster Fitzgerald. The late Victorian era saw a surge of interest in the afterlife, séances, spiritualism and the dreaming mind; Freud brought a scientific approach to subjects that were much discussed in his time*

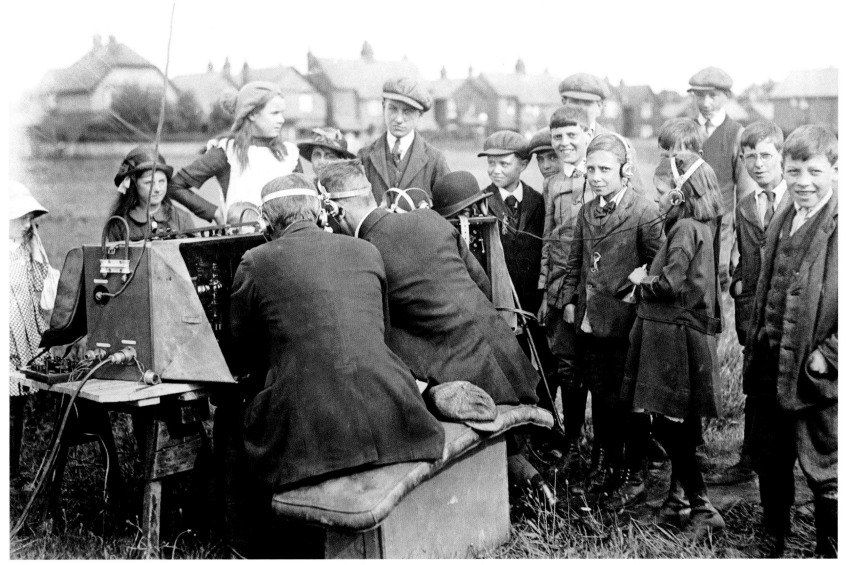

"THIS JUST IN ..." *In 1919, some 18 years after Marconi transmitted a transatlantic radio message, British children were still fascinated by hearing voices travel through the air*

Communication Enters the Wireless Age

69 Radio waves, like black holes in outer space, were predicted in hypothetical form before they were observed in nature. Scottish physicist James Clerk Maxwell posited their existence in 1864 as a form of electromagnetic radiation. In the 1880s Germany's Heinrich Hertz proved the waves were real. And that triggered a worldwide search to be first to free telegraphy from its constricting electrical lines and create wireless communication. Many pioneers contributed to this process. But the man who emerged at the head of the pack was an Italian, Guglielmo Marconi, who in 1901 thrilled the world by sending the first radio message, in Morse code, across the Atlantic.

Most inventors seem to have viewed radio as no more than an improved telegraph until Canadian physicist Reginald Fessenden invented a continuous-wave voice transmitter in 1905 and coupled it with a new "triode" amplifying tube based on a design by Lee De Forest. On Christmas Eve 1906, Fessenden transmitted one of the first long-distance broadcasts of the human voice by radio. It was received by startled wireless operators aboard ships in the North Atlantic who were expecting to hear Morse code. Pioneering U.S. executive David Sarnoff took the next step, developing "programming" for radio broadcast and setting up a network of regional radio stations to transmit the programs. Selling millions of home "radio music boxes," he helped create a new industry, broadcasting, and a new kind of product, consumer electronics—objects of desire whose form continues to evolve but whose appeal has never waned.

Modern Times

DAWN OF AVIATION ■ EINSTEIN RECHARTS THE UNIVERSE ■ HENRY FORD'S MODEL T
BIRTH OF TECTONIC THEORY ■ THE PRICE OF WORLD WAR I ■ THE SPANISH FLU PANDEMIC
COMMUNIST REVOLUTION IN RUSSIA ■ ADVENT OF TELEVISION ■ GLOBAL ECONOMIES FAIL
THE RISE OF HITLER ■ GERMANY INVADES RUSSIA ■ JAPAN'S SURPRISE ATTACK ON THE U.S.
D-DAY BEGINS HITLER'S FALL ■ THE HOLOCAUST ■ THE U.S. DEPLOYS AN ATOM BOMB
THE TRANSISTOR IS INVENTED ■ INDIA WINS INDEPENDENCE ■ ISRAEL BECOMES A NATION
COMMUNISTS TAKE POWER IN CHINA ■ A STANDOFF IN BERLIN STARTS THE COLD WAR
DNA IS DECODED ■ THE BIRTH CONTROL PILL ARRIVES ■ U.S. BLACKS WIN CIVIL RIGHTS
THE WAR IN VIETNAM ■ MAN WALKS ON THE MOON ■ OIL WEALTH RESHAPES GEOPOLITICS
A RELIGIOUS REVOLUTION IN IRAN ■ THE BERLIN WALL FALLS ■ NELSON MANDELA IS FREED
THE WORLDWIDE WEB BOOTS UP ■ ISLAMIC TERRORISTS ATTACK THE U.S.

Cultures wax and wane; so do the visions that sustain them. Christians of the hierarchical Middle Ages accepted St. Augustine's dream of a spiritual City of God that was a glorious contrast to the drab, earthbound City of Man. For 17th and early 18th century Europeans, the dominant metaphor was the Great Chain of Being, an orderly progression from the lowliest of organisms to God the creator on high. The 19th century was an era of unparalleled growth and prosperity—albeit unevenly distributed—for Western Europe and many of its former colonies. That mechanistic age's prevailing belief was the idea of inevitable progress, which translated into continuing material success for society's fittest. This seductive dream was no more sustainable than previous models of civilization, and Sigmund Freud's exploration of the unconscious mind and Albert Einstein's unsettling new theories of relativity shattered the vision of a clockwork universe. The Great War of 1914-18, an exercise in pointless slaughter, firmly shut the door on the past. Along with millions of soldiers, faith in the beneficence of progress died in that war's muddy trenches. An even greater war followed. The rise and fall of Adolf Hitler, the horrors of the Holocaust and the advent of the atom bomb underlined the message: technological change was far outpacing ethical change. The late 20th century saw the end of failed socialist ideologies in both the Soviet Union and China, but even as the cold war receded an era of global terrorism was taking shape. In the early 21st century, an electronic revolution began stitching people together in startling new ways, but the World Wide Web will never mend the enduring fissures in the human heart.

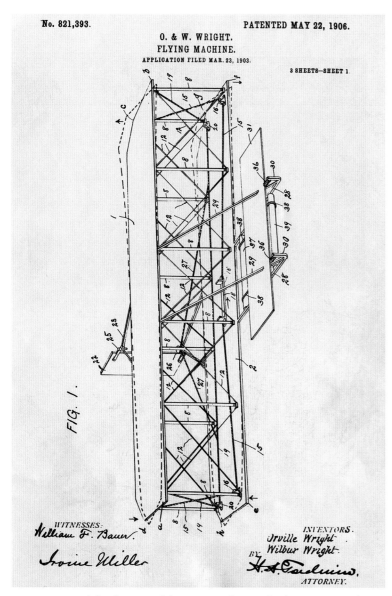

No. 821,393. PATENTED MAY 22, 1906.

O. & W. WRIGHT.
FLYING MACHINE.
APPLICATION FILED MAR. 23, 1903.

3 SHEETS—SHEET 1.

FIG. 1.

WITNESSES:
William F. Bauer.
Ivonne Miller.

INVENTORS:
Orville Wright
Wilbur Wright
BY
H. A. Toulmin,
ATTORNEY.

UPLIFTING *Both brothers signed the patent application for their invention, above. Flyer 1 boasted a curved, or cambered, wing that provided vertical lift as the craft moved forward. At right, Wilbur Wright steers a glider in 1902 at Kitty Hawk; the brothers conducted extensive tests with gliders before attempting powered flight*

The Wright Brothers Perfect The First Flying Machine

70 For centuries humans had dreamed of taking wing, of flying through the air unencumbered by gravity. Leonardo da Vinci sketched hypothetical flying devices, and with the advent of hot-air balloons in the late 18th century, the dreams of flight were realized. But the development of the internal combustion engine some 100 years later focused inventors on a new goal: now the prize was to create a flying machine that was not a plaything of the winds, but instead powered its way through the heavens, charting its own path and managing its own speed.

Enter Orville and Wilbur Wright, two brothers who operated a custom-bicycle shop in Dayton, Ohio. As boys, they had played with kites and gliders. As young men—inspired by the work of Otto Lilienthal, a German scientist who died in 1896 while experimenting with gliders—they studied aerodynamics, even building their own wind tunnel to study the physics of lift. The result, *Flyer 1*, was powered by a 12-h.p. engine placed at one side of the driver. Keeping the plane stable while aloft proved essential to flight, and the machine featured a movable vertical rudder that helped it attain what pilots call three-axis control—direction of the craft's up-and-down pitch, its side-to-side yaw and its lateral motion, or roll.

The initial manned flight in a powered airplane was flown by Orville on Dec. 17, 1903. It lasted only 12 seconds, and the plane traveled only 120 ft. across the sand dunes near Kitty Hawk, N.C. Before the day was over, the brothers achieved a flight of 59 seconds that covered 852 ft. While they exulted, at least one witness was let down. A local undertaker had been observing them from a horse-drawn buggy, in hopes of picking up a little business. By 1905 the two had built *Flyer 3* and were staying aloft for almost half an hour. Flight technology developed rapidly, thanks to a major boost from the adoption of airplanes as armaments in World War I. If necessity is the mother of invention, war is its father.

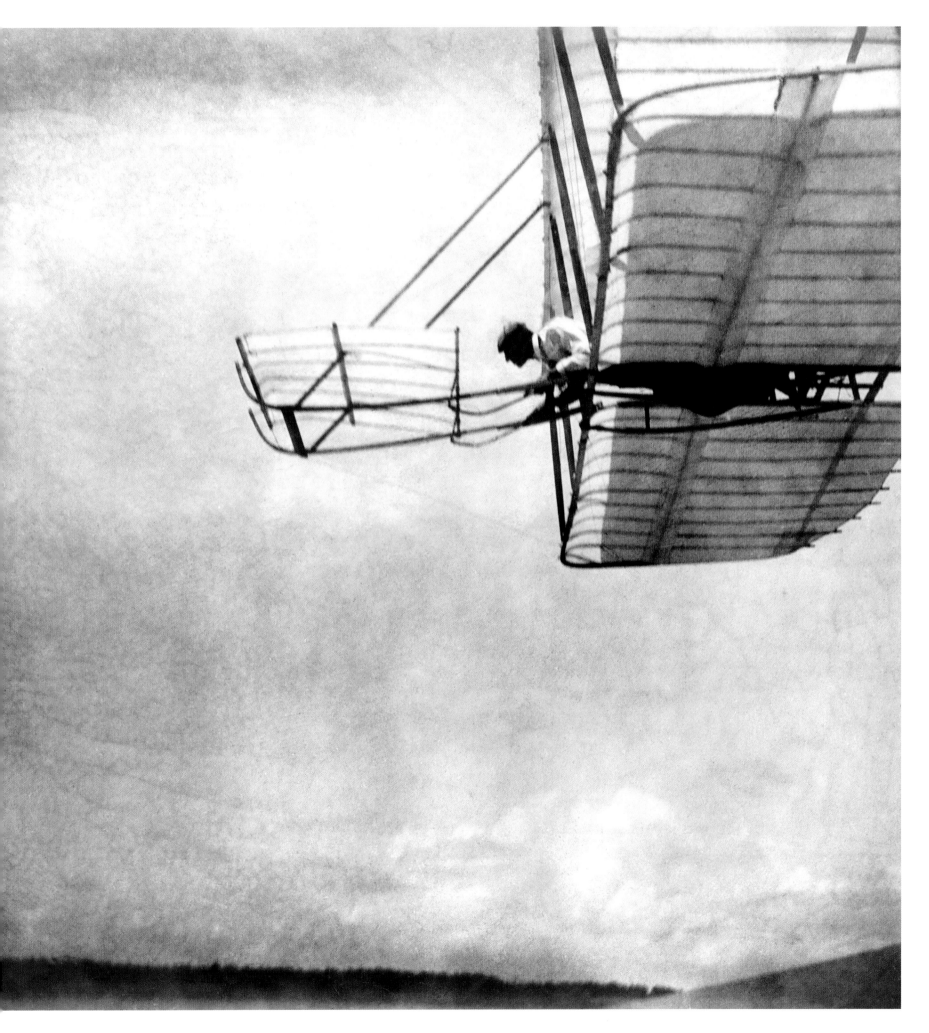

Einstein's Theories Paint a Strange New Vision of a Universe in Flux

71 "In a century that will be remembered foremost for its science and technology—in particular for our ability to understand and harness the forces of the atom and the universe—one person stand out as both the greatest mind and paramount icon of our age: the kindly, absentminded professor whose wild halo of hair, piercing eyes, engaging humanity and extraordinary brilliance made his face a symbol and name a synonym for genius: Albert Einstein." So wrote TIME Managing Editor Walter Isaacson in 1999, when the magazine named Einstein its Person of the 20th Century.

The son of Jewish parents from southern Germany, Einstein was a physics prodigy whose miracle year was 1905. While working as a young technical officer in the Swiss patent office in Bern, he produced three papers in a single year that changed science forever. The first, for which he later won a Nobel Prize, described how light could behave not only like a wave but also like a stream of particles called quanta, or photons. This wave-particle duality became the foundation of what is known as quantum physics. The second paper confirmed the existence of molecules and atoms, then still a hypothesis, by showing statistically how their random collisions explained the jerky motion of tiny particles in water.

It was the third paper that truly upended the universe. In his special theory of relativity, Einstein showed that energy and matter are merely different faces of the same phenomenon. Though not a recipe for an atom bomb, it explained why one was possible. Special relativity also explained that under certain conditions, space and time appear relative. In his general theory of relativity (1916), Einstein described gravity as a geometric property of space and time; his theory was given dazzling proof in 1919 when observations showed the sun's gravity bending light from a distant star.

Einstein fled Hitler's Germany early in the 1930s for the U.S. As World War II approached, he wrote President Franklin D. Roosevelt to explain that a new kind of weapon, the atom bomb, might be built, in line with the theories he had helped develop. Paradoxically, the lifelong pacifist became one of the fathers of the nuclear bomb. The ripples spreading out from his startling theories of relativity first upended physics, then went on to also jangle the underpinnings of society. Indirectly, relativity in physics paved the way for a new relativism in morality, arts and politics. There was less faith in absolutes, not only of time and space but also of truth and morality. "It formed a knife," historian Paul Johnson said of relativity theory, "to help cut society adrift from its traditional moorings."

GENIUS *Einstein lectures at the Collége de France in Paris in 1922. The physicist, a Jew, fled Hitler's Germany and was a strong proponent of the Jewish state of Israel*

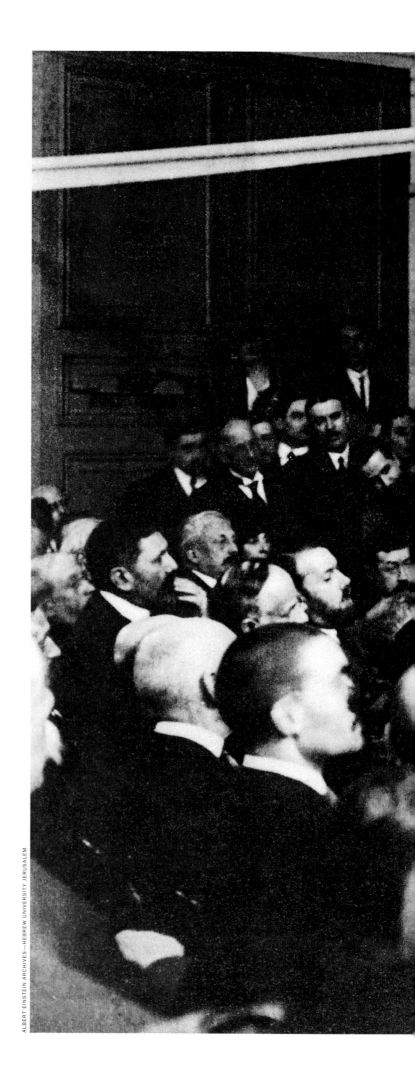

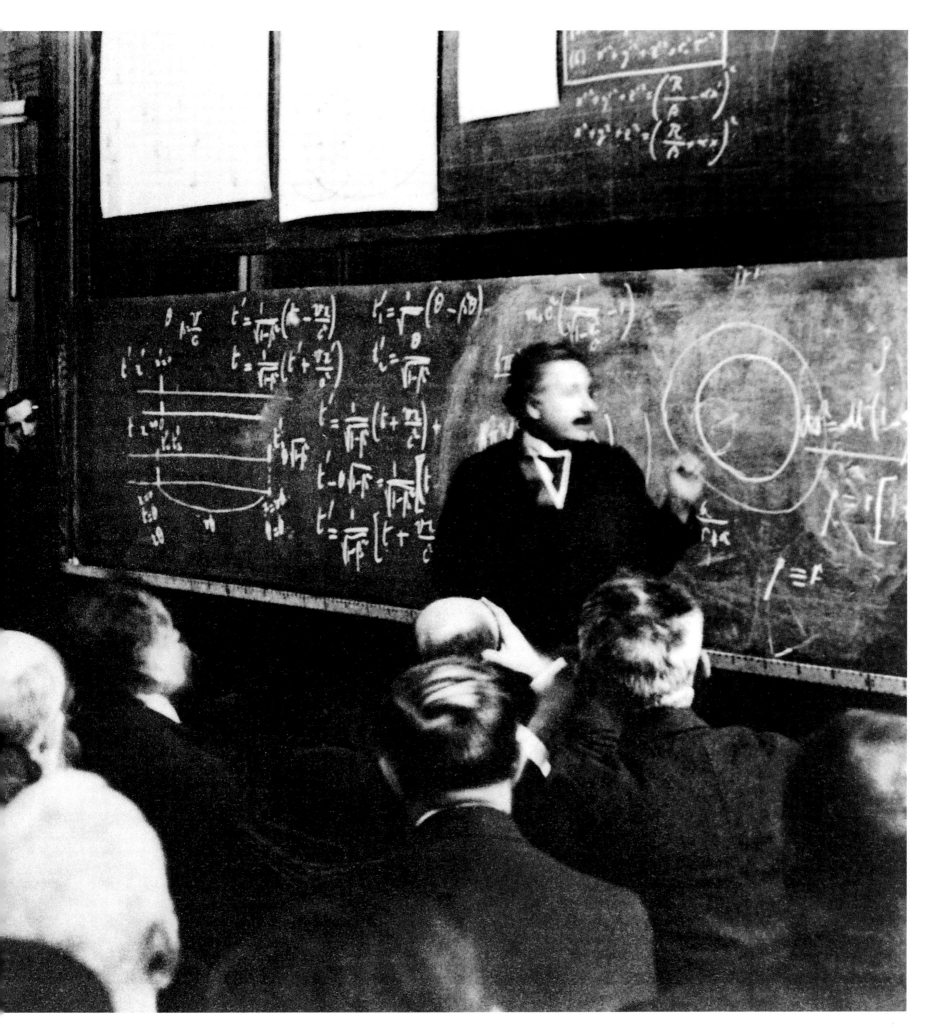

Henry Ford's Vision Puts the World on Wheels

72 With the introduction of his Model T in 1908, Henry Ford jump-started the 20th century, ushering in a series of revolutions that transformed modern society. Ford was one among many inventors in Europe and the U.S. who helped create the automobile, but he stands out as the visionary who first created a motorcar affordable enough to be bought by the average citizen, the Model T. In 1913 Ford's engineers perfected another innovation: by placing the auto components to be assembled on a moving production line and radically simplifying the specific task of each worker, the Ford team accelerated the assembly process even as they lowered labor costs. The very next year, Ford wrought another revolution: he doubled wages, paying his workers an unheard-of $5 a day. Believing that mass production relied upon mass consumption, he claimed that if he paid his factory workers a real living wage and produced more cars in less time for less money, everyone would profit. Twelve years later, in 1926, Ford put his workers on a 40-hour workweek, with two days off each week.

Ford's vision helped create a middle class in the U.S., transformed the nation's cities, accelerated the pace of commerce and life and eventually gave birth to the suburbs. Affordable automobiles even altered dating and sexual habits, providing young people with rolling retreats from prying eyes. And as the automobile became the essential tool of modern living, Ford's breakthroughs altered geopolitics, showering wealth on nations that possessed rich reserves of the indispensable lifeblood of the new freedom: oil.

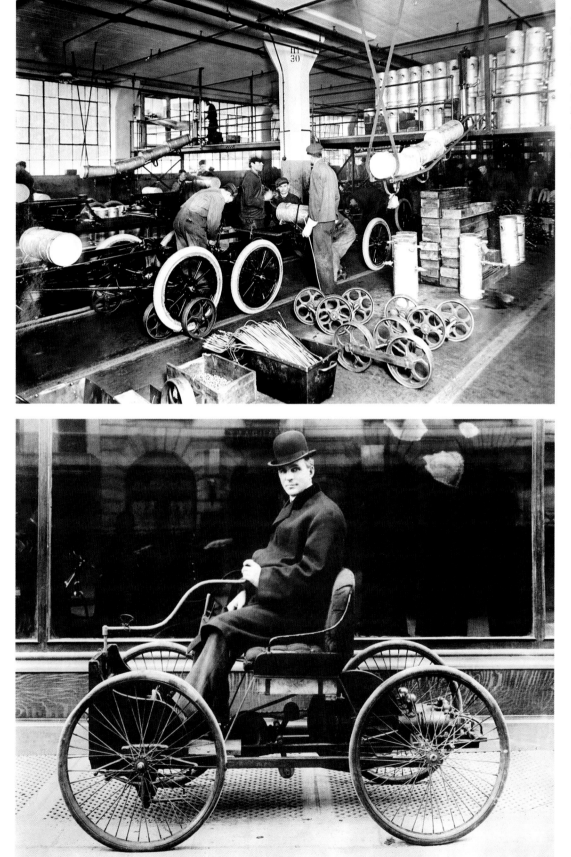

THE HORSELESS CARRIAGE *Ford's Model T transformed U.S. cities, as the automobile replaced the horse. At far left, a steady stream of cars passes the New York Public Library in 1922*

ACCELERATING *At left, cars are built on a Ford assembly line; a finished model rolled off the line every 93 minutes. Below left, Ford's first auto was the "Quadricycle," which he unveiled in 1896. It ran on bicycle wheels*

Inventing the Automobile

1861 Nikolaus August Otto, a German, builds his first gasoline-powered engine.

1876 Otto builds an internal-combustion engine using the four-stroke cycle, which offers the first practical alternative to the steam engine as a power source.

1885 Germans Gottlieb Daimler and Wilhelm Maybach develop a new, much more efficient version of the four-stroke internal-combustion engine.

1890 Daimler founds Daimler-Motoren-Gesellschaft company, one of the world's first auto manufacturers.

1896 Henry Ford completes his self-propelled vehicle, the Quadricycle; it has a gasoline engine. American Ransom E. Olds completes his first gasoline-powered vehicle the same year.

1897 Olds founds Olds Motor Works.

1903 Henry Ford founds the Ford Motor Co., which begins selling its first car, the Model A, within months.

1908 Ford introduces the Model T, the first car mass-produced on assembly lines with interchangable parts. Its price ($825) quickly makes the "Tin Lizzie" the most popular automobile in the world.

1912 Ford cuts the price of the least expensive Model T to $590, and it would continue to fall. In the 1920s, Model Ts sell for as little as $290.

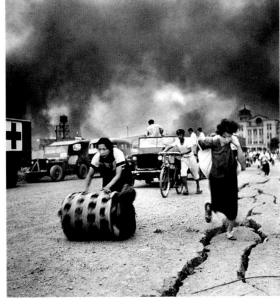

SEAMS OF THE GLOBE *At left, gigantic tectonic plates converge at a rift valley in Iceland, the dividing line between the North American and Eurasian plates. The island of Iceland was formed by volcanic activity. A similar pattern of rifts along the perimeter of the Pacific Ocean is home to thousands of volcanoes and is known as the Ring of Fire. At top above, Italy's famed Mount Etna erupts; the Sicilian volcano is the largest active cone in Europe. At bottom above, the surface of the planet cracks apart during a 1948 earthquake in Japan's Fukui prefecture. Like Iceland, the Japanese archipelago is of volcanic origin. Wegener's theory was the first to show that rifts, volcanic eruptions, earthquakes and tsunamis are all aspects of the tectonic processes that shape the planet*

LEFT: RAGNAR TH SIGURDSSON—ARCTIC IMAGES—ALAMY; RIGHT, TOP: MARIO CIPOLLINI—AURORA CREATIVE—GETTY IMAGES; BOTTOM: CARL MYDANS—TIME LIFE PICTURES

A Restless Planet, Decoded

73

For countless centuries, humans struggled to survive in a world whose workings they did not understand. Erupting volcanoes, destructive earthquakes and overwhelming tsunamis were among the great scourges of history, killing hundreds of thousands in cataclysmic events that seemed spontaneous and unrelated. It was a German meteorologist, Alfred Wegener, who first proposed that these seemingly disparate natural events were all threads of a single tapestry. His audacious proposal: the continents we stand upon are in constant, slow motion across the surface of the planet. Africa and South America had once been joined, he said; indeed, all the planet's landforms had once composed a single Ur-continent, which he christened Pangaea.

When Wegener published his theory of "continental drift" in his 1915 book, *The Origin of Continents and Oceans,* his ideas were dismissed by his contemporaries. Yet Wegener marshaled striking evidence for his claims, including identical dinosaur fossils found only in two places: the bulge of eastern South America and the notch in western Africa into which it snugly fits (this juxtaposition, familiar to anyone who has ever pondered a globe, first sparked Wegener's theories). Clinging to orthodoxy, Wegener's doubters explained such anomalies by hypothesizing a "land bridge" that once linked the two continents. It is fair to say that at the time of his death in 1930, Wegener's theories commanded roughly the same amount of scientific respect that speculation about the Bermuda Triangle enjoys today.

Confirmation of Wegener's proposals did not come for decades. But a series of developments in the 1960s—the discovery of seafloor spreading, the observation of the creation of new land matter by erupting volcanoes, the development of sensitive seismological instruments and many more—led to the acceptance of tectonic theory. Named for the Greek word "to build," this grand unifying theory holds that the surface of the planet is in a continual process of slowly reshaping itself—at mankind's peril.

113

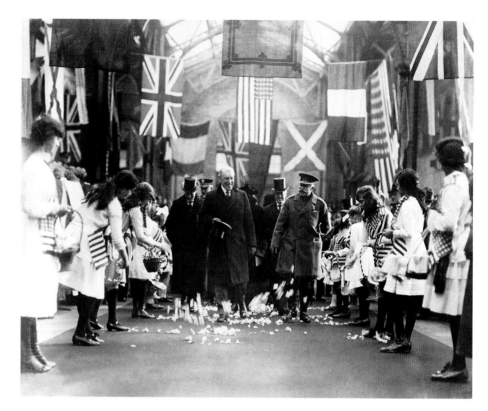

A Great War Shatters Europe

74 Confused about World War I? Don't be ashamed. Historians are still arguing over why the conflict began, and even the young men called upon to feed their bodies into what often seemed no more than a great machine of slaughter had little sense of why they were sacrificing their lives. The story that soldiers ordered to leave the safety of their trenches and go "over the top" to almost certain death once expressed the futility of their plight by *baahing* like sheep may be apocryphal, but it rings true.

The war came amid a great surge of nationalist pride in European nations, which increasingly viewed themselves as empires vying for land, resources and overseas colonies. Goaded by a military that had binged on a buildup of massive battleships and yoked in the chains of interlocking diplomatic alliances, the Continent's great nations allowed themselves to be drawn into war after a Serb nationalist in obscure Sarajevo in the Balkans assassinated Archduke Franz Ferdinand of Austria-Hungary in 1914. The two foes—Austria-Hungary, Germany and Turkey's Ottoman Empire on the one side; the United Kingdom, France and Russia on the other—fought one great battle after another to inconclusive ends, at an incalculable cost. The war became a static stalemate between trench-bound armies, where progress came only in the technology of killing. Tanks, submarines and airplanes were first used as weapons in this conflict, and both sides unleashed a horrific new agent of death, poison gas.

Even the smugly isolationist U.S., separated from the conflict by the Atlantic Ocean, was finally drawn into the fray in 1917. When 2 million Americans went "over there," they helped tip the balance against the exhausted German allies. The war spelled the end of great empires: in its wake czarist Russia, the Austro-Hungarian Empire and the Ottoman Empire simply collapsed. And though idealists like U.S. President Woodrow Wilson called for a League of Nations to prevent such slaughters in the future, the Treaty of Versailles demanded such a high degree of reparations from the vanquished Germany that the defeat festered like a sore until it expelled a man who vowed to restore his people's pride, Adolf Hitler.

HIGHER-UPS *At top right, Woodrow Wilson, a crusader for global unity, traveled to France in 1919 for the Versailles Conference after the war's end. At right, British and German biplanes engage in combat in an undated photo*

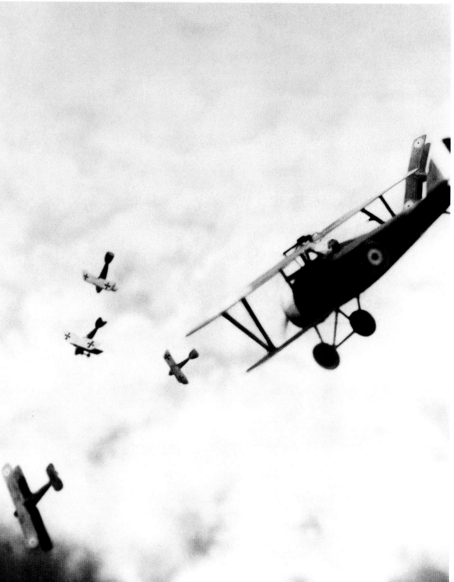

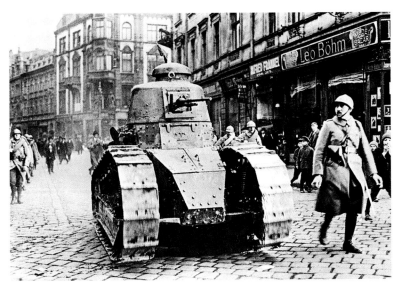

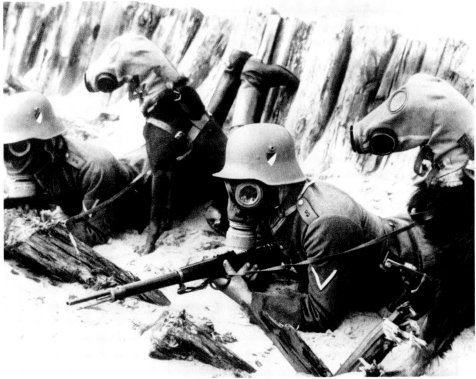

TANKS AND TRENCHES *The war accelerated technology: above, a small French tank enters Germany's Rhineland region after the war's end. At right, German soldiers (and their dogs) don gas masks against Allied attacks; gas weapons were outlawed by international treaty after the war. Entrenchment was the military hallmark of the war: soldiers ordered to go "over the top," like the British troops at the Battle of the Somme in 1916, below, entered killing fields blasted by artillery fire and divided by barbed wire*

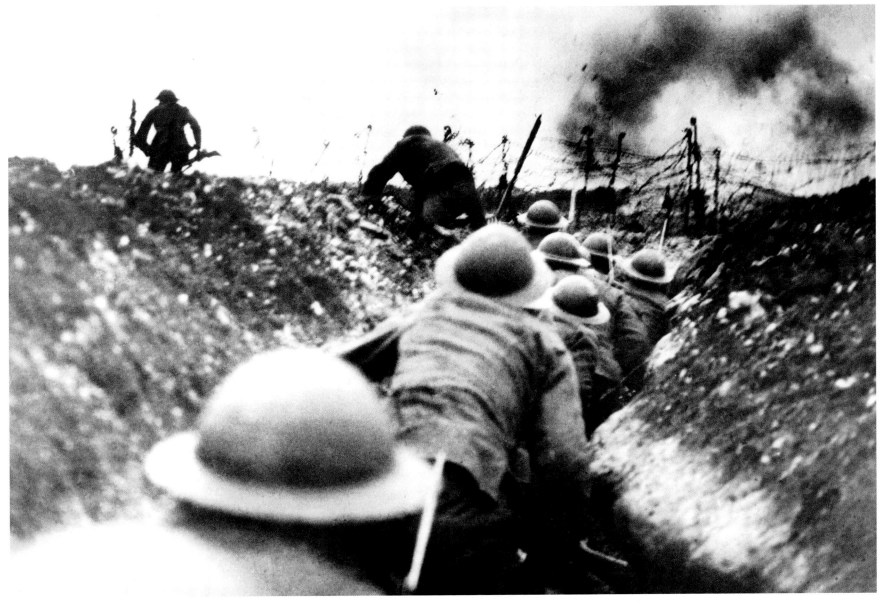

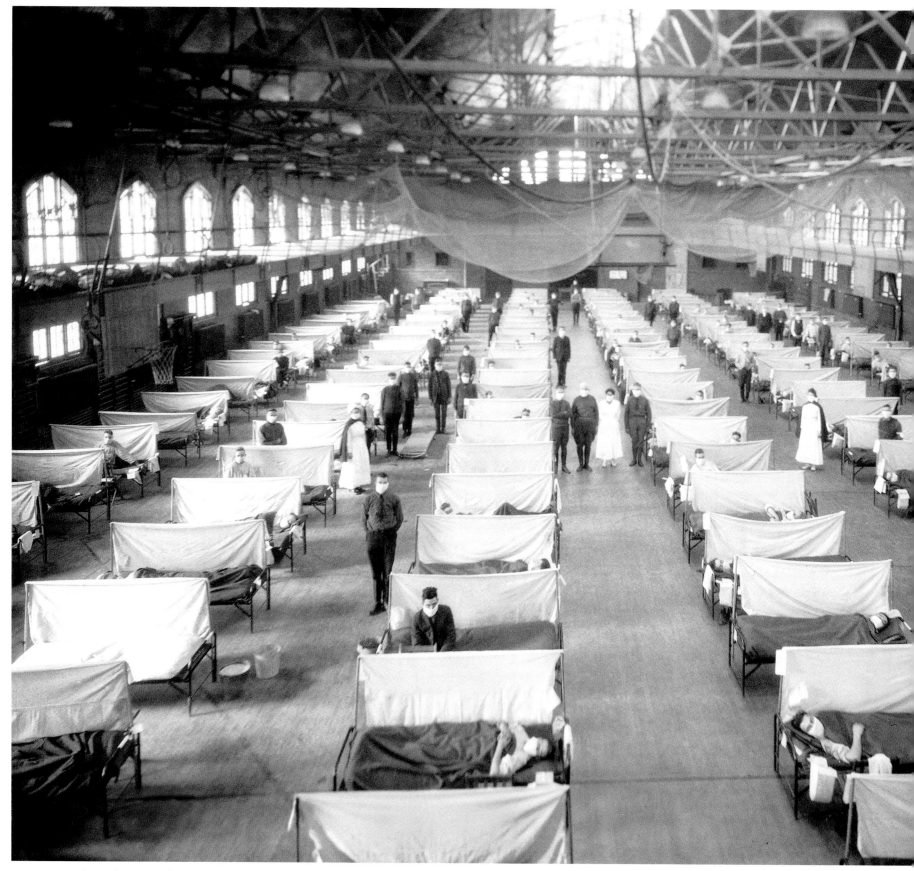

ISOLATED *As the pandemic spread around the world, victims were quarantined and doctors and nurses wore masks for protection. This gymnasium at Iowa State University was converted into an influenza ward*

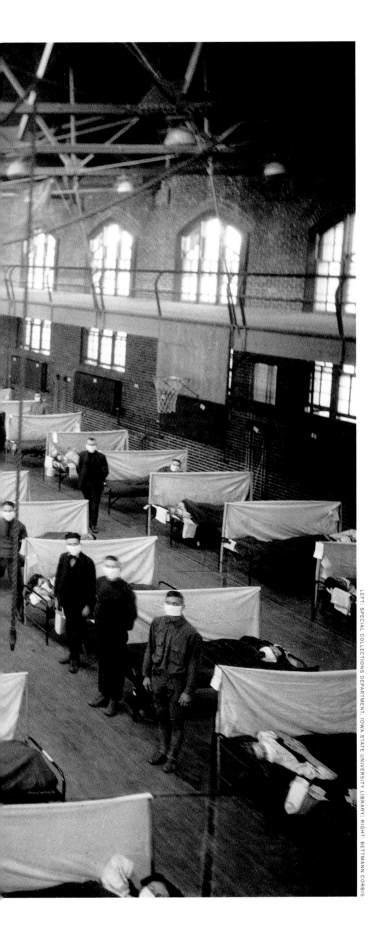

MEDICINE SHOW *American boys wear camphor bags in hopes of warding off the disease*

An Influenza Pandemic Claims Millions of Lives

75 A few days of fever, chills and generally feeling rotten: that's a typical case of the flu. But several times a century, influenza viruses mutate so radically that they can trigger a pandemic—an epidemic on steroids. Such was the case with the Spanish flu outbreak of 1918-19. The flu struck a world already afflicted by the ghastly slaughter of World War I; indeed, soldiers returning home from the war may have helped the disease spread rapidly around the globe.

Epidemiologists now believe the Spanish flu may have caused as many as 100 million deaths. The flu struck Spain so hard it was named for that nation, but that's a misnomer: it seems to have first appeared in Fort Riley, Kans., in March 1918. As it raged, undertakers were so overwhelmed that corpses were left inside homes for days. Cities passed laws requiring citizens to wear masks in public places, but the virus defeated that barrier; little stemmed the spread of the flu. At its height, average life expectancy in the U.S. dropped an amazing 12 years. Cruelly, the 1918 virus was particularly lethal to young and healthy people, who are usually more resistant to flu. The disease seemed to trigger a massive overreaction of victims' immune systems; when autopsies were performed on flu victims, lungs were found to be blue and sodden. They had died by drowning.

The pandemic ended only when the virus had infected so many people that it burned itself out. Today, doctors have better tools—vaccines, antivirals and respirators—that would cut the potential death toll. But influenza is unpredictable. "There's no standard picture for how this develops," Keiji Fukuda, a top World Health Organization official, told TIME in 2009. "We can prepare, but in the end, we're at the mercy of a virus."

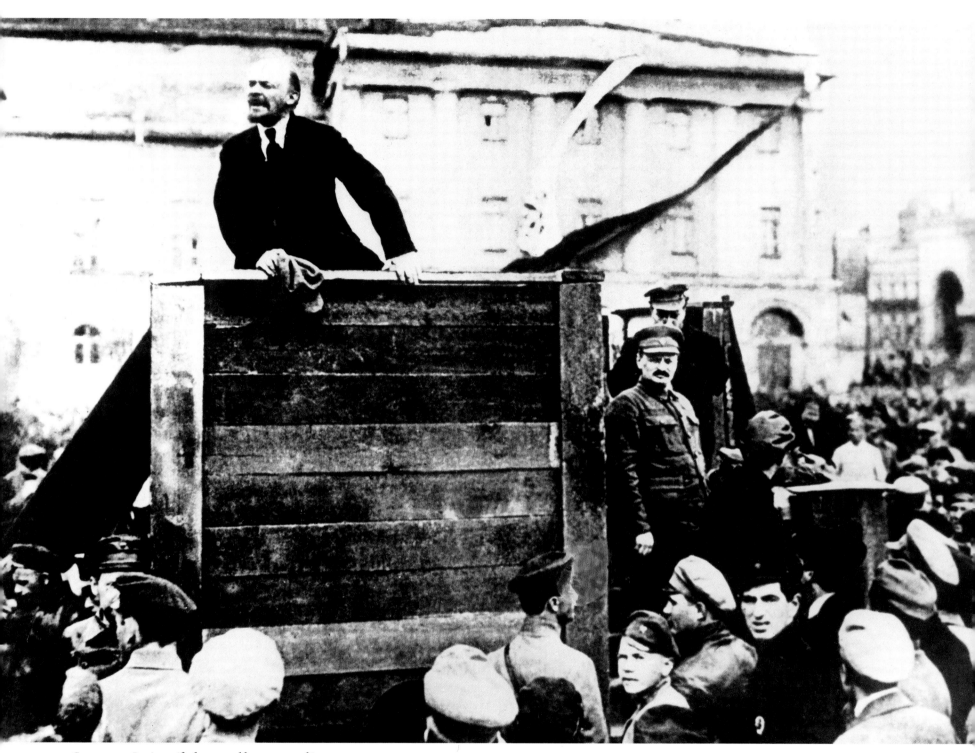

COMRADES *Lenin, a gifted orator, addresses a crowd in Moscow's Sverdlov Square on May 5, 1920. On the right below the podium is Bolshevik leader Leon Trotsky, who would later be purged by Lenin's successor, Joseph Stalin*

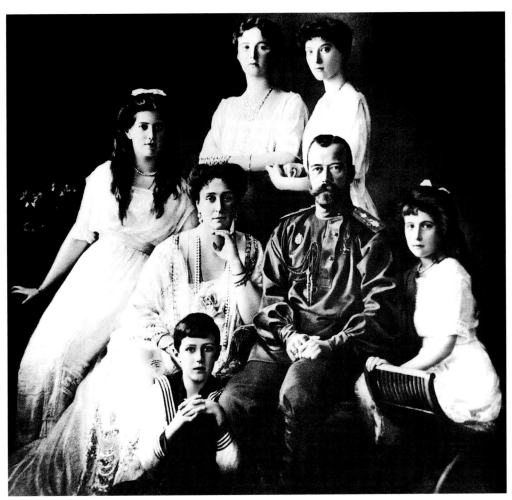

DOOMED *Above, Czar Nicholas II, his wife Alexandra and children were murdered by Bolsheviks in July 1918. At right, a 1917 poster urges: YOU—STILL NOT A MEMBER OF THE COOPERATIVE—SIGN UP IMMEDIATELY!*

Communists Take Power in Russia

76 Like a dread bacillus kept tightly confined, the 47-year-old revolutionary passed from Switzerland through Germany on a closed train, arriving at Finland Station in Petrograd (St. Petersburg) on April 16, 1917. The agent of infection was Marxist revolutionary Vladimir Ilyich Lenin, and he had been hurled into the crucible of chaos that was Russia in World War I by the Germans, in hopes of destabilizing their foe to the east. Lenin marshaled his growing cadre of communist followers, the Bolsheviks, as power beckoned. Battered by German triumphs, disheartened by bread riots and other signs of popular hostility, Czar Nicholas II had abdicated in March, handing Russia's reins to a provisional government.

By the summer political demonstrations were banned, Lenin was in hiding, and his fellow rebel, Leon Trotsky, was in prison. By the fall, the provisional government had lost its ability to govern. The change in command that followed did not involve a major armed rebellion; the Bolsheviks, now the most highly organized party in the country, simply stepped into the vacuum of authority to take control of government buildings, electric plants and finally the Czar's Winter Palace. Within a year, Lenin had banned all other political parties; by 1921 he had defeated the last elements of resistance, the "White" armies. For the first time in history, the idealistic theories of socialism would be put to the test in the real world. Spoiler alert: Russia's new boss would be worse than the old boss.

The Road to Revolution

1881 Czar Alexander II is assassinated by a member of People's Will, a Russian socialist revolutionary party.

1905 Under growing pressure for social reforms from a broad swath of his countrymen, Czar Nicholas II agrees to a series of liberalizing actions, including an end to most government censorship and the granting of more political power to municipal and regional authorities. Later, Nicholas agrees to the formation of Russia's first Duma, or federal legislature, and to more wide-ranging reforms, including the right to establish political parties and increased civil rights for individuals.

1905 Russia endures a humiliating defeat by Japan in the Russo-Japanese war, further crippling the Czar.

1914 Siding with the Serbs, fellow Slavs, Russians are drawn into World War I in alliance with Britain and France.

TUBE OF PLENTY *The first rudimentary video images were created in the mid-1920s and by 1934 Philo T. Farnsworth was able to transmit recognizable images like this close-up of Hollywood star Joan Crawford*

Inventing the Video Age

1884 German inventor Paul Nipkow creates a mechanical spinning disk that breaks the image of an object into vertical lines.

1923 Vladimir Zworykin patents his Iconoscope, a camera that uses vacuum tubes to dissect images.

1925 John Logie Baird transmits a low-resolution still image of a puppet's head, using an advanced version of Nipkow's spinning disk to scan the subject.

1927 Philo T. Farnsworth develops an electronic picture tube that is superior to previous versions.

1931 German inventor Manfred von Ardenne exhibits a video system that uses a cathode-ray tube for both transmission and reception.

1939 The National Broadcasting Company, NBC, transmits live television images from the New York World's Fair using technology developed by both Farnsworth and Zworykin.

1957 Farnsworth appears on the TV show *I've Got a Secret*. When a panelist asks "Dr. X" if the device he invented causes pain when in use, he replies, "Yes. Sometimes it's most painful."

Tuning In to Television

77 Once cinema and radio had been developed, inventors chased a new communications grail: a medium that could broadcast both sound and pictures. So powerful was the vaporware's appeal that its name, television, was coined long before the medium was perfected. Many people share the credit for its creation, but three inventors stand out: John Logie Baird, a Scot; Philo T. Farnsworth, an American; and Vladimir Zworykin, a Russian American.

Farnsworth claimed that he got the inspiration for his version of television as a farm boy in Idaho. Noting the straight rows of soil he created with his plow, he posited that if he could break images down into a series of lines, arranged into gradations of black and white, he could transmit the lines through the air like radio waves. He called the machine he built to scan reality into such lines an Image Dissector; it was an electronic tube with a photoconductive plate. His receiver was based on the vacuum-tube oscilloscope invented by German scientist Karl Braun in 1897.

Baird chose to dissect his images mechanically, using a system of rapidly spinning disks perforated with tiny holes to scan an image and similar disks within a receiver to recompose it. The process indeed yielded fuzzy images, but the electronic model was clearly superior. Zworykin, like Farnsworth, created an electronic version of video: his camera, the Iconoscope, proved inferior to Farnsworth's, while his receiver, a Kinescope, was superior. By the late 1930s, TV was ready for its close-up, but economic depression and World War II delayed its wide debut. The medium exploded after the war, as TV sets invaded living rooms everywhere, driving revolutions in entertainment, politics, journalism and social behavior that are far from signing off.

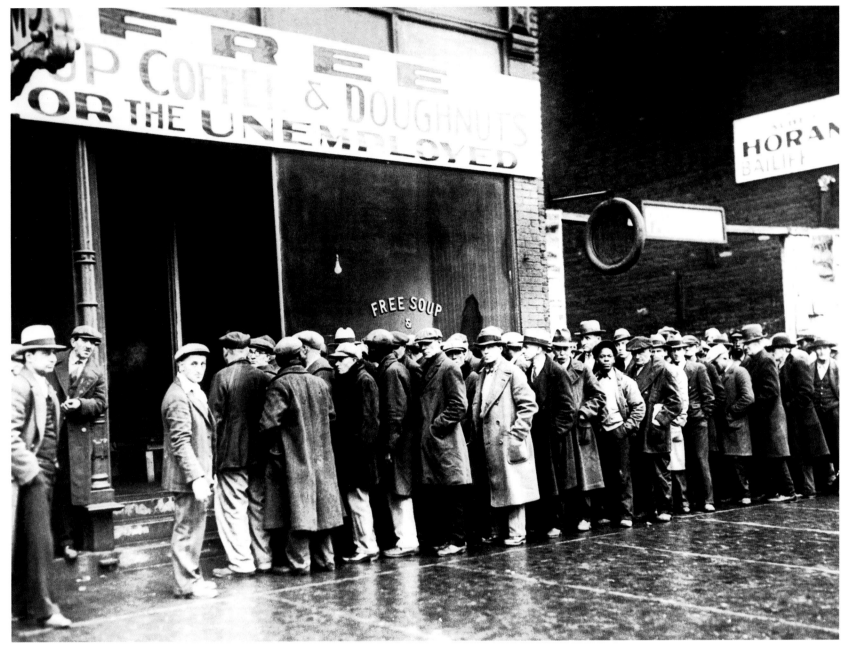

CAN YOU SPARE A DIME? *Out of luck, out of work and out of hope, idle men queue up at a Chicago soup kitchen established by noted gangster Al Capone in 1931*

An Economic Cataclysm Afflicts Western Nations

78 The day was cold and somber. Nearly 1 in 4 U.S. workers was unemployed. Banks had shut their doors. Farms were going belly up. Breadlines like the one shown above snaked through city streets; shantytowns squatted in city centers. Such was America's state on March 4, 1933, more than three years after the stock market crashed in October 1929.

That day, standing jut-jawed at the lectern at the U.S. Capitol on his first Inauguration Day, new President Franklin Delano Roosevelt countered the sense of helplessness, telling shaken Americans, "The only thing we have to fear is fear itself." He then outlined a plan of economic revolution: bank and stock-market reforms, public-works programs and emergency relief for the nation's farmers.

That program, the New Deal, returned a welcome sense of vitality to American life and succeeded in putting many people back to work. But it would take the economic mobilization of World War II to pull America completely out of the Great Depression, whose hard times were shared by capitalist nations around the world, linked together in the web of international investments we now call globalization.

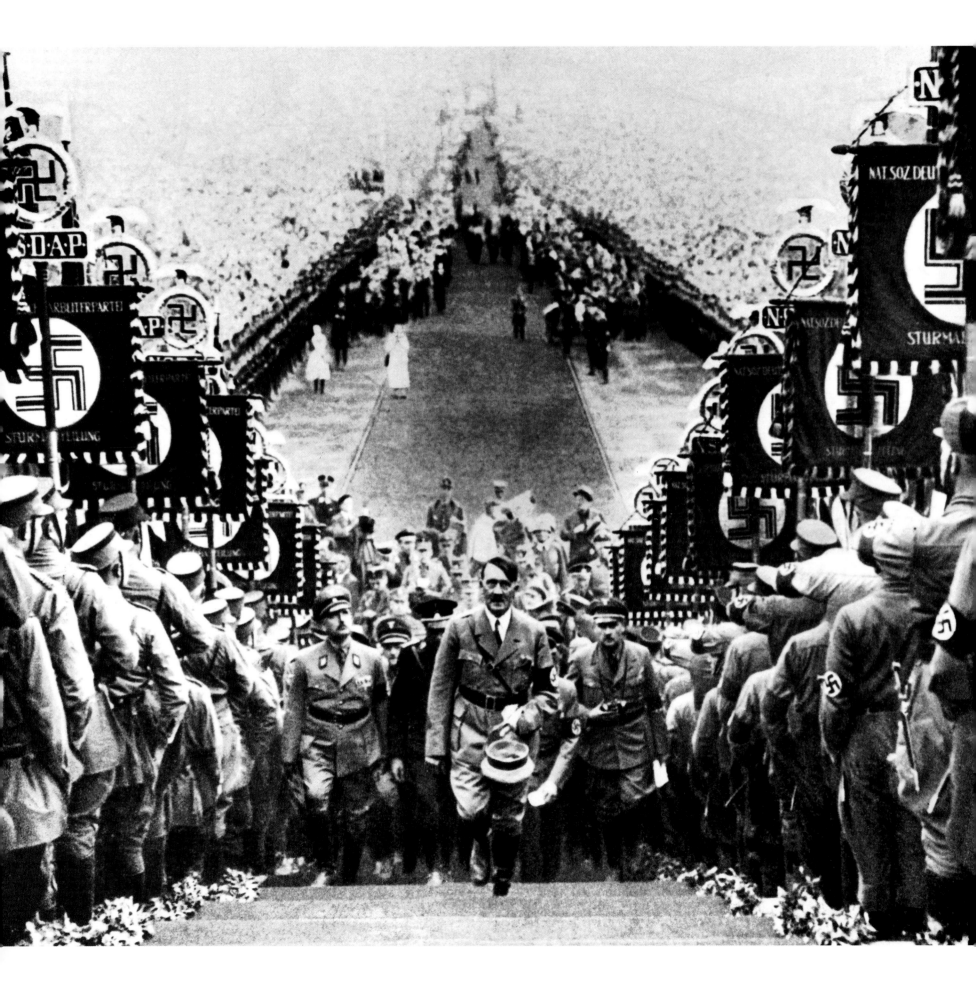

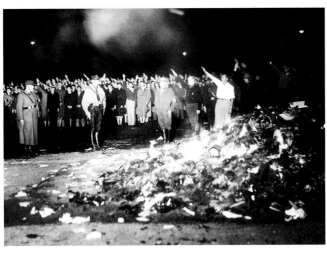

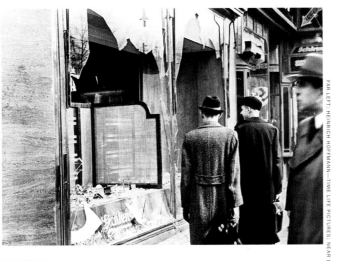

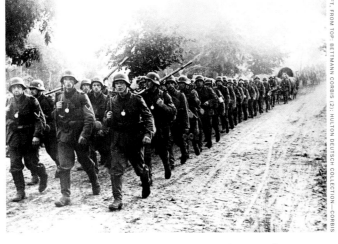

ON THE MARCH *At left, Hitler, the unquestioned master of Germany, mounts the stairs at a gigantic party rally in Buckeburg in 1934. Hitler's Germany became an unlikely mirror image of the Soviet Union of his despised foe, Joseph Stalin: both were totalitarian states run by a strongman and a close cabal of party officials, but the U.S.S.R. was avowedly socialist and the Nazis were the party of Germany's right. Above, from top: Nazis burn books in the streets in 1933; Jewish-owned stores across Germany were trashed on* Kristallnacht, *the "night of broken glass," Nov. 9, 1938. At bottom, German troops march into Poland in September 1939; by month's end, Poland had fallen*

Adolf Hitler Steps Up

79 When the Great War ended, 29-year-old Austrian corporal Adolf Hitler lay in a hospital northeast of Berlin, partly blinded by mustard gas, raging at defeat and vowing revenge. An end product of World War I and the Treaty of Versailles that followed, he threw in with an outfit called the German Workers' Party and began making speeches, denouncing Bolsheviks, the Jews, the French. In 1923 he organized a failed "Beer Hall Putsch" in Munich; he was arrested, tried and served nine months in prison, where he wrote his racist call to arms, *Mein Kampf* (My Struggle). As a starving Germany suffered through the 1920s, Hitler formed the National Socialist Party, and by 1932 the Nazi demagogue was poised for power.

On Jan. 30, 1933, Hitler became Chancellor of Germany. Adding a modern twist to the age-old arsenal of dictators, he banned all political parties and strikes; he even banned some books, then burned them in the streets. Under his thumb, the media issued a steady diet of Nazi propaganda, while Jews were persecuted and barred from public service. He cultivated generals, industrialists and prelates and surrounded himself with a quasi-military private army.

Now Hitler was prepared to avenge the Versailles pact, and in a Europe still haunted by the slaughter of the Great War, there was little mood to resist him. In 1936 he sent his mighty, modern army to reoccupy the demilitarized Rhineland. No one called his bluff: the Allies preferred "appeasement"—negotiation—to fighting. In 1938 Hitler launched a "war of nerves" against the flaccid Austrian government that resulted in its unification, or *Anschluss,* with Germany. He achieved his next goal when British Prime Minister Neville Chamberlain agreed to dismember Czechoslovakia in exchange for a false promise of peace. Then, on Sept. 1, 1939, Germany invaded Poland, jump-starting history's greatest conflict, World War II.

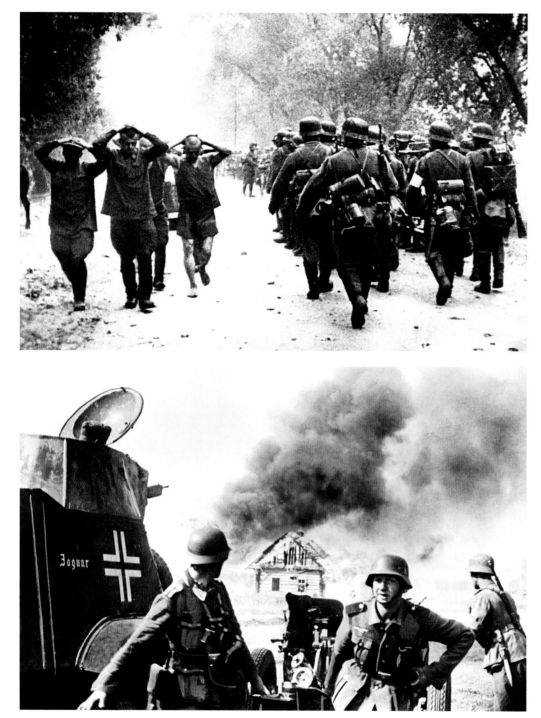

INTO RUSSIA *At top, captured Russian soldiers march to the rear as German troops continue their rapid advance into Russia on July 2, 1941. At bottom, German troops move their position away from artillery fire as the Russians mount stiff resistance in October 1941. The Germans' surge was finally halted just short of Moscow*

Double-Crossing Stalin, Hitler Invades Russia

80 Adolf Hitler unleashed his blitzkrieg, or lightning war, against Poland in September 1939 only days after he had consummated one of the most cynical diplomatic pacts in history. On Aug. 23, Germany and the Soviet Union, bitter enemies throughout the 1930s, signed a nonaggression pact that guaranteed Joseph Stalin's Kremlin would not resist Hitler's advance east into Poland.

Britain and France honored their commitment to defend Poland and declared war on Germany, but through the winter of 1939-40 there was no fighting on Germany's Western Front. Finally on May 10, 1940, Hitler moved west. His Panzer brigades rolled easily over the Netherlands, then smashed through France's army. By the end of June the British army on the Continent had narrowly escaped annihilation in a miraculous evacuation from the French port of Dunkirk, and Hitler had celebrated his conquest of France by visiting the Eiffel Tower.

Germany's full might focused on Britain, now led by the lone Cassandra who had long warned his people of Hitler's intentions, Winston Churchill. In the Battle of Britain that followed, the modern bombers of the German air force, the Luftwaffe, were held off through the summer of 1940 by a thin cadre of British airmen, aided by a newly invented remote sensing device, radar. That winter was quiet on the Western Front, as Hitler, flush with success, began indulging his hatred of communism by scheming to double-cross his supposed ally, Joseph Stalin. On June 22, 1941, Hitler unleashed his new offensive, Operation Barbarossa, sending more than 3 million soldiers on a surprise attack against the Soviet Union. His troops won early success, but Hitler's hubris would lead to his downfall. In opening a second front against an enemy whose resources were great, whose armies were multitudinous and whose land was vast, the dictator's pride took him a steppe too far.

A Surprise Attack Brings the U.S. into the War

81 Isolated from the world for centuries, Japan made up for lost time quickly after it opened its doors to other nations in the 1850s. Its people—proud, industrious and ambitious—longed to take a leading role in world affairs. By 1905 Japan's military was so powerful that the island nation defeated Russia in the Russo-Japanese war. In the 1920s and '30s, the Japanese began angling to become the dominant power in the Pacific. With its emperor under the sway of military leaders, Japan invaded Manchuria and China in the 1930s, and its leaders soon began planning to unseat the major powers across the vast Pacific area, the U.S., Britain and the Netherlands.

On Dec. 7, 1941, Japan announced its imperial ambitions in explosive fashion, as 351 airplanes, launched from six aircraft carriers, devastated the U.S. Navy's Pacific Fleet at its home port in Pearl Harbor, Hawaii, sinking five battleships and killing 2,403 Americans. The deadly surprise attack rocked Americans, many of whom had strongly opposed becoming entangled in World War II, which they viewed as a strictly European war. Now the U.S. declared war on Japan, and on Japan's allies in Europe: Germany and Italy.

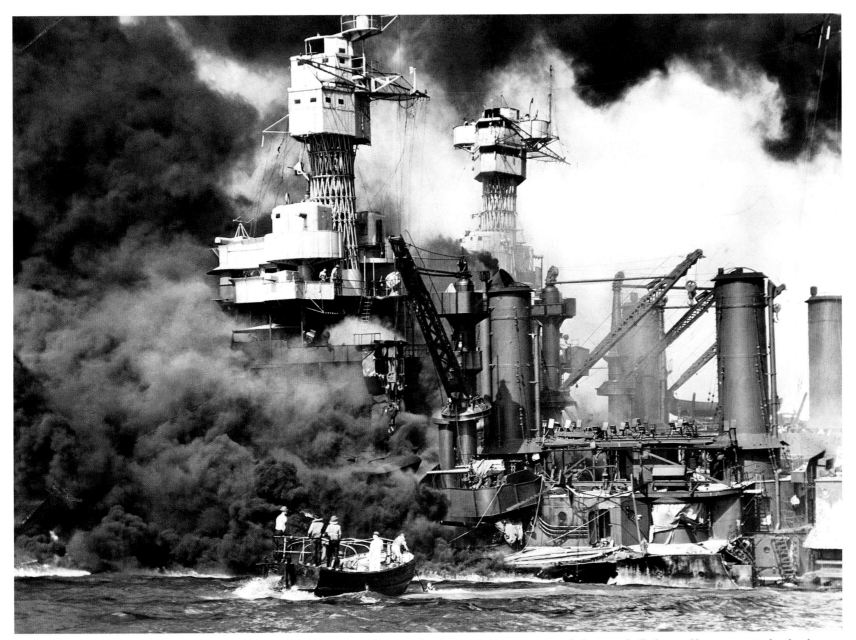

SURPRISED *Rescue boats aid crews from the battleships U.S.S. West* Virginia, *foreground, and U.S.S.* Tennessee, *rear. Both ships were badly damaged but were repaired and took part in the war. In a stroke of good fortune, U.S. aircraft carriers were on maneuvers and thus were not attacked. Japan soon attacked the Philippines, Thailand and Hong Kong as well*

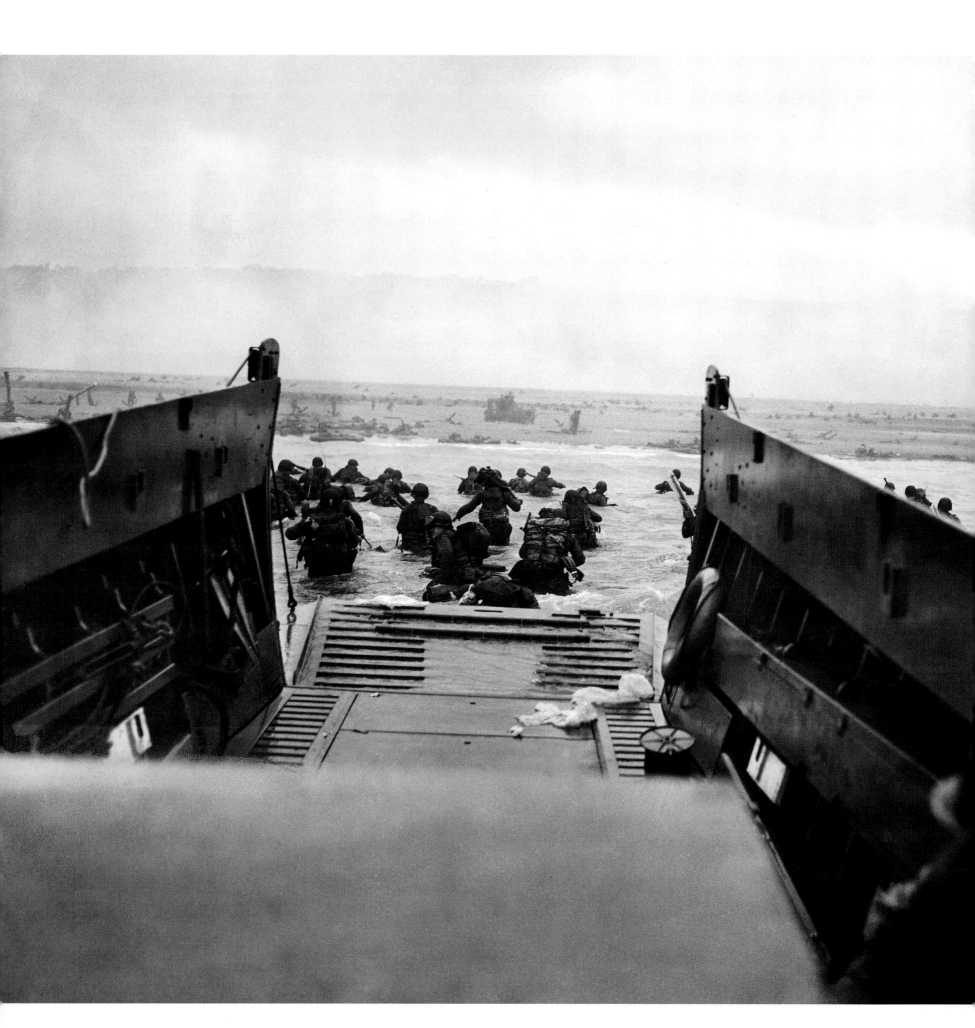

D-Day Paves the Way for Germany's Defeat

82

It was one of history's grand set pieces, its power undiminished by its inevitability. War-watchers knew that the Allies—the U.S., U.K., and Free France—could only dislodge Germany's stranglehold on Europe with an amphibious invasion. Even so, when the day finally came—June 6, 1944—Operation Overlord was thrilling in its size and range. Attacking German-held beaches in Normandy, France, in one of the largest operations in military history, the Allies hurled some 150,000 troops, borne by more than 5,000 ships and landing craft and supported by 12,000 aircraft and a preliminary strike by 19,000 paratroopers, against Hitler's "impregnable" Fortress Europe.

Thanks to brilliant planning, valiant troops and overwhelming superiority in arms, the Allied soldiers gained a foothold in Normandy; by August, they had liberated Paris. Even as two Russian armies advanced quickly on Germany along the Eastern Front, Allied troops now pushed across Belgium and into Germany from the west. In February 1945, Allied leaders met in Yalta in the Crimea to lay plans for their occupation of Germany: the sun was setting on Hitler's Third Reich. U.S. leaders decided to allow Joseph Stalin's Russian armies to claim the prize of Germany's capital, Berlin, and the German dictator committed suicide in his underground bunker as Russian troops took control of the city. After six years of devastation and sacrifice, World War II ground to an end in Europe, at a staggering cost of tens of millions of deaths.

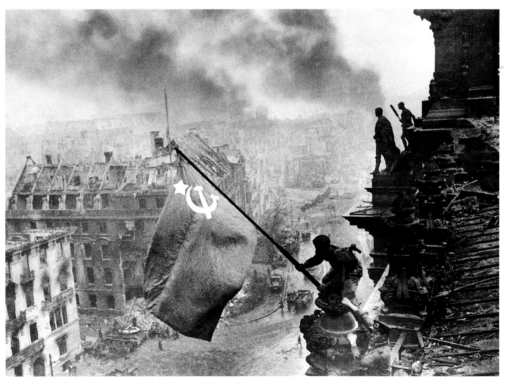

D-DAY AND BERLIN'S FALL *At left, U.S. troops exit a landing craft and wade toward a strand designated Omaha Beach in Normandy, where fighting was particularly deadly on D-Day. Above, a Russian soldier waves a Soviet flag over the Reichstag, Germany's parliament building, on May 2, 1945, as the capital city is taken*

The Horrors of the Holocaust Shock the World

83 As British troops prepared to enter Adolf Hitler's collapsing Germany early in 1945, Prime Minister Winston Churchill addressed them, warning that they must maintain their courage as they entered Hitler's "dire sink of iniquity." The troops recalled his words when they began to liberate the prisoners trapped in Germany's vast network of concentration camps. Amid scenes of horror that still defy credulity, the Allies uncovered the full extent of Hitler's maniacal racism: his political prisoners, numbering in the hundreds of thousands, had been starved, beaten, humiliated, experimented upon, all in the name of German cultural supremacy. Singled out for mass extermination were Europe's Jews, long Hitler's obsession. More than 6 million Jews died in what we now call the Holocaust; millions more Gypsies, disabled people, criminals, homosexuals and members of "inferior" ethnic groups also died at the Nazis' hands. The message of these assembly lines of death: the technological advances of the 20th century, if thrilling, had far outpaced man's ethical progress.

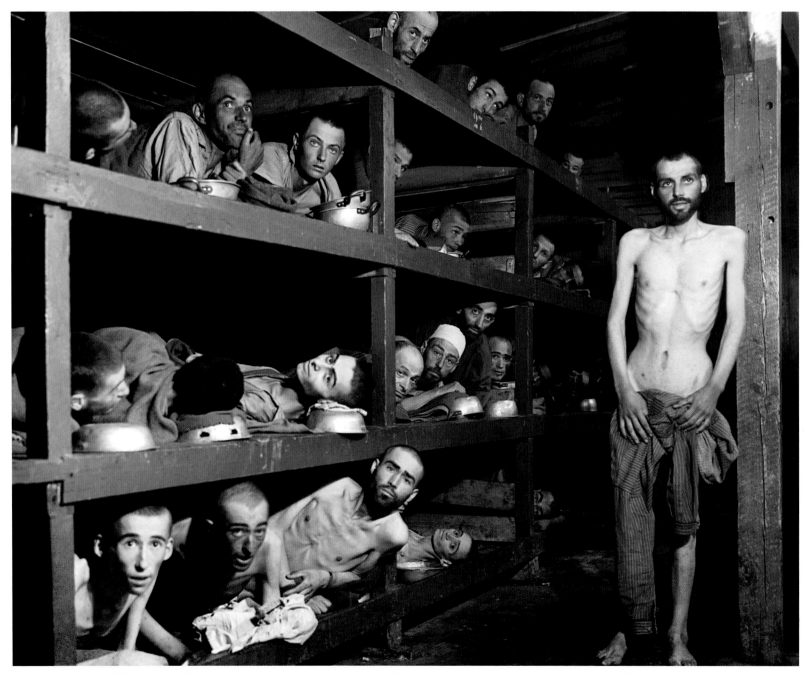

CAPTIVES *Inmates of the Buchenwald concentration camp are photographed on April 16, 1945. Holocaust chronicler Elie Wiesel is seventh from left on the second row of bunks*

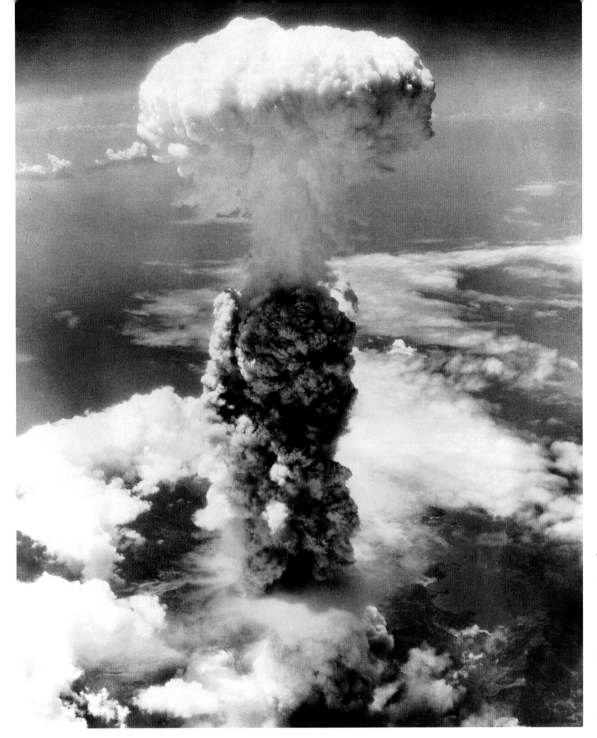

SHAPE OF DREAD *The first atom bomb was used on the Japanese city of Hiroshima on Aug. 6, 1945, killing as many as 150,000 civilians; many victims died of radiation sickness after the event. At left, the detonation of the second bomb leaves a characteristic mushroom cloud over Nagasaki on Aug. 9, where as many as 80,000 people died*

A New Weapon Brings the War to a Sudden End

84

Hitler's Germany may have fallen by May 1945, but World War II was far from over. That month, 180,000 U.S. troops who had been island-hopping toward the Japanese homeland were battling Japanese troops on Okinawa, south of the Japanese archipelago. The soldiers they faced clung tightly to the nation's Bushido warrior code, refusing to surrender and even committing suicide to kill Americans. Okinawa's civilians joined their fight: by battle's end some 110,000 Japanese troops and 150,000 civilians would be dead. The message: an invasion of Japan's home islands might last years and claim millions of lives on both sides. But that invasion never took place, thanks to a secret new weapon, the atom bomb, that not only brought Japan's surrender but also ushered in a new age of energy based on the splitting of the atoms of radioactive elements, releasing their latent power.

It was physicist Albert Einstein who first brought the destructive power of atomic energy to President Franklin D. Roosevelt's attention. In the top-secret Manhattan Project, U.S. scientists created the first nuclear reaction—achieved by Enrico Fermi's team in Chicago late in 1942—and then built three atom bombs. President Harry Truman decided that using the bombs would in the end save many more lives than they would claim, and he ordered them deployed against two Japanese cities. Within the week, Japan surrendered. World War II was over, but a new age of nuclear insecurity—soon dubbed the Age of Anxiety—had begun.

A Tiny Gizmo Sparks Electronic Wonders

85 The 20th century marched in to the clank of steel and surfed out to the clicks of millions of computer mice. The transition from an industrial age to an information age neatly divides at the midpoint of the century, with the invention of a new workhorse of electronics, the tiny transistor. Much as the discovery of oil primed the pump for the development of the automobile, the transistor broke the ground for the computer revolution.

Early computers—essentially, elaborate webs of electrical switches—processed information via electronic vacuum tubes similar to those used in radios. But they soon ran up against three barriers: the tubes were large, they were expensive, and they generated staggering levels of heat. The first electronic computers, mainframes built by Remington Rand and IBM, were hulking monsters that filled entire rooms. Enter William Shockley, Walter Brattain and John Bardeen, scientists at Bell Labs who created the first transistor in December 1947. Using a class of materials known as semiconductors (because, under certain predictable conditions they conduct electric current, while in other predictable cases, they block it), they rigged up a circuit that could be used to both transfer electricity and resist it: hence the name transistor.

The transistor is the master invention of the second half of the 20th century; it drove the entire computer revolution and is in the guts of almost every consumer-electronics product, from TVs and radios to watches, ovens and cell phones. Its inventors were awarded the Nobel Prize in Physics in 1956.

TWO-WAY STREET *Like all transistors, the first working model, above, was what scientists call a binary switch: it was either "on," allowing electricity to flow, or "off," stopping the current*

India's Independence Is Purchased in Blood

86 When TIME named Mohandas Gandhi, the leader of India's independence movement, its Man of the Year in 1930, the brilliant shaper of public opinion was residing in a British prison in Poona. The lawyer-activist devoted much of his life to freeing his people from Britain's colonial rule, and in time he succeeded: in the wake of World War II, European hegemony could not survive. An exhausted United Kingdom was finally prepared to bid farewell to its treasured Raj in the subcontinent.

Independence arrived at the stroke of midnight on Aug. 15, 1947, and in the chaotic first days of self-rule, India erupted in religious and ethnic rioting. A new nation, Pakistan, had been partitioned from India as a homeland for its large minority Muslim and Sikh populations, and now millions of people were uprooted and moved to new homes—or stayed at home to face violence from ethnic foes. Hundreds of thousands died in the region's bloody round of birth pains. East Pakistan, a province of the new Islamic nation, was set aside for Muslims living in India's eastern provinces; in 1971 a civil war there would bring forth another new nation, Bangladesh.

MOVING OUT *Sikhs in India's Punjab region march toward new homes in Pakistan. Freedom came in August; by late October, TIME reported: "... at least 100,000 have died, not of germs or hunger or what the law calls 'Acts of God,' but of brutal slaughter ... Everywhere the armed and the many devoured the helpless and the few"*

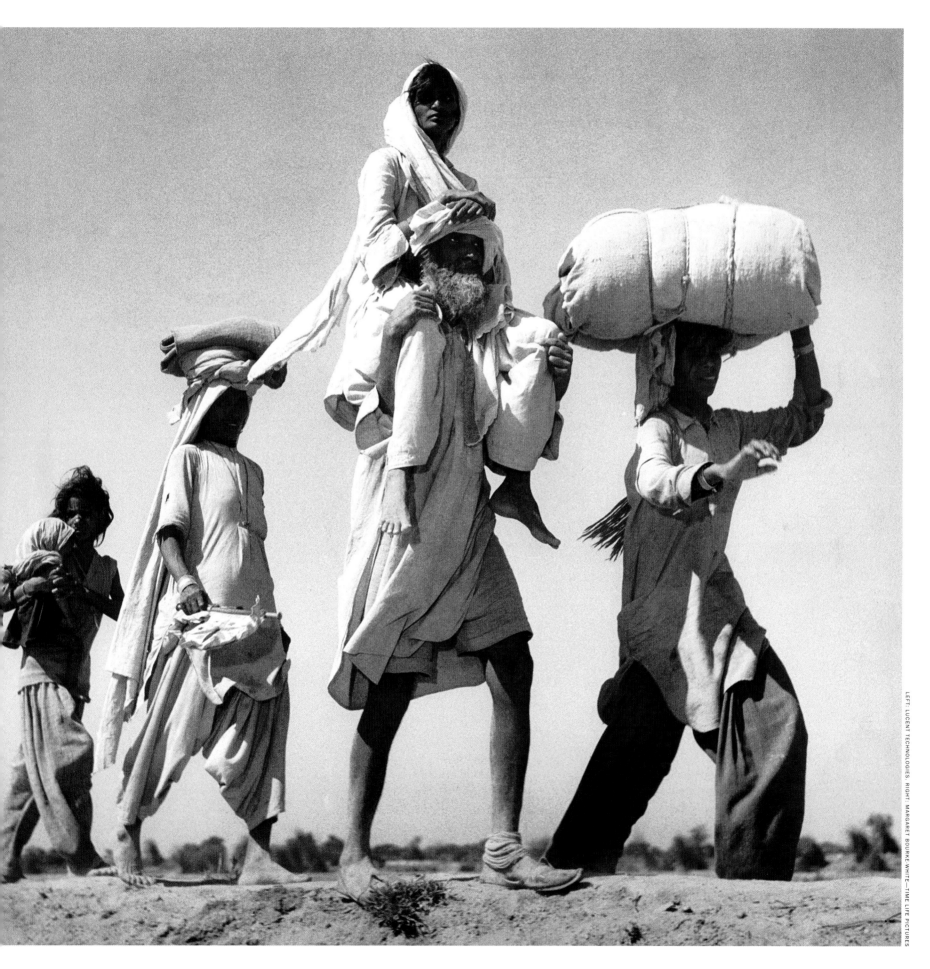

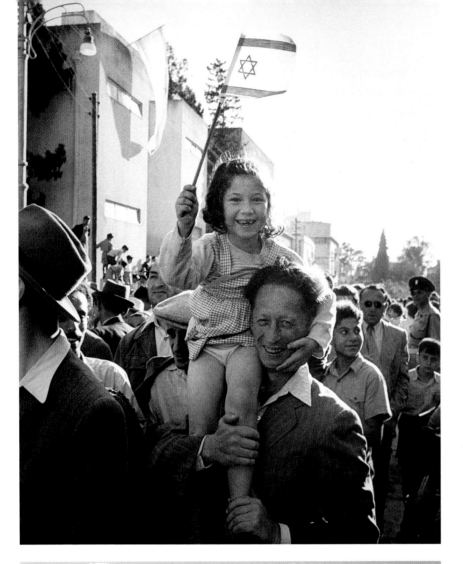

Jews Force the Creation of A Long-Sought Homeland

87 Shortly after sunrise on May 14, 1948, Britain's Union Jack flapped down from its staff over Government House, on Jerusalem's Hill of Evil Counsel, ending the British Mandate over Palestine after 26 years. At 4 p.m. David Ben-Gurion, the longtime leader of the Jewish settlers, or Zionists, who had flocked to Palestine from Europe, proclaimed "the establishment of the Jewish State in Palestine to be called Israel." Jubilant citizens of Tel Aviv danced in the streets, paraded with blue-and-white Star of David flags, prayed in their synagogues. From the ashes of Hitler's Holocaust, in the harsh sands of Middle Eastern deserts, on land sacred to its scattered people for two millenniums of wandering, Israel had forced itself into being in a hostile part of the world by combining its own energy and the world's sympathy, by force of arms and by self-reliance.

The Israelis had a friend in the White House, where President Harry Truman, rejecting the advice of close counselors, strongly supported the founding of Israel; the U.S. immediately recognized the new nation, the first other state to do so. Israel's Muslim neighbors, united as the Arab League, welcomed the new arrival with an attack, as troops moved in from Transjordan and Lebanon, Egypt and Syria. The Jews' tough underground army, the Haganah, hardened from years of fighting to protect Jewish settlements in Palestine, stymied the attack. By the summer of 1949 all Israel's enemies had signed cease-fires brokered by the U.N. Israel had elbowed its way into existence, but it did so by elbowing out as many as 700,000 Palestinian Arabs, who fled the new state. Today, more than 60 years later, Jews and Palestinians seem to stand no closer to peace than they did on that historic day in 1948.

A NEW STATE *At top: Jews celebrate Israel's founding in the streets of Tel Aviv on May 14, 1948, when British rule ended and independence was declared. In the middle picture, a Jewish settler works on a kibbutz in the Negev Desert in 1947. At bottom, Palestinian refugees who left Israel in the wake of its independence take shelter in a Roman amphitheater in Amman, Transjordan*

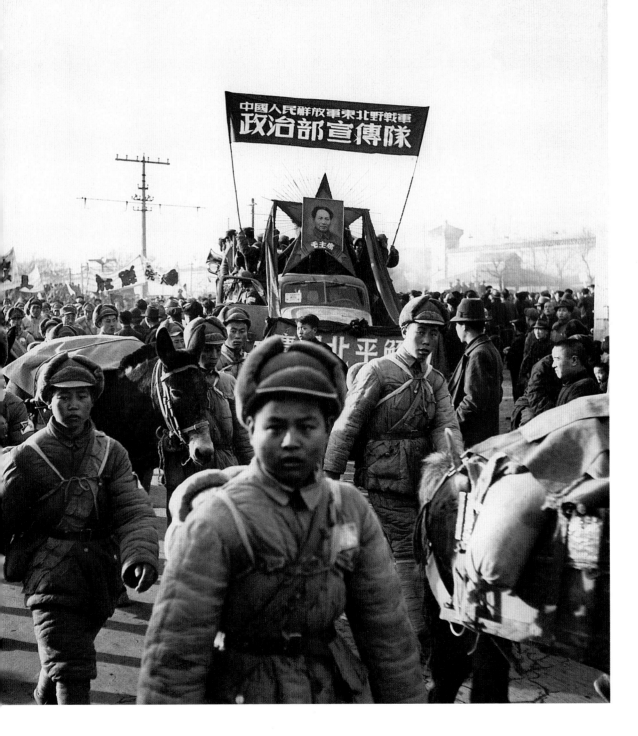

Mao Zedong Wins the Battle to Control China

88 "Let China sleep, for when she wakes, she will shake the world," Napoleon Bonaparte observed. Two centuries after that remark was made, it is finally coming true: at the beginning of the 21st century, China's rocketing economy is the envy of the world. But the vast nation's newfound energy was hard-earned and long in coming; it followed a century in which China's citizens waged a lengthy civil war that was won by the communist guerrillas led by Mao Zedong, a child of privilege who grew up to become an ardent and effective socialist revolutionary. Yet once firmly under Mao's seemingly pathological rule, his people only sank further into madness and misery.

Through the 1920s and '30s, Mao's rural guerrillas, supported by their communist allies in Russia, battled the Nationalist forces led by U.S. ally Chiang Kai-shek, although in times of deep national peril, as when the Japanese invaded China in the 1930s, the two fierce antagonists turned their attention to fighting a common foe. The Nationalist forces were hated for their corruption, arrogance and disdain for the nation's masses; Mao's guerrillas, in contrast, were admired for their honesty and humility, strictly enforced at Mao's command. Despite extensive U.S. aid during World War II, the Nationalists lost the battle for the hearts and minds of the Chinese people. Chiang fled to Taiwan; on Oct. 1, 1949, Mao addressed a crowd of some 300,000 cheering people in Beijing's Tiananmen Square, declaring that at last "China has stood up!" No longer, he was saying, would China be content to take a second place on the world stage. Totalitarian tyranny would follow, but China's reveille had been sounded.

VICTORY *Mao's guerrilla army enters Beijing in June 1949; months later he took full control of China's government*

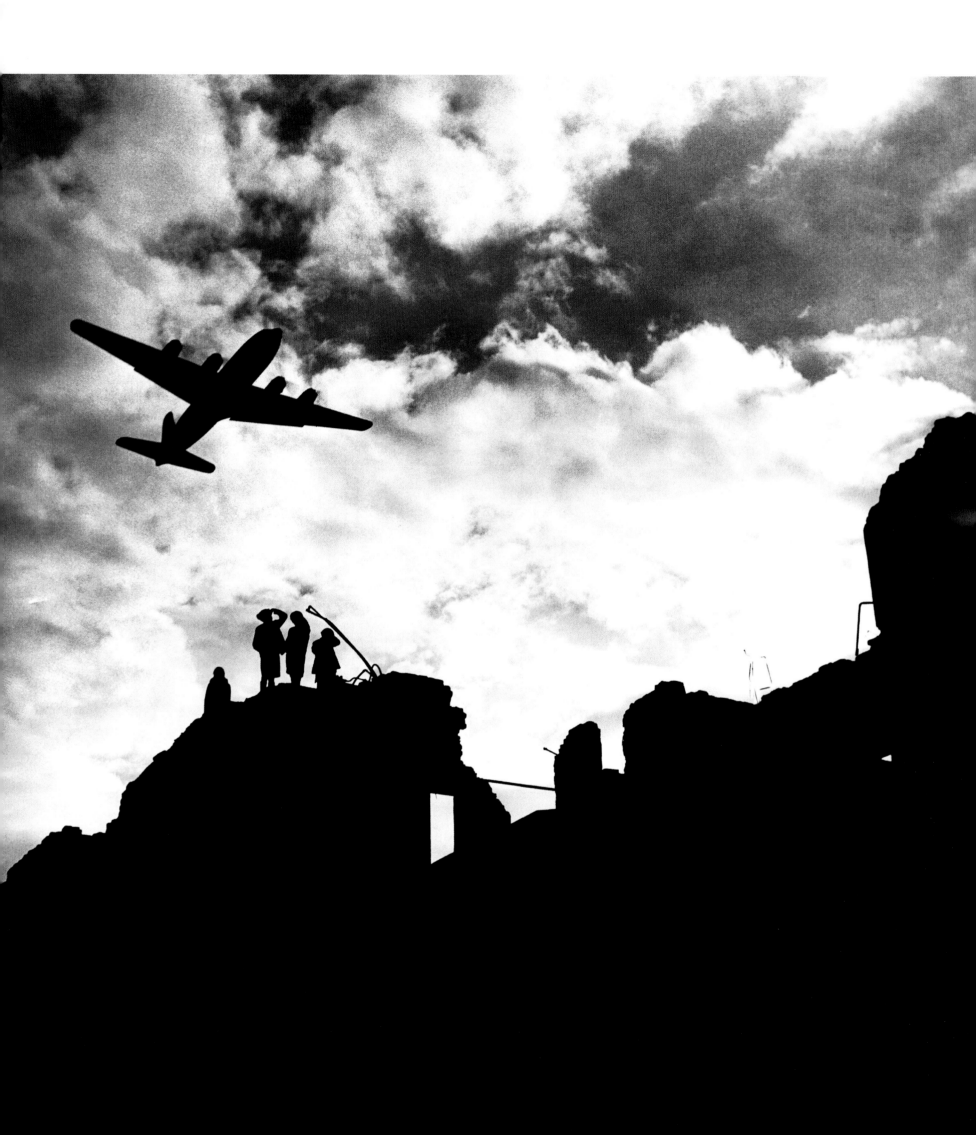

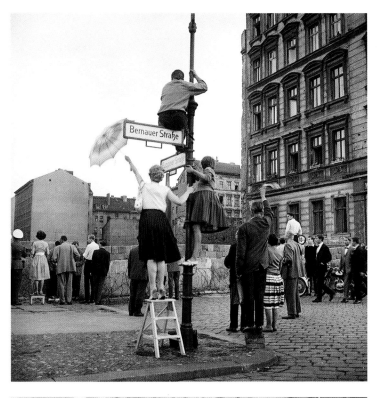

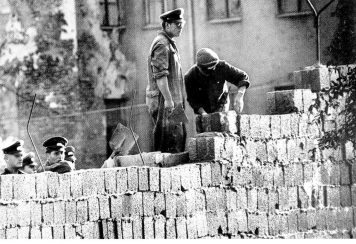

AERIAL BRIDGE *Allied planes flew more than 200,000 relief flights into West Berlin, left, supplying some 1.5 million tons of food and supplies. Above, in 1961, 13 years after the airlift began, the Soviets built the enduring symbol of the cold war, the Berlin Wall; at top, Berliners wave to each other across the great divide*

An Airlift to Isolated Berlin Ushers in the Cold War

89

The incessant roar of the planes—that typical and terrible 20th century sound, a voice of cold, mechanized anger—filled every street in Berlin. It reverberated in the shattered houses; it throbbed in the weary minds of the people, who were bitter, afraid, but far from broken; it echoed in intently listening ears in the Kremlin. The sound meant that the West was standing its ground and fighting back in a new kind of world war: a cold war.

The U.S., Britain and other allies had teamed with their ideological foe, Joseph Stalin's U.S.S.R., to defeat a common enemy, Adolf Hitler. But Germany's utter destruction by the end of World War II created a power vacuum in Eastern Europe, and Stalin rushed to impose Soviet hegemony "from Stettin in the Baltic to Trieste in the Adriatic," in the words of Britain's Winston Churchill, who memorably christened the Soviet power zone the Iron Curtain. The cold war would define geopolitics until the Soviet Empire dissolved in the early 1990s. Berlin, occupied after the war by the four Allied powers (the U.S., Britain, France and the U.S.S.R.) but lying within the Soviet region, became a flash point where the Soviets tested Western resolve, again and again.

In 1948 and '49 the battle for allegiance was fought in the hearts and minds of Berliners—but most of all it was fought in their bellies. When the three Western allies united their occupation sectors in Germany to create a new entity, West Germany, the Soviets blockaded access to Berlin, attempting to starve into submission the 2 million people in the city's Western zones. Led by U.S. President Harry Truman, the Allies vowed to feed West Berliners by air. In Operation Vittles (the G.I.s' term) they landed several planes an hour, 24/7, until the Soviets lifted the blockade—after 318 days of flights. The West had won a battle; winning the cold war would take decades.

TWISTS AND TURNS *At right, Watson, on left, and Crick pose with their 3-D model of DNA; Crick's initial sketch of the double helix is below. X-ray images of DNA created by British biophysicist Rosalind Franklin played a key role in the two men's breakthrough*

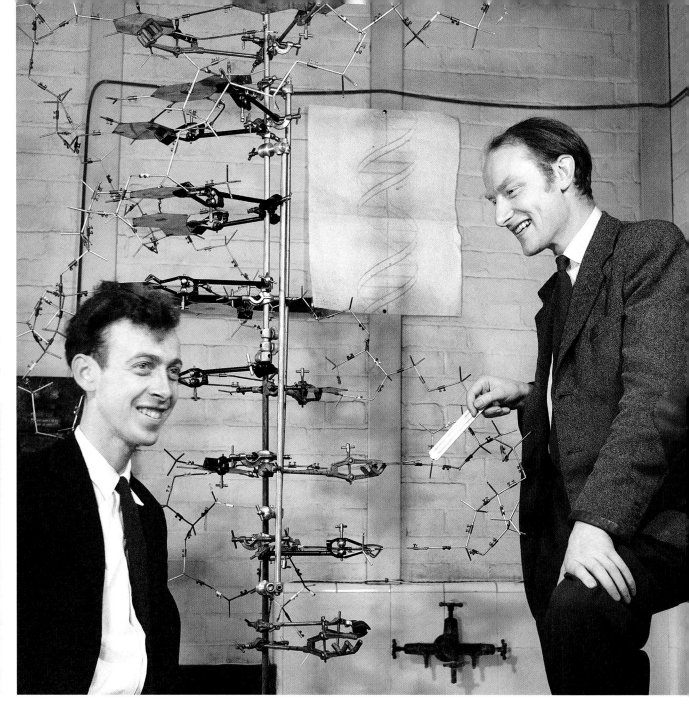

Deciphering the Blueprint of Life

90 James Watson remembers cringing when his colleague Francis Crick burst into the Eagle pub in Cambridge, England, on Feb. 28, 1953, and declared to regulars that the two men had discovered "the secret of life." True, the onetime ornithologist and the former physicist had created a plausible model for the structure of DNA, heredity's master molecule, that morning. If they were right, biologists would finally understand how parents pass characteristics on to their children. Watson, 24, an American, and Crick, 36, a Briton, would have unlocked the blueprint for how the human body operates, solving the mysteries of heredity and evolution all in one shot.

But they also might have been wrong, as they had been a year and a half earlier, when the two rookies' first attempt to map DNA failed. Even Linus Pauling, the world's greatest chemist, had blown his own "solution" to DNA's makeup a couple of months before. So when their double-helix model seemed to make biochemical sense, a more cautious man might have toned down his rhetoric. The fact that the double helix and the names Watson and Crick are so familiar today, though, proves that DNA was every bit as important as Crick thought. Not only did it explain heredity, but it would also lead to such practical applications as DNA forensics in law enforcement, testing for genetic diseases and the development of an entire biotechnology industy. Crick's bold assertion was, if anything, stunningly accurate. Cheers!

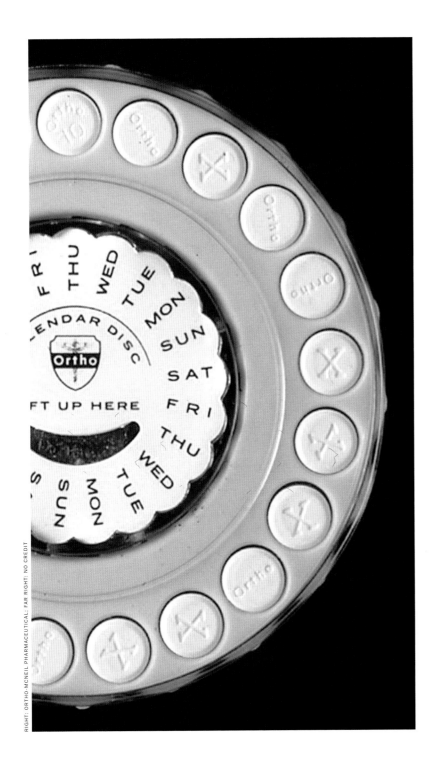

The Pill is Developed, and Sex And Pregnancy Get a Divorce

91 Margaret Sanger, totally unaware that her lifelong dream had become reality, spent the day of May 9, 1960, at her home outside Tucson, Ariz. Since 1914 she had battled ridicule and rigid laws, even gone to jail, all in pursuit of a simple, inexpensive contraceptive that would change women's lives—and save some as well. Now she was 80 and retired from her globe-trotting efforts. No one from G.D. Searle & Co., the drug firm, thought to call the woman who had pioneered and pushed for funding to develop the world's first birth-control pill, called Enovid-10, a synthetic combination of hormones that suppresses the release of eggs from a woman's ovaries. Nor did she hear from John Rock and Gregory Pincus, the doctors who developed the oral contraceptive with $3 million that Sanger had raised from her friend Katherine McCormick, the International Harvester machinery heir.

Sanger got the news the next morning in the newspaper, where a five-paragraph story announced the Food and Drug Administration's approval of what everyone soon called the Pill as safe for general use. The life-long birth-control crusader, who developed her sense of mission after watching her mother die at age 50, worn out by 18 pregnancies and 11 children, celebrated her victory alone.

The Pill was one factor in the new openness about sexuality that characterized the 1960s and '70s. Millions of women—and men—hailed the breakthrough: for the first time in human history, sexual intercourse had been pharmaceutically separated from the possibility of pregnancy, and a new term, "family planning," entered the vocabulary.

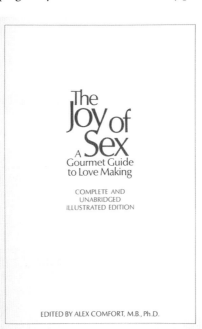

BRAVE NEW WORLD *The Pill was hailed as a force for personal liberation by many, but other voices—including that of the influential Roman Catholic Church—denounced birth control as human tampering with a reproductive cycle created by God. Many blamed the Pill for the sexual revolution that began in the 1960s, as exemplified in the 1972 best seller at near left. But TIME's Nancy Gibbs noted in a 2010 cover story that: "[The Pill] was blamed for unleashing the sexual revolution among suddenly swinging singles, despite the fact that throughout the 1960s, women usually had to be married to get it."*

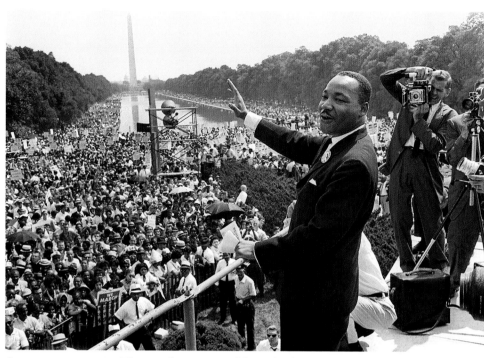

CALL HIM A DREAMER *The most eloquent voice of the civil rights movement belonged to Atlanta-born preacher Martin Luther King Jr., who galvanized the nation with his "I Have a Dream" speech at the Lincoln Memorial in Washington in August, 1963, above. King was felled at 39 by an assassin's bullet in April, 1968. At right, black protesters in Birmingham, Ala., are drenched by powerful police hoses earlier in 1963*

U.S. Blacks Finally Win Their Civil Rights

92 "What happens to a dream deferred?" asked African-American poet Langston Hughes. "Does it dry up/ Like a raisin in the sun?/ Or fester like a sore—/ And then run?" For U.S. blacks, the answer was: All of the above. The dream deferred was that of equality with America's white majority, whose price, it seemed, had been paid in blood in the U.S. Civil War. Yet for long decades after that conflict ended, U.S. blacks were still denied the most central of American promises, opportunity. But after black soldiers fought with distinction abroad in World War II, only to return to inferior status at home, the walls in the fortress of segregation began to crack. In the long-running civil rights movement that followed, African Americans and their white supporters confronted the system of segregation, especially in the nation's South, in a series of struggles that produced heroes of great courage and scenes of high drama.

In 1954 the U.S. Supreme Court ruled that U.S. schools could no longer be segregated by race. In 1956, a black boycott successfully ended segregation on the Montgomery, Ala., bus system. In 1957, President Dwight Eisenhower sent the National Guard into Little Rock, Ark., to protect young black students who were integrating a city high schools. As the 1960s began, blacks "sat in" at segregated lunch counters, only to be ridiculed and attacked, while "Freedom Riders" risked beatings by riding buses into segregated stations. Under the inspired leadership of the Rev. Martin Luther King Jr., blacks engaged in nonviolent marches and protests that won over most Americans to their cause. Finally, under the ramrod leadership of President Lyndon B. Johnson, the U.S. Congress passed legislation in 1964 and '65 that for the first time extended full equality under the law to America's black citizens.

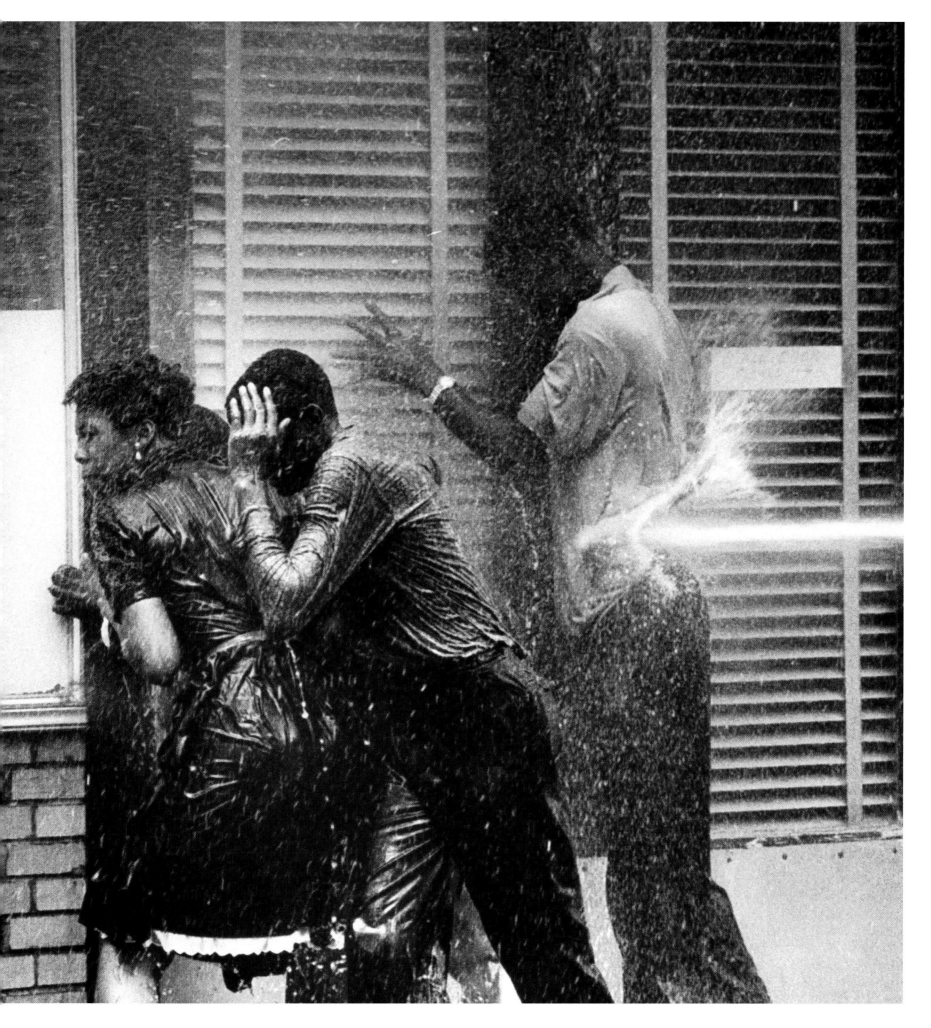

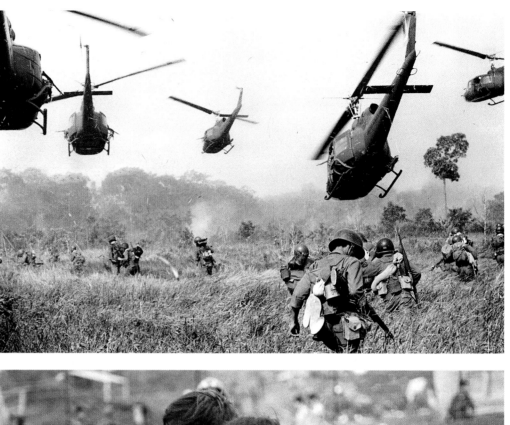

A Long, Brutal War Divides Both Vietnam and the U.S.

93 The battles of the cold war flared up all around the world, but no land would be so devastated by the global rivalry as the small Asian nation of Vietnam, where the U.S. waged a long war only to suffer a grave defeat. Backstory: in 1954 a group of freedom fighters led by communist Ho Chi Minh defeated a French army at Dien Bien Phu, ending France's colonial hegemony. Per a Geneva peace accord that followed, Vietnam was partitioned into communist-leaning North and West-leaning South, pending a 1956 election. Concerned that the communists might win, the U.S. backed South Vietnamese leader Ngo Dinh Diem's successful plan to stop the election. The nation remained divided, and the Viet Cong, Northern insurgents, launched a guerrilla war in the South.

President John F. Kennedy sent 16,000 U.S. military "advisors" into South Vietnam; his successor, Lyndon Johnson, fearing that a communist victory in Vietnam might eventually put all of Southeast Asia into the Soviet-Chinese sphere, upped the ante. Beginning in 1965, he poured U.S. troops into the South: the U.S. commitment escalated from some 22,000 troops in 1964 to more than 500,000 in 1968. The massive ramp-up seemed to have little effect on North Vietnam, but it led to serious unrest in a troubled America, where draft-age students and many others increasingly spoke out against the war. Johnson declared he would not run for re-election in 1968, and new President Richard Nixon further escalated the war by invading Cambodia in 1970. He managed to get the last U.S. troops out of the country by 1973, under the fig leaf of a "peace accord"—two years before North Vietnamese troops over-ran the South, and U.S. civilians in Saigon were forced to flee from rooftops via helicopter. The glow of the U.S. victory in World War II seemed ancient history.

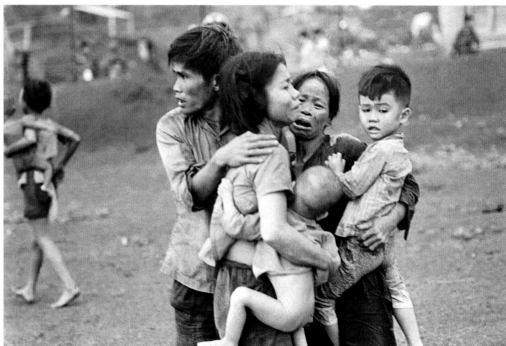

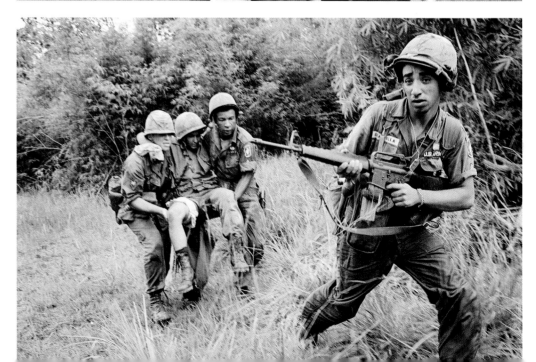

LEFT PAGE, FROM TOP: HORST FAAS—AP IMAGES (3); RIGHT PAGE, FROM TOP: LARRY BURROWS—LIFE MAGAZINE, KEYSTONE—GETTY IMAGES

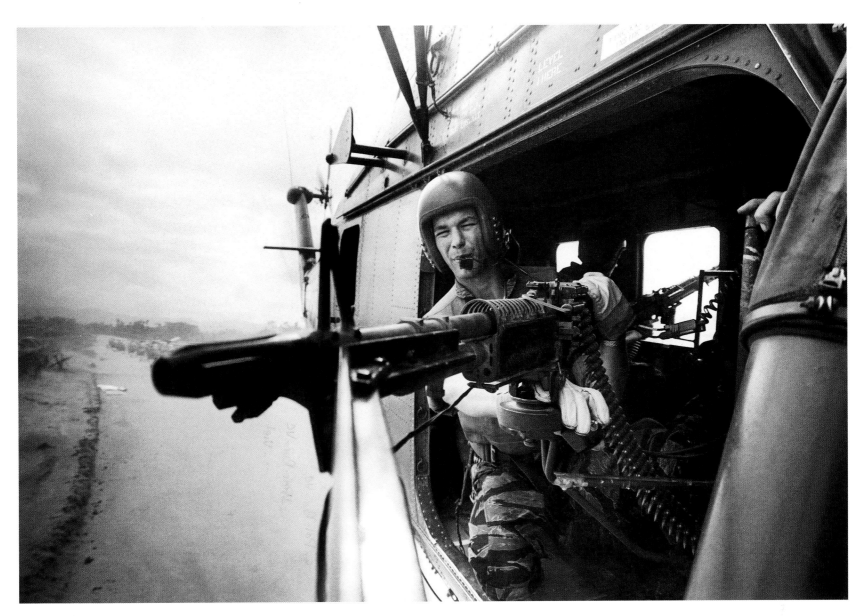

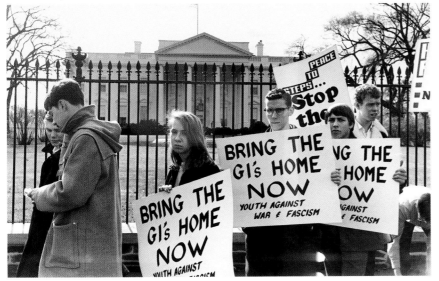

TWO STATES, DISUNITED *Above, a U.S. helicopter gunner returns fire from the ground in 1965, when all these photos were taken. By war's end, more than 58,000 Americans were dead and more than 300,000 wounded; it is estimated that more than 2 million Vietnamese on both sides died in the long conflict. Below, young Americans protest the war outside the White House. Antiwar feeling began slowly but gained momentum, and by the late 1960s, police and protesters were fighting on the streets of U.S. cities. Left page, top: U.S. Army helicopters support a ground offensive near the Cambodian border. Fighting in alien environments against committed local forces, U.S. troops found themselves in a position like that of British soldiers in the American Revolution. Middle: South Vietnamese civilians at Dong Xoai, where some 150 local residents were killed in two days. Bottom: U.S. medics carry a wounded paratrooper to receive aid outside Bien Hoa, South Vietnam*

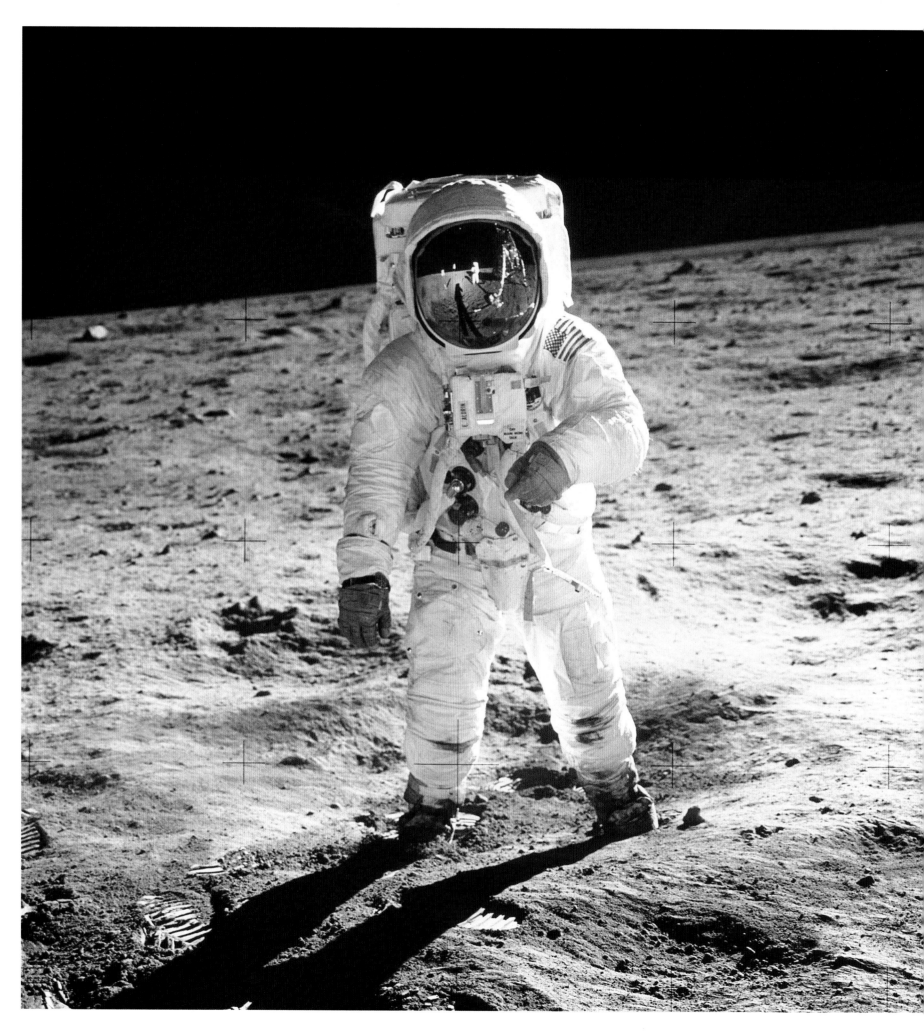

Humans Set Foot on the Moon

94

July 20, 1969: A ghostly, white-clad figure slowly descended a ladder. Reaching the bottom rung, he lowered himself into the bowl-shaped footpad of *Eagle,* the spindly lunar module of the U.S. Apollo 11 mission. Then he extended his left foot, tentatively, as if testing the water in a pool, for he was indeed testing a wholly new environment for man. After a few short seconds—that only seemed interminable—astronaut Neil Armstrong placed his foot firmly on the fine-grained surface of the moon. After a brief pause, the first man on the moon spoke the first words on lunar soil: "That's one small step for [a] man, one giant leap for mankind."

Minutes later, Armstrong was joined by Edwin ("Buzz") Aldrin; gaining confidence with every step, the two loped across the barren landscape for 2 hr. 14 min., while the TV camera they had set up 50 ft. from the *Eagle* lander transmitted their steps with remarkable clarity to enthralled audiences on Earth, some 250,000 miles away. Their feat was the crowning moment of the space race, in which the U.S. and U.S.S.R. carried their cold war rivalry into the realm of science, and the act of discovery became a proxy for national and economic pre-eminence. The moon landing fulfilled slain President John F. Kennedy's challenge to Americans to land a man on the moon by the end of the 1960s. But this act extended beyond the realm of politics: for the first time, man had broken his terrestrial shackles and set his feet on another world. Armstrong's groping foot, said TIME, "was a symbol of man's determination to step, and forever keep stepping, toward the unknown."

STAR SEARCH *The Carina Nebula, photographed by the Hubble Space Telescope in 2009*

Journeys into Space

1957 The Soviet Union launches Sputnik, the first artificial satellite, igniting a space race with the U.S.

1961 Soviet cosmonaut Yuri Gagarin orbits Earth, putting the U.S.S.R. firmly in the lead of the space race.

1962 Astronaut John Glenn becomes the first American to orbit the planet, as U.S. space agency NASA rushes to catch up with the Soviet lead in space.

1967 Three U.S. astronauts die on the launchpad during tests for the Apollo program, which seeks to land men on the moon by the end of the 1960s.

1968 On Christmas Eve, three U.S. astronauts in low lunar orbit read passages from the Old Testament as the Apollo program hits high gear.

1969 Two U.S. astronauts land on the moon in July.

1972 The Apollo 17 mission in December is the last visit by U.S. astronauts to the moon.

1982 The U.S. space shuttle program becomes active, and a fleet of craft performs low-Earth-orbit missions.

1990 The Hubble Space Telescope is launched; after a faulty mirror is fixed in 1993, the array of scopes on the orbiting platform returns a host of significant findings.

1998 In-orbit construction begins on the International Space Station, a multinational facility in low Earth orbit. The station is slated to be completed late in 2010.

MOONWALKING *At left, U.S. astronaut Buzz Aldrin stands on the moon, capping the 8-year U.S. Apollo program. Above, the command module of the previous lunar mission, Apollo 10, is seen as photographed on May 22, 1969, from the lunar module, which did not land*

143

Liquid wealth *A supertanker docks on the Persian Gulf at the huge oil refinery in Ras Tanura, Saudi Arabia, one of the world's largest*

Oil Riches Create a New Map of The World's Wealth and Power

95 The discovery of large oil reserves in Pennsylvania in 1859 and the development of drilling technology to extract the petroleum arrived with exquisite timing: within decades, the advent of the automobile made oil the world's essential lubricant of mobility and economic growth. The regions of the world that boasted large reserves of the precious fluid found themselves showered with wealth, from the dusty plains of Texas and Oklahoma to Venezuela, Iran and the deserts of Arabia. Within years, "black gold" became one of the most sought-after substances on the planet. In time, this quest for "the prize," as Daniel Yergin termed it in a 1990 best seller, would radically shift the world's balance of power.

Early in the 20th century, John D. Rockefeller's Standard Oil Company exerted a stranglehold on the U.S. economy. In 1941 Japan's lust for oil sent its aircraft to bomb the U.S. naval base at Pearl Harbor in Hawaii; in 1942 the lure of petroleum drove Montgomery against Rommel in the deserts of North Africa. And in a transformation rivaling a story from the *Arabian Nights,* long-neglected Middle Eastern kingdoms suddenly found themselves at the center of power. Oil's sway over the world's economic engines was highlighted in 1973, when an embargo by OPEC, the Organization of Petroleum Exporting Countries, crippled the global economy and signalled the ascendance of Islamic states on the world stage.

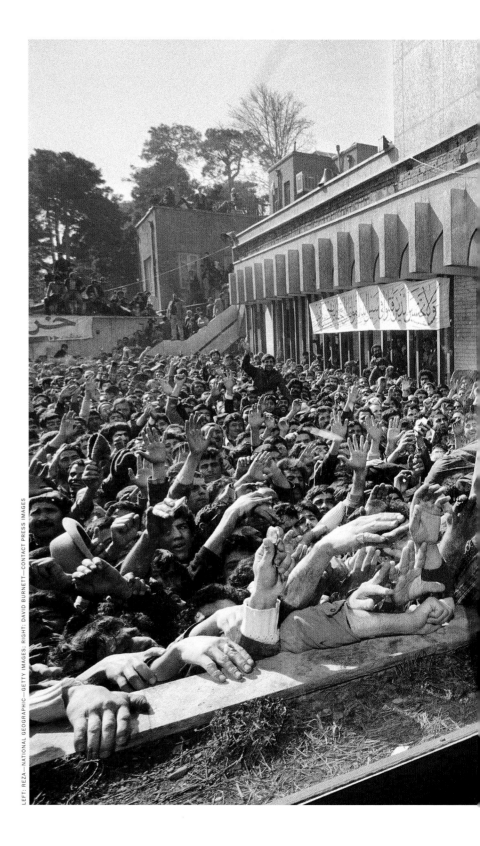

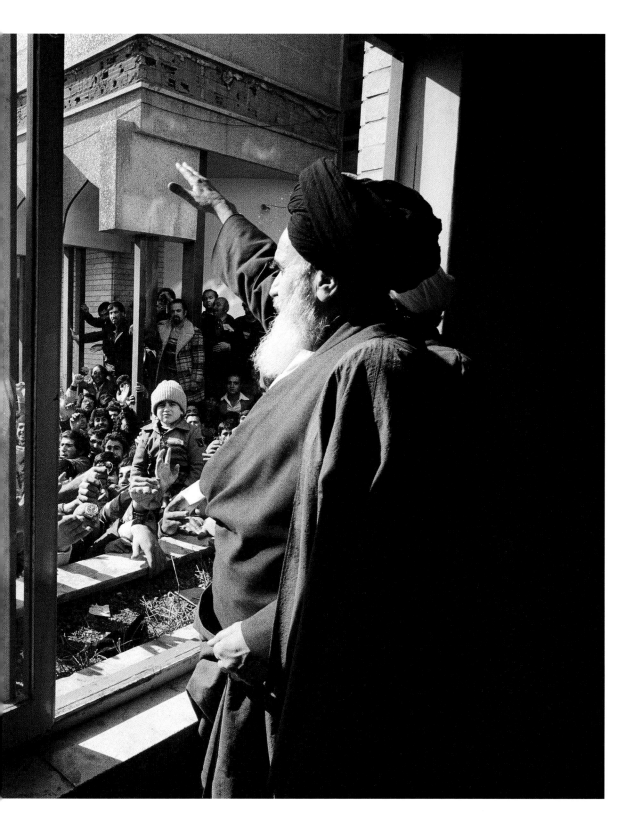

Iran's Revolution Ignites An Islamic Resurgence

96

It was an age-old recipe for revolution: a corrupt regime led by a greedy ruler who turned his back on his own culture; an austere, committed rebel whose power and mystique grew once he was exiled from his land. The nation was Iran in the 1970s. The ruler was Shah Mohammad Reza Pahlavi, a U.S. client who had been placed on the Peacock Throne by a CIA-organized coup in 1953 that overthrew elected leader Mohammad Mossadegh. The rebel was Ayatullah Khomeini, a militant Muslim holy man banished by the Shah.

Just as the power of apartheid foe Nelson Mandela grew while he languished unseen in a South African prison, Khomeini's mystique flourished while he was in exile. As the fundamentalist Ayatullah's clandestine tapes urging revolt spread through Iran, the Shah's regime tottered. Finally, the Shah left the country in January 1979, and the Ayatullah returned to Iran to a hero's welcome.

Soon, with the aid of fundamentalist clerics, Khomeini began running an even stricter dictatorship than the Shah's. When fanatic anti-American Iranians attacked the U.S. embassy in Tehran in November 1979, Khomeini supported their seizure of 52 hostages. It was the first act of a long-running crisis; for 444 days, Americans watched in agony as their countrymen were humiliated by their captors. When President Jimmy Carter attempted a daring rescue operation, it fizzled in the desert; Khomeini held the hostages until Carter left office in 1981.

Khomeini's revolution was not limited to Iran: it set the spark to a long-simmering fundamentalist revival across the entire world of Islam. Fueled by oil riches and newly inspired by religious yearnings, the Muslim lands of the Middle East were now prepared to assume a more active role in global politics.

RETURN IN GLORY *On Feb. 5, 1979, shortly after returning from almost 15 years of exile in Iraq and France, Ayatullah Ruhollah Khomeini salutes his followers at a Tehran school*

A Peaceful End to the Cold War

97

The cold war was well named: throughout its 44 years, spanning 1945 to 1989, this battle between rival superpowers was generally fought not by its principals' armies but by client nations, by espionage, by economics, even through scientific laurels, in the space race. But if the duel between superpowers was cold, it did not end in a whimper: it concluded with a crash, when the Berlin Wall, the 28-mile-long dividing line between Western capitalism and Soviet communism, came falling down 28 years after the Soviets erected it in 1961.

As a crowd of 20,000 of his East German countrymen implored him to "Open the gate!" on the chaotic evening of Nov. 9, 1989, Harald Jager, head of passport control at the Bornholmer Strasse checkpoint, kept shouting a rhetorical question at the guards under his command: "What shall I do? Order you to shoot?" It was nearly 11 p.m., four hours since Jager heard the stunning news on TV: the East German Politburo, reponding to weeks of peaceful demonstrations and a flood of refugees from their nation fleeing through Hungary and Czechoslovakia, had announced that all citizens could leave East Germany at any border crossing "immediately." Minutes later, Jager made his decision: he told his men at the gates to "open them all." By dawn, some 100,000 delirious East Germans had slipped past the guards on their way to a raucous celebration in West Berlin. The fall of the Wall was a combination of the storming of the Bastille and a New Year's Eve blowout. More important, it was the stunning affirmation that more than four decades of steady Western pressure had finally exposed the failure of the communist vision.

The Cold War In Eastern Europe

1945-48 In the power vacuum that follows the fall of Hitler's Germany, the Soviet Union extends its sway across Eastern Europe, dominating such nations as Poland, Czechoslovakia, Hungary and Romania.

1956 Soviet leader Nikita Khrushchev sends Russian tanks into Hungary to crush a popular revolution against Kremlin control.

1961 Khrushchev tests young U.S. President John F. Kennedy by erecting a wall between occupied East and West Berlin.

1968 Soviet tanks enter Czechoslovakia to crush the liberalizing "Prague Spring" led by President Alexander Dubcek.

1978 Polish Cardinal Karol Wojtyla, a foe of the Soviets, is elected Pope John Paul II.

1980 Polish workers in a shipyard in Gdansk form an anti-Soviet labor union, Solidarity, led by Lech Walesa.

1985 After three Soviet leaders die in quick succession, reformer Mikhail Gorbachev is named to lead the U.S.S.R. His policies of *glasnost* (openness) and *perestroika* (restructuring) kindle the flames of resistance to the Kremlin in the Soviet sphere.

1989 The Berlin Wall falls.

1989 East European nations begin to win back their sovereignty in a series of elections and generally nonviolent revolutions.

1991 The Soviet Union formally dissolves, and the 15 formerly united republics of the U.S.S.R. become independent nations.

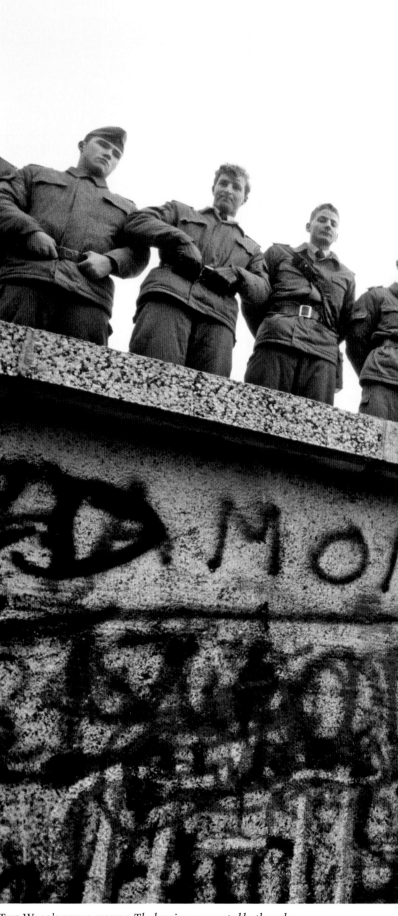

THE WALL'S FINAL HOURS *The barrier was erected by the order of Soviet leader Nikita Khrushchev in August 1961. Above, East German citizens challenge soldiers defending the wall, shortly before the order to allow free passage was given on Nov. 9, 1989*

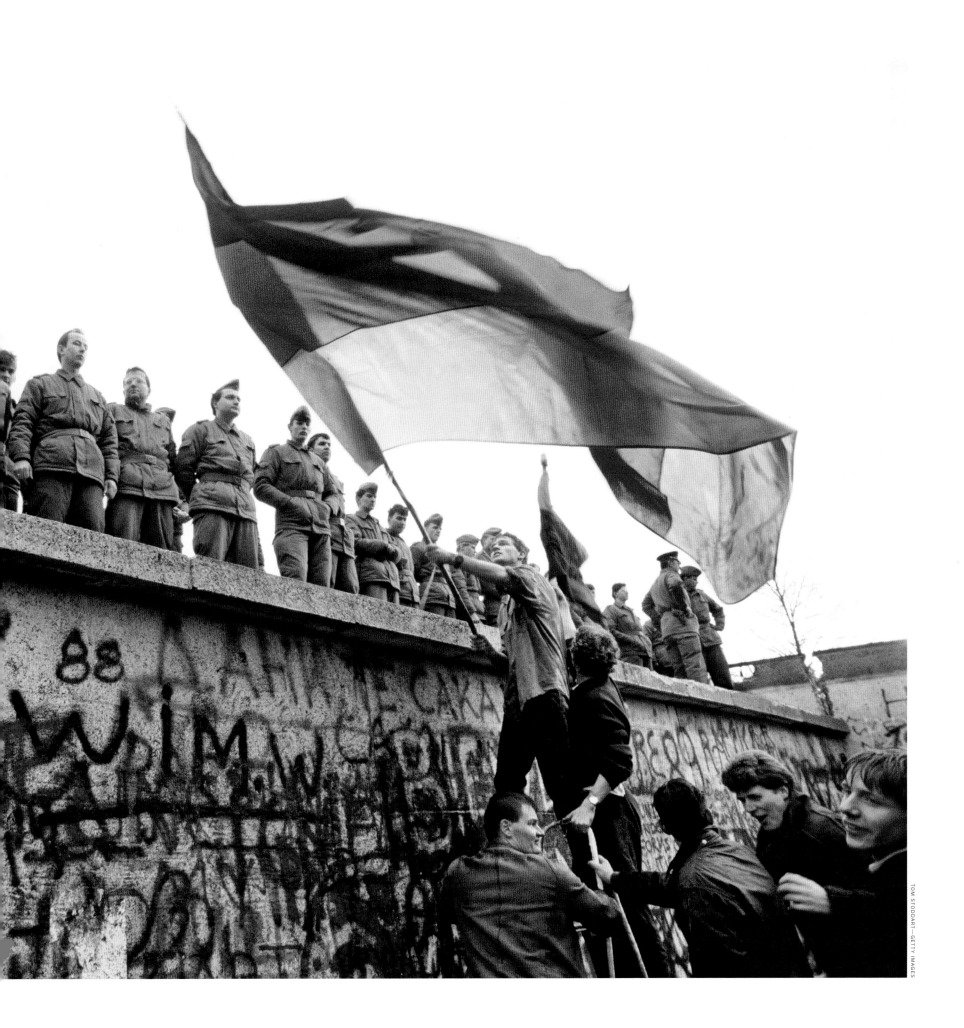

147

Nelson Mandela Is Freed; Apartheid Is Abolished

98 Perched at the southern tip of the African continent, South Africa became an essential port for Portuguese and Dutch navigators bound from the Atlantic to the Indian oceans around the treacherous Cape of Good Hope. But when rich deposits of gold and diamonds were discovered in the late 19th century, Europeans vied to control them, with British colonists eventually defeating Dutch settlers, the Afrikaners, in the Boer War. The losers in this race to riches were the land's indigenous peoples, who were pushed into subordinate positions, then legally consigned to second-class status under a strict system of racial segregation, apartheid.

As the injustices mounted, the nation's white rulers brutally clamped down on native blacks who demanded equal rights. One such protester was Nelson Mandela, a noble of the Tembu tribe and a Johannesburg lawyer who initially followed Mohandas Gandhi's principles of nonviolence, then became more radical in the early 1960s, leading an underground group that actively battled the white regime. Mandela was apprehended and sentenced to life in prison in 1964, but his stature only grew during the 27 years he was a political prisoner. By the late 1980s, he had become a global icon, the invisible yet inescapable symbol of resistance to a system that had turned South Africa into a war-torn land in which a minority of some 4 million whites clung to an unjust, tight-fisted rule over a majority of more than 35 million blacks.

Finally, international pressure and internal rebellion forced the white regime to set Mandela free. Within four years of his release, the aging leader—who, remarkably, declared he had forgiven his captors in order to move the nation past its divisions—became the first President of a new South Africa, where all citizens were able to vote, and where apartheid was consigned to history's dustbin.

LONG WALK TO FREEDOM *Mandela and then-wife Winnie raise clenched fists of victory and defiance as he walks free from South Africa's Victor Verster Prison on Feb. 11, 1990*

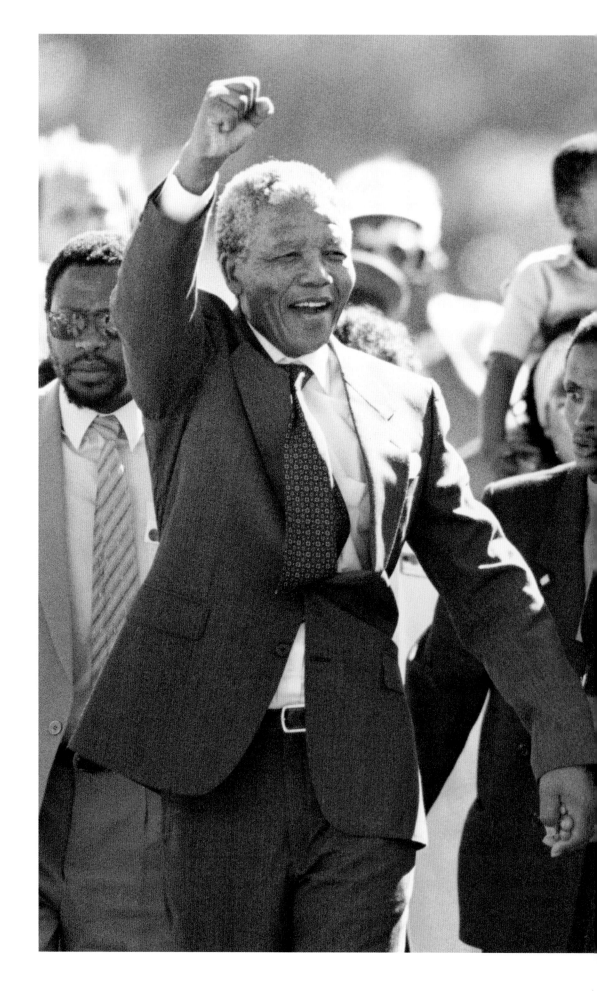

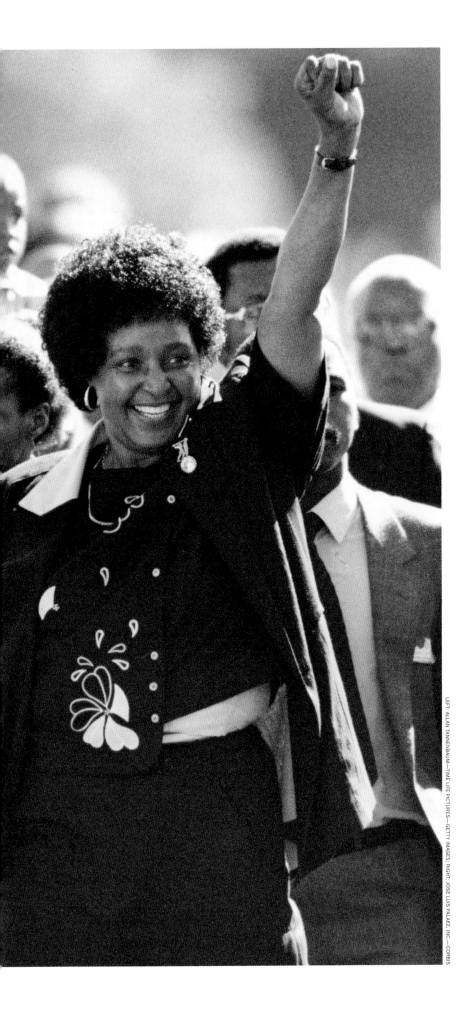

The World Wide Web Is Spun

99 Nobody was paying attention to Tim Berners-Lee and his pet idea. The young British scientist at CERN, the noted physics lab in Geneva, had conceived a radical new way for scientists to share data by linking documents to one another over the Internet. He had kicked around a few different names for his vision, including "Infomesh" and the "Information Mine." But he wasn't getting much interest from his bosses. His proposal came back with the words "vague but exciting" written across the cover.

So Berners-Lee took his invention to the people. He posted a message to a newsgroup—a kind of electronic public-access bulletin board—announcing the existence of the "World Wide Web (WWW) project." The message included instructions on how to download the very first Web browser, also called World Wide Web, from the very first website, *http://info.cern.ch*. Berners-Lee's computer faithfully logged the exact second the site was launched: 2:56:20 p.m., Aug. 6, 1991.

He posted it, and we came. Traffic to *info.cern.ch* rose exponentially, from 10 hits a day to 100 to 1,000 and beyond. Berners-Lee had no idea that he had fired the first shot in a revolution that would bring us home pages, search engines, eBay auctions, Facebook fads and Twitter tweets, but he knew that something special had happened. The Web sprouted wings after U.S. students gave it a user-friendly graphic interface in 1997.

Like the telephone and telegraph before it, Berners-Lee's device has reprogrammed every aspect of human life. Commerce, travel, politics, science, social behavior—all have been transformed by this ubiquitous, instantaneous digital tom-tom. Yet this revolution is still less than 20 years old: stay tuned ... or, on second thought, keep tweeting.

Terrorists Strike on American Soil

100 On Sept. 11, 2001, the Islamist militant group al-Qaeda carried out the single most successful terrorist attack in world history after their operatives hijacked four U.S. jetliners almost simultaneously. Two of the big planes were flown at top speed into the Twin Towers of the World Trade Center in lower Manhattan, bringing down two of the world's tallest skyscrapers and killing some 1,800 people. A third plane hurtled into the Pentagon in Washington, D.C., killing 184. And the fourth jetliner plummeted into the ground in Pennsylvania, killing 40, after passengers launched a valiant attack on their hijackers that crashed the plane.

The attacks stunned Americans, shattering their cherished sense of inviolability. And it humbled them: a small band of terrorists had dealt a critical blow to the world's lone superpower. Within weeks of the attacks, President George W. Bush sent U.S. troops into Afghanistan, where the ruling Taliban, Islamic fundamentalists, had given safe harbor to Osama bin Laden, the Saudi millionaire who led al-Qaeda. The Taliban regime was toppled, but Bin Laden eluded capture, escaping to the vast border regions between Afghanistan and Pakistan.

Declaring a "war on terror," Bush soon turned his focus to Saddam Hussein's Iraq: U.S. officials declared the dictator possessed hidden caches of weapons of mass destruction (WMD). On March 20, 2003, the U.S. and several allies launched an attack on Iraq that sent Saddam into hiding and eventual capture, though no WMDs were ever found. After seven years of a vexing and deadly occupation, fewer than 100,000 U.S. troops remained in Iraq, and all combat troops were slated to return to the U.S. by August 2011. In December 2009, President Barack Obama rejoined the fight in Afghanistan, ordering 30,000 additional U.S. troops to the troubled land, where the Taliban had been staging a resurgence in recent years.

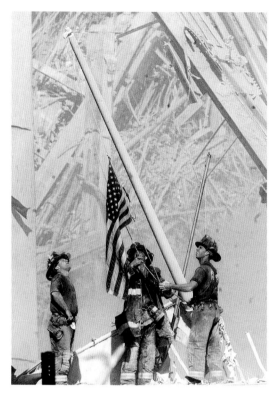

UNVANQUISHED *Firefighters raise an American flag at the remains of the World Trade Center in downtown Manhattan on 9/11/01. Nearly 3,000 people died in the terrorist attacks; most victims were U.S. officeworkers at the Trade Center. Fifteen of the 19 hijackers were citizens of U.S. ally Saudi Arabia; none were Iraqis or Iranians*

Islamic Terrorists And the U.S.

1983 241 U.S. Marines on a peacekeeping mission in Lebanon are killed when a suicide bomber allied to Islamic militant group Hezbollah attacks their barracks.

1992 A bomb set off in a hotel in Yemen kills two Austrian tourists. U.S. intelligence agencies believe this is the first terrorist attack involving Osama bin Laden.

1993 A car bomb rocks the World Trade Center in New York City, killing 6 people and injuring some 1,000. Mastermind Ramzi Yousef is a Kuwaiti of Pakistani descent.

1996 19 U.S. airmen are killed and 400 injured by a bomb at the Khobar Towers apartments in Saudi Arabia. Bombers include 13 Saudis and a Lebanese man.

1998 U.S. embassies in Kenya and Tanzania are bombed; more than 200 die and more than 4,500 are wounded. Al- Qaeda is linked to the two attacks.

2000 Al-Qaeda suicide bombers explode a boat alongside U.S. Navy destroyer U.S.S. *Cole* in a Yemen port, killing 17 U.S. sailors.

2001 The World Trade Center and Pentagon are attacked in an al-Qaeda plot to sabotage U.S. finance and military might.

2001 British citizen Richard Reid fails to explode a jetliner crossing the Atlantic via explosives concealed in his shoe.

2009 U.S. agents foil Afghan Najibullah Zazi's plot to blow up Manhattan subways.

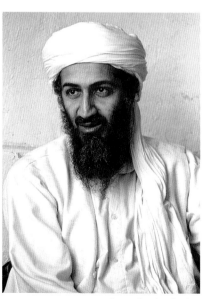

OSAMA BIN LADEN *Al-Qaeda's leader has eluded capture since the 2001 attacks*

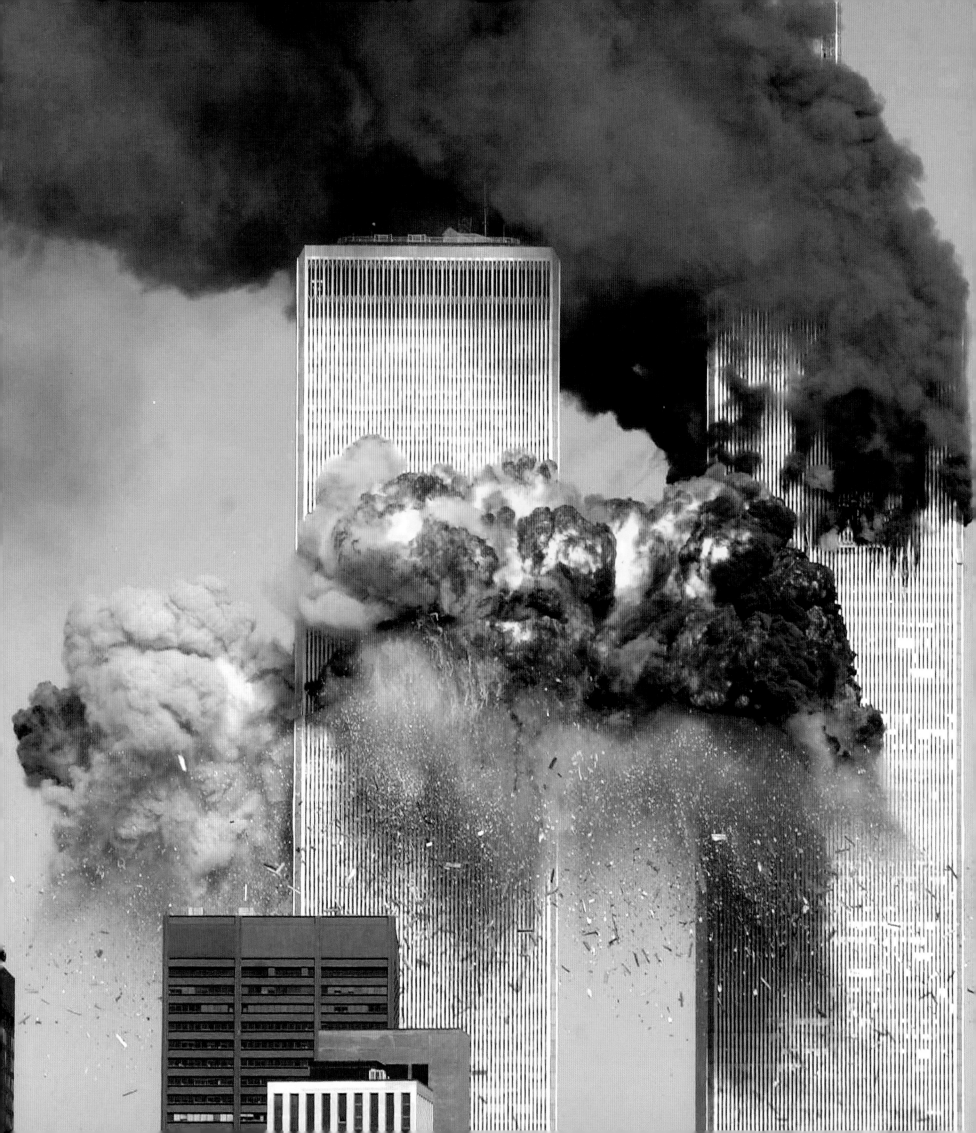

INDEX

FRONT COVER. (Lincoln) Prints and Photographs Division—Library of Congress; (Great Wall) Keren Su—Corbis; (D-day) U.S. Coast Guard; (Napoleon) *Napoleon Crossing the Alps* by Jacques Louis David, ca. 1801—Bridgeman Art Library; (M.L. King) AFP—Getty Images; (*The Birth of Venus*) Sandro Botticelli—Imagno—Getty Images; (chip) Tom Grill—Corbis; (Jesus) Cappella Palatina, Palazzo dei Normanni, Palermo, Sicily, Italy—Scala—Art Resource; (Wright Brothers) Bettmann Corbis; (Caesar) Marie-Lan Nguyen; (Berlin) Tom Stoddart—Getty Images; (Edison) Bettmann Corbis; (Sphinx) Samantha Lee—Overworks—Time Life Pictures—Getty Images; (Moon) NASA; (bomb) Corbis; (guillotine) *Execution of Marie Antoinette* (detail) Musée de la Ville de Paris, Musée Carnavalet, Paris—Giraudon—Bridgeman Art Library; (Ford) Library of Congress—Getty Images; (cave paintings) Jean-Daniel Sudres—Hemis—Corbis; (mask) British Museum, London—©The British Museum—Art Resource, NY; (Lenin) Hulton-Deutsch Collection—Corbis

BACK COVER. (Buddha) Thom Lang—Corbis; (Copernicus chart) Staatsbibliothek zu Berlin, Stiftung Preussischer Kulturbesitz, Berlin, Germany—Photo by Dietmar Katz—Bildarchiv Preussischer Kulturbesitz—Art Resource, NY; (Voltaire) Institut et Musée Voltaire—Imagno—Getty Images; (9/11) Spencer Platt—Getty Images